Since '45

Since '45

America and the Making of Contemporary Art

Katy Siegel

REAKTION BOOKS

Published by Reaktion Books Ltd
33 Great Sutton Street
London EC1V 0DX, UK

www.reaktionbooks.co.uk

First published 2011

Printed and bound in Great Britain
by the MPG Books Group.

British Library Cataloguing in Publication Data
Siegel, Katy.
 Since '45 : America and the making of contemporary art.
 1. Art, America – 20th century. 2. Art and society –
 United States – History – 20th century. 3. United States –
 Civilization – 1945 –
 709.7'3'09045—dc22

ISBN 978 1 86189 773 2

Contents

I dedicate this work to the USA, that it may become just another part of the world, no more, no less.
—John Cage

Preface

My estimate of America . . . sometimes runs very low, sometimes to ideal
prophetic proportions.
—Ralph Waldo Emerson, 1862[1]

Seek the extremes. That's where all the action is.
—Lee Lozano, 1969[2]

This book is the outcome of a long effort to understand how
contemporary art relates to history and how history, including
the history of art, is written. Specifically, it is about how art has
changed since 1945. For a long time I tried to think about 1945—
both the year itself and all it stands for—from a contemporary
perspective, in an effort to grasp what it felt like to live at that
moment, and how the experiences of that moment affected the
making of art. This led me to consider what 1945 meant historically,
how it shaped social conditions and art in subsequent decades,
how it is still affecting the world we live in today. Finally, I have
struggled with the more abstract question of how the idea of 1945
as a world-shifting event has shaped the way we understand history.

I wrote my doctoral dissertation, years ago, on the ways artists
and critics in the postwar period understood time, in its historical,
generational or social, and individual dimensions, utilizing
such theoretical constructs as the "paradigm shift" and the
"epistemological rupture," the "generation gap," and the "artistic
breakthrough," along with the concept of "postwar" itself. The
dissertation traced the creation and expression of these constructs
by following the use of particular terms (like "new" and "young")
in the art criticism of the time. It was a historical study, in the
sense of addressing a past moment, and also in that my main
subject was the way history was written, the way that art criticism
became history.

In my first teaching job, I found myself working primarily
with studio art undergraduate and graduate students who wanted
to know about contemporary art. My own academic training and

knowledge stopped with the art made in 1968, so I began teaching myself, piecemeal, about more recent art. Like most other academics, I began with artists who were not only well known but congenial to a largely theoretical or text-based understanding of their work, professorial favorites who fit neatly into the march of academic art history. But as my knowledge of art broadened and deepened, I branched out to study and teach different types of artists, including both those left out of the history because they did not fit in artistically, ideologically, or socially, and those often scorned, apparently, for their success in the art market. Learning more, I came to see that the way I had learned to understand contemporary art, largely shaped by the concepts I had examined in my thesis, was wrong.

In discussing American and contemporary European art (and, still, today, art from around the world), critics and historians relied too much on an older European model of artistic activity framed in terms of an avant-garde, rejecting the market and attempting to shock the public, with an insider intelligentsia leading clueless collectors to the important work of the moment. This model just did not fit, except, superficially, for a small group of artists, often themselves academics, who, shaping their practice after this image, hoped to place themselves in the avant-garde lineage. Art writers tended to take for granted an autonomous history of a way of making art called "modernism." Of course, American postwar art had some things in common with older European modernism: the general condition of capitalism, and art's place in this social system; the wish of some artists to connect to modernist tradition; and a seeming perpetual run of beginnings and endings, particularly endings. (While these were often cast as generational—the end of Abstract Expressionism and the takeover of Pop, for example— they could also be medium-based—the end of painting was a particularly common event.) But what was never discussed were the American social conditions, history, or earlier art that might have shaped the new art, aside from work that overtly critiqued (or was seen to critique) America. The sole exception to this was the treatment of Abstract Expressionism, portrayed by recent writers as representing America in its predilection for masculinist

bombast. This was ironic, as so many of those artists not only were immigrants but felt quite alienated from many mainstream American social values.

History is the experience of the debris of the past, while criticism is the experience of art as a living thing, made by living artists, whether those artists are undergraduates in Memphis or famous artists in New York. One is attached to an interest in large-scale social transformations and abstract ideas, and the other is based on an engagement with specific art objects. Both, it turns out, have a role to play in understanding the contemporary art that began in 1945. I experienced the tension between past and present directly when learning about present-day art in order to teach my students led me to become a practicing art critic in New York, writing first for the magazine *Artforum* and then for museum exhibition catalogs. But although my critical writing tends to be somewhat historically inflected—and vice versa—bringing together two modes of practice, history, and criticism, or two fields of study, the postwar and the contemporary, required effort. To locate the continuities as well as the changes between the art world of the 1940s and that of 2010 requires looking at once backwards and forwards.

Of the many relationships between present and past, a particularly important one is the way in which the meaning of a thing (an idea, an artwork, an essay, a person) changes over time as it exists in the world. Whether the subject is the dropping of the atomic bomb or the paintings of Jackson Pollock, understanding it validly exploits hindsight and the unfolding of unforeseen consequences to follow its changing *social* meaning for subsequent generations. Specifically, the ways that the art of the present moment is historicized by institutions and academics helps shape its meaning. In the latter half of the twentieth century, for example, the preference for breaks and paradigm shifts as the way to write history has had an enormous influence on our perception of artistic production, if not on that production itself. But this preference can mislead, masking the continuities that exist between past and present. Even if you don't believe that the present is in general the necessary outcome of past events, it is true in particular that the

art of the present, or at least our understanding of it, is very
much the product of the postwar moment and the struggles to
understand that time.

While critics tended to divorce contemporary American art
from its historical past, I saw younger artists involved with the
postwar art I studied, revisiting its ethos of experience and
un-finishedness and even taking on the subject of the Cold War
itself. Their clear-eyed interests helped me see older artists,
generally posited as reacting against Abstract Expressionism, in a
new light, as also engaged with issues raised in the 1940s. In fact,
I believe that it is possible only now to see clearly what the
significant changes of that postwar moment were, ranging from
the climax of the American century to the real meaning and extent
of the often-proclaimed death of the avant-garde, the premium
placed on youth, the rise and fall of art discourse and the figure
of the critic-historian, and the increasing importance of the mass
audience.

This is because contemporary art emerged from a real historical
break, what the atomic bomb was both symbolic of and instru-
mental in producing. The change I am addressing is the shift in
modern art that resulted from the ascension of the United States
to world power, some might say dominance. On the one hand,
what happened in 1945—the use of the atomic bomb and the
American victory in World War II—was an irrevocable wiping of
the historical slate. On the other, it is also true that postwar art
retained ties to earlier modernism: most prosaically, at the same
time that Jackson Pollock wanted to make a new kind of painting
he was very interested in Pablo Picasso, and his work was also
shaped by that of his teacher, Thomas Hart Benton. In addition,
understanding art after 1945 requires attention to the earlier history
of American art and the social conditions in which it existed, so as
to see how this history interfered with the modernism that was
created under European social conditions. The very continuity
with American history produced a break in *art history* (just as
recognizing the element of continuity breaks with recent conven-
tions of history-writing). To make matters even more complicated,
the kind of historical break that 1945 was understood to mean,

merging the First Man of a new age with the Last Man of Armageddon, is an apocalyptic one—not just a rupture but *the* rupture, an absolute endpoint to history—with startling precedents in American literature and historical imagination, a crisis-driven, all-or-nothing tradition that dates back to the rhetoric of the Puritans.

This book is, at heart, an exploration of what happened to art when the vestiges of a modern European tradition intersected with American history. This intersection shaped American art after 1945; to a large extent, as America dominated world politics and culture during the past 50 years, it created what we know as contemporary art.

Most accounts of modern and contemporary art don't focus on the national setting for the art they discuss; while a leading textbook like *Art Since 1900*, for instance, assumes that the most important art is American or European, those national identities are treated as relatively incidental to the import of the art. For fifty years after World War II, however, New York was the center of world art. This allowed American art both to develop outside of its earlier domination by Europe, and even to influence artists everywhere. The specific conditions and history of America—not "exceptional," but specific—have to matter in thinking about American art, and also about contemporary art in general.

There is a long history of struggles over the nature of the United States, starting from the initial colonization. Is it a republic or a true democracy? Are its people and culture homogenous (white, Puritan) or plural (as maintained by Horace Kallen and W. E. B. Du Bois, following William James)? But the dominant disagreement since the nineteenth century has been over whether the U.S. is a typical modern, capitalist state, sharing bourgeois nationalism with its transatlantic counterparts or, as those affirming American "exceptionalism" insist, a special case, a nation *sui generis*. Updating this dispute, some historians argue, tacitly or explicitly, that 1945 marked the beginning of America's true flowering, with domestic affluence joined by international influence. Others insist that the fateful year marked the end of America as an isolated, special nation, which at that moment definitively entered the system of global modernity, impelled to interact with

and even to dominate other countries. 1945 can thus be seen as marking both the beginning and the end of "America."[3]

This uncertainty about whether the end of the war brought the triumph or the end of America is to be found also in the history and criticism of postwar American art. On the one hand, the fact that there was no longer a need to look to Europe for anything, including culture, gradually became clear. Not only did the U.S. produce its own, but the very values of the European past— sophistication, history, avant-garde—no longer applied or appealed. Many artists ambivalently accepted abstract art itself as having an American quality, for better or worse, and Abstract Expressionism was institutionally promoted as the cultural marker of America's importance, famously even its "triumph."

On the other hand, while in the early 1960s Pop was taken as signifying both "America" and "capitalism," articulating the peculiar affinity of the two, American art was subsequently described increasingly as "important," as if its American-ness was incidental both to its formation and to that importance. Critics and historians in the U.S. cherry-picked the "right" kind of American art, assimilating it to a no-context modernism. This tendency was reinforced by the way in which the concept of globalization became central to discussions of contemporary art in the mid-1990s, as the art world in fact became more global, with the development of art markets and production outside the U.S. and Europe and the growing importance of large international exhibitions. The dimensions of this art world, incorporating a wide range of practices not rooted in Western histories, altered the significance of the heretofore dominant country. America appeared more and more as one nation among many, disproportionately powerful, perhaps, but one that might no longer be able to dominate the world culturally or politically in coming years. As a result, the United States became increasingly visible as a specific place, rather than the locus of the abstract condition of contemporaneity or modernity, or simply the things that matter. American artists were seen not as American, but as global. Paradoxically, this allowed the continuation of an art discourse less historical than theoretical, based on a concept of modernism anchored in the European avant-gardes of the past.

This is reflected in the disciplinary split within academic art history between "Americanists" and those who study modern and contemporary art. Attempts by Americanists to deal with postwar art are as a result rarely successful, with occasional exceptions.[4] Recently, however, historians and critics of modern art have begun to discuss artists in terms of social history and so, in the case of U.S. artists, of their specifically American qualities, just as younger artists are making art that deliberately foregrounds these qualities. These developments are perhaps due to America's current decline as a world power. When it fades, the thing that was once so dominant as to seem normal, the way things are, reveals itself as simply one more position, no more or less. And that position is equal in specificity, locality, and historicity to other positions.

Global power is what Henry Luce had in mind in 1941— before the victory, before the bomb—when he declared "the American Century," backdating the moment of dominance to 1900. Today it seems more correct to adapt Eric Hobsbawm's phrase for the period 1914–91 ("the Short Twentieth Century") and speak of a Short American Century. Hobsbawm influenced me also, in writing this book, by his description of that short century as "the age of extremes," marked by wars, revolutions, and other upheavals, as well as by extremes in conflicting political beliefs.[5] This character of the age, I think, is one source of the predilection for breaks and ruptures so common to late twentieth-century historical thinking. These ruptures—including individual artistic breakthroughs, the historical turning-points called modernism and postmodernism, and the supposed perpetual convention-breaking of the avant-garde—which we think of as structuring history, events, relationships, and lives, are actually ways of seeing, symptomatic of an age marked by the clash of extreme ideologies. Hobsbawm's book stops short of the twenty-first century, but the present moment, when the cover once afforded by ideologies of freedom, equality, and progress, has for the most part faded, seems more an age of extremes than ever, with the inequality between rich and poor reaching historic heights while global warming brings sudden bursts of cold and other modes of extreme weather.

While this has become the condition of much of the world and contemporary culture, it resonates especially with a traditional view of America as a land of extremes, a harsh land of contrast and struggle, with a history shaped not by tradition or slow development but by a recurrent choice between all or nothing. Some of the extremes that have shaped American history, like the contrast between the individual and mass, are shared by other modern nations, but here take on peculiar and exaggerated forms. The either/or of success and failure is basic to capitalist society, but the American version has become the model, if not the reality, for the world. Other extremes seem specifically American, like the dualism of black and white. Americans have long imagined their country as a land of destiny suspended between being the best and the worst. Puritan imagery won a new lease on life with the nation's ascension after World War II, when the promise and threat of the bomb, in particular, engendered secular apocalyptic thinking alongside the earlier evangelical mode. In the postwar age the tension between extremity, with its wildness and violence, and monotony, between terror and boredom (as Susan Sontag put it), is the meta-extreme.

The book that follows opens with "Beginning and End," sketching the art scene in New York just before and after 1945, and following various attempts by artists, dealers, curators, and especially critics to understand what they experienced as a momentous change in American art. If they saw modern art as suddenly changing its address to New York, they could not foresee the ways in which that move would reshape contemporary art. The apocalyptic undercurrent of American culture (reinvigorated by the threat of atomic disaster) led to an emphasis on absolute beginnings and threatened endings in a way that superficially resembled avant-gardism, but which did not imply a progressive trajectory. Rather, both the future and art were seen as undetermined, "unfinished," with the usual American potential to be all or nothing. This lack of certainty rhymed with an unfinished or unframed landscape, a sense of expanse and possibility that always teetered on the brink of ruin, of a sense of pastness seen from the future.

The second chapter, "Black and White" has the most visual subject of all the chapters. While painters have been particularly involved with black and white since the abstract expressionist embrace of house enamel, based on its insistent value contrast (as well as low cost), these colors also weave together issues of race, pragmatics, and reproduction, all intrinsic to American art. The social aspect of black and white is as strong as the formal one: race is central to America, as to few other national stories (except, perhaps, for South Africa), and told largely in terms of black and white. But there is also a (related) history of black and white as central to American literary imagery, to the imagined snowy north, the bleak landscape, and the white whale. Finally, black and white are the original colors of print, photography, and film, poised today between document and nostalgia.

"Success and failure" form a pair of social extremes central to American life (although certainly universally distributed by capitalist values). The negative side of the putative freedom and class mobility of the U.S. meant that here individualism took the form of total personal responsibility for one's success or failure in life, above all in the commercial world. While European artists have tended to play aristocrat or bohemian, American artists from early on were affected by the pressing need to be professional, and to achieve success. The pressure to "make it," to be Somebody, as opposed to aspirations for loftier, unworldly success, jarred post-war artists raised on the European model. Later artists took this struggle for granted, and even often made it the subject of their art work.

The problem of the individual in relation to everyone else is the subject of the following chapter, "The One and the Many." Certainly the audience for art has expanded in recent years, as museum and even gallery-going is increasingly available, and even semi-obligatory for tourists and others. At the same time, the clueless public that, in its famous "plight," needs the critic's advice to like art work that it doesn't get on its own has been replaced by an army of enthusiastic consumers who don't need to be led to drink (which they happily do in galleries and museums, at First Fridays, wine and cheese singles nights, and weekend DJ spins).

The anxious bourgeois striving to master culture in the form of a hostile but dependent avant-garde has been replaced by a band of jolly rich folks and a middle-class public, what the mid-century critic might have called "middlebrow." The postmodernist theoretical writing of the 1970s and '80s that proclaimed the death of the author and the birth of the reader has been overtaken by mass culture, as well as by technology, making the same case in much stronger terms. Increases in the scale of production and distribution of art, as well as an American ethos of art for everyone, have increasingly blurred the line between the millions who are the audience for art, and the millions of people who make it.

The final chapter, appropriately, is "First and Last." A bookend to "Beginning and End," which focuses on the dramatic break in history effected by 1945, "First and Last" reviews the myths of first and last men that show up so often in American art. All the peculiar strains of American primitivism—native peoples, cavemen, pioneers, cowboys, pilgrims—relate to the founding imagination of America as an Edenic new world. That newness was of course itself founded upon a violent erasure; it was also perpetually threatened by apocalypse, particularly after 1945. The first man might thus often be the last man (and vice versa), closely tied together in a vision of destruction and rebirth that drew on the extremes of past and future. Thus, if I began this book thinking about the enormity of the social and cultural consequences of America's use of the atomic bomb, it ends there too.

Throwing out the models of avant-garde and academy, and that of a progressive, Hegelian history, we can think more productively of artists who work with extreme ideas, expressions, or forms, not as pushing forward in a single direction but as operating under extreme social and cultural conditions. Artists make these conditions the subject of their work, and are also shaped by an art world, consisting of institutions, ideas, money, and people, that belongs to the larger social world. While I am focusing on a particular place and period, one perhaps particularly visible in its moment of decline, I also wish to analyze a more global situation blandly identified as "contemporary." I believe that, even as art and artists grow from many traditions, it must

be that these social conditions have shaped not only the market for art but the art itself. This book seeks to understand these conditions in all their confusing interactions. But above all, it is the artists' making of the world that I wish to illuminate.

1: Beginning and End

The Beginning or the End?
—title of 1947 movie about the atomic bomb

I definitely like the fact that [my paintings] could be at the beginning of
something or at the end.
—Dana Schutz, 2004[1]

In 1950, historian Perry Miller surveyed apocalyptic literature in
the wake of its postwar American revival; his title, "The End of
the World," alluded to his own contemporary position as well as
his historical Biblical subject.[2] Miller found the fulfillment of the
vision of Jonathan Edwards ("in America, the greatest artist of
the apocalypse") in the *United States Bombing Survey*, the latest
entry in the apocalyptic canon, which described the predicted
elements of intense light and heat, and the uselessness of human
institutions, in the face of the American bombing of cities during
World War II.[3] Miller was certainly not alone in making the
connection, although of course, unusually self-aware. For example,
a biblically apocalyptic imagination was at work in the 1948 road
trip physicist Freeman Dyson took from Cornell to Albuquerque
with Richard Feynman, a fellow physicist who had worked on the
Manhattan Project:

> As we drove through Cleveland and St. Louis, [Feynman] was
> measuring in his mind's eye distances from ground zero,
> ranges of lethal radiation and blast and fire damage. His view
> of the future was bleak indeed. I felt as if I were taking a ride
> with Lot through Sodom and Gomorrah.[4]

While the history of European modernism of the late
nineteenth century and the early twentieth was structured by
radical shifts, conceptualized as breaks or crises, this venerable
terminology is inadequate to grasp the change to what would
become contemporary art in the United States. Referred to as "the

new world," as if it were a blank slate, America had long stood in distinct contrast to "old Europe," and this trope became more pressing than ever after 1945. Up until that moment, the United States had represented a lack of culture, in contrast with European sophistication; after World War II, it came to represent not only the possibility of a radical beginning—and an even more desirable break from the weight of the historical past—but also the future of modern culture.

Several things put that future in doubt. First were the facts that the new era was an atomic one, and that now, as so many put it, a complete and total end to humanity was imminently possible, if not inevitable. Second, as Miller noted, was the peculiar current of apocalypticism that underlies America history. The evangelical conviction that the nation is suspended between Edenic potential and millennialist catastrophe was present from America's beginning, a conviction not confined to religious sermons, but one that has enflamed political and cultural writing as well. Third, this ruin or apocalypse often merged oddly with a more local insistence on endings, born out of generational competition, that expressed the urge on the part of younger figures to close the door on older art, artists, and critics. This pattern superficially resembled the avant-garde model of European modernism, but also, confusingly, the end of that model, because the specific mode of ultimate beginning and ending was so American. Early on, critic Harold Rosenberg articulated the common belief that American art did not fit into the predominantly European history of modern art, until then the only art history: "Despite [their] efforts to prove that American painting and sculpture 'breathe naturally in the history of art,' alienation from the past remains the inescapable condition of American creation."[5] Rosenberg implied that in some way, both American art and America itself repelled historical thinking.

Thus the social and political break effected by the American triumph of 1945, was imbued with beginnings and endings in a specifically American tradition. The ascendance of America on the world stage also fits into a long history of debates about America's mission, marked by the belief that America would be ruined by any deviation from its original philosophy, such as engagement

with the wider world, its special identity and democratic promise betrayed almost immediately.[6] The idea that from the beginning America was over recurs again and again in the postwar period. Despite the fact that the unabashedly commercial nature of the culture-less country might be seen as its defining condition, the defiling of American democracy in the mid-nineteenth century, around the time of the Civil War, by European industrial capitalism has been a lynchpin of the elegiac branch of American studies, energized by the final entry of the U.S. into the international scene in the 1940s. Later, historian Frederick Jackson Turner marked the end of America in 1890, when the frontier met the Pacific. But such crises of the end of America reached a fever pitch after World War II, when what had seemed like a resurgence of possibility and democracy in the 1930s with Roosevelt culminated in America's full imbrication with the world. Even as 1945 represented a break with the past for art, in part because art now was American, and America was the New, uncultured World, it also meant the end of the isolation of American artists from the wider world of art. Art since 1945—contemporary art—has inherited this American suspension between beginning and ending, though critics have tried to rush artists and their work to various theoretically determined conclusions.

Beginning: Art since '45

It is unusual for art history to date a period by a social break. The history of modern art in particular is usually punctuated by important individual works of art, like Manet's *Olympia* or Picasso's *Demoiselles d'Avignon,* seen as so radical that they ushered in new aesthetic eras. But while Jackson Pollock's drip paintings had come to be associated with the postwar sensibility, representing an extreme in art-making matching the extremism of the war itself, the period that came by the 1950s to be called "art since 1945" took its identity not from the work of Pollock or any other artist but from the ending of World War II. "Postwar"—in use even before the war's end or public awareness of the bomb—did not just

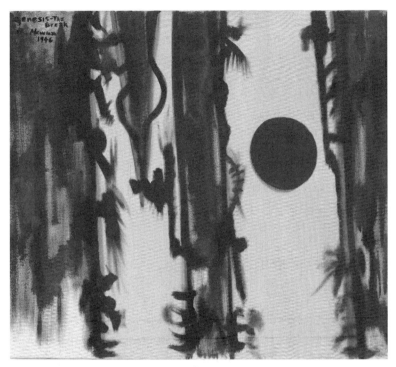

Barnett Newman, *Genesis—The Break*, 1946, oil on canvas.

mean the end of something, but was a euphemism for the ascension of the United States to military and economic domination of what was called, by virtue of that very domination, the free world.

More pointedly, politicians, official commentators, and ordinary people described the atomic bombs dropped on Japan as ushering in a "new epoch in history." While European intellectuals and scholars focused on the impact of the concentration camps and the devastation of German cities, in the U.S. journalistic reports focused on the invention of the bomb and its effects on Hiroshima (and, to a lesser extent, Nagasaki—that first shocking event seemingly overwhelming the imagination). The bomb not only symbolized those changes, but was itself an important agent of change—98 percent of Americans knew about its use, more than knew the name of the president (then or now) or have been aware of any other social phenomenon. The imagined future use of the bomb would preoccupy imaginations for decades to come, the

direness of its threat waxing and waning with international relations. While its use marked the beginning of an era, the bomb also peculiarly encapsulated an anticipated ending, perhaps of equal absoluteness.

For ambitious artists in New York, 1945 marked the confluence of several things: a decisive break with Europe, its failures and depredations revealed fully in the aftermath of the war, and a consequent rethinking of America's difference from Europe in a manner more penetrating than the chauvinistic and simplistic fictions of Thomas Hart Benton and the other American Scene artists. The painters in New York who came to be called Abstract Expressionists talked about making art as if it had never been made before, asserting that the atomic age needed its own art, in light of the mind-expanding quality of the scientific discoveries and the existential weight of the incumbent violence. As Barnett Newman put it, "we actually began, so to speak, from scratch, as if painting were not only dead but had never existed."[7] Why? "We now know the terror to expect. Hiroshima showed it to us. We are no longer, then, in the face of a mystery. After all, wasn't it an American boy who did it?"[8] The bomb ushered in a new and total beginning, but at the same time an idea of how the world would end, though not when.

Given the marginality of American artists in the 1940s, it is startling how rapidly their sense of a new beginning of art was accepted and institutionalized. Accounts of "the new American painting" began to circulate broadly in the 1950s, echoing (without his ambivalence) Clement Greenberg's conviction that the world's best painting was currently being done by young artists in the U.S. Two events of the late 1950s made clear the general acceptance of this judgment: the second Documenta exhibition in Kassel, Germany, subtitled "Kunst nach 1945," and the publication of the first text surveying what was already being called postwar art, *Art Since 1945*, with essays by different authors on twelve European countries and one on American art, by Sam Hunter, curator of the Minneapolis Institute of Art.[9] Both projects were international in scope, as the book appeared simultaneously in Britain, France, Germany, and the United States. The institution-

alization of the period "Art Since 1945" not surprisingly emerged from this international context—a German curator working in Kassel would hardly be inclined to measure modern art from a point in the 1930s or earlier '40s—but this periodization would become the standard for American critical and pedagogical histories as well. Accounts in both American and European magazines of Documenta II and the traveling exhibition "The New American Painting" were primarily concerned with the European–American relationship, variously described in conflicting variations of break and continuity.[10]

Hunter's contribution to *Art Since 1945* was, as the first written history of postwar American art, the subject of much controversy among American critics writing for a wide variety of publications, from the "little" magazine *It Is* to *ArtNews*.[11] The reviews were overwhelmingly negative, even puzzlingly so, considering the relative generosity the same critics showed to the European authors in their brief references to the essays on French and British art. Looking back at what is primarily a list of artists' names framed by introductory and concluding remarks within an obviously limited space, Hunter's chapter is a typical example of art survey-text writing, and one that today certainly would not be reviewed or of interest to professional critics or major art world figures. Its significance, in fact, resides in what has become the ordinariness of its periodization: in the fifty years since, whether they begin in 1945 or 1940, surveys blandly assume a major shift in art at mid-century, usually explaining it with some announcement of a "new moment."[12]

The refocusing of institutions and histories was accompanied by changes in the artists' fortunes. After a relatively brief period when they could find no audience, as the small number of sophisticated collectors and curators in New York were still looking to Europe and official institutions boosted more happily and obviously national art, Pollock, de Kooning, David Smith, and others began to be celebrated, bought, promoted. But even as the artists benefited, they and their early supporters were uncomfortable. "Abstract Expressionism" had succeeded as the official category organizing and describing this art, and curators

and historians had "understood" the artists and incorporated their work in a structure, explaining it not critically but historically. This meant that the contemporary art of the living artists in Hunter's book was becoming *history*, and dragging the critics along. Not only were the artists ambivalent about America, and not only were they generally against institutions, but they rejected the very concept of history. History meant closure, fixed meanings, a beginning that had come to an end.

The criticism written by this new painting's most acute supporters, Clement Greenberg and Harold Rosenberg, carried the same kind of ambivalence about beginnings and endings. Greenberg described the new painting as throwing the modern tradition of easel painting into crisis, threatening its end.[13] Rosenberg, whose championing of the struggle on the blank canvas has been much lampooned as cracker-barrel, movie-ready existentialism, also saw the inevitable ruin and commercialization of the most radical and personal experiments become formulae, even ahead of the take-off of the market for Abstract Expressionism in 1956.[14] While Rosenberg's "The American Action Painters" asked, among other things, Will Success Spoil Rock Hunter?, it was suggested more generally that the "movement's" achievement of official status had ruined the art, even as the official Cold War policies of international military intervention and executive power ran counter to American ideals.

In the face of their institutional success, supportive critics praised the autonomy of the art; the artists talked about the organic quality and the liveliness of their paintings and sculptures, emphasizing their undetermined nature and thus the refusal of history, leaving only beginnings and endings. For those wishing to relate to a work as an entity this refusal cast art as organic. For those who refused anthropomorphic analogies, particularly artists of the 1960s, it meant work that was perhaps not fully delineated, not finished, not fixed in its social position. Vacillating between various beginnings and endings, trying to wipe the slate clean, critics and artists made a deeply American gesture, one that continues to the present day, in its perpetual contemporaneity. Are we waiting for the next thing? this work asked; Or waiting for the end?

Unfinished

In 1950, as a shared sense of artistic purpose was building in New York, a group of artists met privately to discuss the issues of the day. Although the three-day meeting was called in part to define their common ideas and practices, the discussion was almost comically multi-vocal, with very few points of consensus, even as to what they should be talking about. One of the few topics they agreed on was the question posed by Robert Motherwell: "How do you know when a work is finished?"[15] One after another (with the exceptions of Louise Bourgeois and Ad Reinhardt), the artists insisted that they did not finish their works. Their responses included the idea that they were "in" their paintings while they were making them and that the paintings were done when they were "out," whenever the artist was no longer deeply engaged. The artists agreed on the wish not to finish a painting. Finish meant, for one thing, what they viewed as the French manner of refined picture-making, with a delicacy of touch and surface detail. In contrast, their surfaces ranged from de Kooning's turbulence to Still's slow thickness to Newman's straightforward paint application. Finish also meant, more generally, coming to the end of making a painting, declaring it complete or, as they would say, "resolved." As James Brooks put it, "There is some peculiar balance which it is necessary to preserve all through a painting which keeps it fluid and moving. It can't be brought to a stop. I think you have to abandon it while it is still alive and moving, and so I can't consider a painting 'finished.'"[16] Sculptor Ibram Lassaw was particularly eloquent, saying, "It would be better to consider a work of art as a process that is started by the artist. In that way of thinking a sculpture or painting is never finished, but only begun. If successful, the work starts to live a life of its own . . ."[17] These ideas are repeated again and again in interviews and artists' statements, as artists insisted that their work died if pushed too insistently towards resolution. In this insistence, the two meanings of "finish" come together: the heavily worked surfaces of the gestural painters in particular have an emotional and psychological meaning suggestive of ongoing activity, the actual experience of working rather than completion.

While many of the artists stressed the moment of beginning, others saw painting as a journey, reflecting the practice of artists like de Kooning who used pieces and tracings from previous works to ease into a new painting, or Franz Kline, who enlarged small sketches with an opaque projector. But the primary emphasis was on a lack of refinement and conclusion, against a preconceived end that spoke too much of theory, of ideology, of social instrumentality—the deadness of fixed positions, of usefulness, of the commodity. While Smith welcomed analogies with factory production, it was not to stress usefulness but a materialist pragmatism: "the locomotive method bows to no accepted theory in fabrication."[18] Baziotes, perhaps more typically, emphasized the element of discovery, writing: "I cannot evolve any concrete theory. What happens on the canvas is unpredictable and surprising to me."[19] Visible brushstrokes, handprints, scraping all evidenced the artists' struggle, and allowed their work to escape these deadly fates.

Perhaps the most famous and extreme example is de Kooning's *Woman I* (1952), which the artist worked on for two years and even then didn't consider finished until friends convinced him and his dealer removed the work from his studio. During that time, occasional photographs of the work in process were taken by Rudy Burckhardt and another friend for a proposed article in *ArtNews*; six of these accompanied "de Kooning Paints a Picture."[20] They testify that the final product was no more or less resolved, realistic or refined than the intermediary stages; it is amusing to see the disappearance and reappearance of elements like a window and even a little Dutch cap in successive photographs. As Thomas B. Hess, the author of the article, wrote "It would be a false simile to compare the two years' work that resulted in *Woman* to a progress or a development. Rather there was a voyage."[21] While there are a fair number of mythological and literary allusions in Hess's essay, the particular voyage he had in mind was that of a car—it's not the destination, it's the trip, as in the popular car advertising slogan of the day.

In 1951, at the time de Kooning was working on his series of *Woman* paintings, the architect and sculptor Tony Smith took a

drive with three of his students from Cooper Union. He had found out how to get onto "the unfinished, unopened New Jersey turnpike," and they drove from the Meadows to New Brunswick. "It was a dark night and there were no lights or shoulder markers, lines, railings, or anything at all except the dark pavement moving through the landscape of the flats, rimmed by hills in the distance, but punctuated by stacks, towers, fumes, and colored lights."[22] This trip was a transformative experience for Smith, who described the feeling of moving through the artificial landscape in the dark of night: "There's no way to frame, you just have to experience it . . . something that had nothing to do with function, created worlds without tradition."[23] The experience that moved Smith comes very close to what many of the Abstract Expressionists were looking for; above all, a creation separate from the past, from history, "without tradition." His emphasis on the unfinished nature of the structure relates directly to the subject of the 1950 discussion on finishing art works. The quality of a physically unbounded space was also an ideal for many of the Abstract Expressionists, who wanted the viewer to be completely immersed in the work. Pollock once told a reporter,

> "There was a reviewer a while back that wrote that my pictures didn't have any beginning or end. He didn't mean it as a compliment, but it was. It was a fine compliment. Only he didn't know it." "That's exactly what Jackson's work is," Mrs. Pollock said. "Sort of unframed space."[24]

Smith's story connects an understanding of the unfinished as uncompleted with the sense of the unfinished as unframed, without spatial boundaries as well as without temporal end.

Both of these facets belong to the most commonplace image of America itself, as a new country and a boundless space, as in the recurrent idea of the frontier. This image dates back to the early days of the nation, seen from both the domestic and the European perspective. For postwar Americans, particularly those of a politically radical or anarchist orientation, like the Abstract Expressionists, regard for the unfinished also expressed their hatred

for doctrine and authority, so central to European history. For them, incomplete material realities had the potential to elude social framing, were not—at least yet—determined by instrumental value, in terms of ideology or politics. The highway with no signs that led nowhere, and the art work without fixed images, were both literally good for nothing—"not socially recognized," as Smith put it.

Ironically, Smith's fable of an open terrain marked by unrecognizable forms has been written into American art criticism as a story about endings, marking an absolute break with the art of the previous generation. This is perhaps in part because, although the experience dated to the early 1950s, it was first recounted in *Artforum* in 1966. Shortly thereafter, it became the lynchpin of an argument about the nature of contemporary art. A Harvard-trained art historian and hardline Greenbergian critic, Michael Fried, cited the story in his 1967 screed against Minimalism, as an example of what he considered Minimalism's "bad" temporal quality, its endlessness, in contrast to the immediacy of earlier modernism.[25] In a letter written in reply to Fried, Robert Smithson celebrated Smith's experience (and the story surfaced in his other writing as well). Both Fried and Smithson cited Jonathan Edwards, though Fried was insensitive to the way the idea of an end to art as it belonged to the American apocalyptic tradition traceable to Edwards and his peers.

Because this exchange took place in *Artforum*, the central magazine of the art world, and because editor Philip Leider took the occasion to dramatize his personal conversion from Fried to Smithson as the leading intellectual light of contemporary art, this story and the rather provincial quarrel to which it gave rise came to mark a sharp dividing line not only between specific bodies of artwork—those of Anthony Caro (favored by Fried) and Smithson—but between modernist and postmodern art. Smith's experience on the unfinished highway made art seem inadequate; as he put it, "It ought to be clear that's the end of art."[26] Those who read his account as a manifesto for a break with earlier art took it as an announcement of postmodernism. But generally, as in this seminal example, what we might call "American post-modernism," until the mid-1970s, when French poststructuralist

theory was added to the mix, was really a mode of territorial competition among critics and artists that often played out generationally. That is, Smith and Smithson (and the supporters of their position) focused on the perceived difference of their work from older art and left unmentioned the overarching shared ethos, so visible now.

That the artistic target was Abstract Expressionism was, to a certain extent, merely a by-product of the fact that the success of that art was seen as the work of a dominant critic, Clement Greenberg. Ironically, the image of Greenberg as an omnipotent figure was itself the work of the younger generation. Along with fellow student Fried, Rosalind Krauss first built up Greenberg, while she was studying at Harvard in the early 1960s, to a status far beyond that which he enjoyed in the 1940s and early '50s, when only a few artists were deeply engaged with him and his criticism. The admiring students chose Greenberg as their model as an antidote to the hated belle-lettrism of Harold Rosenberg and other more minor writers, praising him for the objective and analytic quality of his writing.[27] In the process, they created a reading of Greenberg that calcified his critical judgments into a theory quasi-scientific in its authority. Because the younger critics had established Greenberg as a towering figure, their generational break with him was all the more dramatic. Krauss, for instance, described lecturing about flatness in Picasso, using Greenberg's work as a model. In her recounting, she suddenly turned to the screen and saw

> this huge amount of space in the painting. It was a Friday, I remember, and I turned around to the class and said, "Everything I said to you in the last twenty minutes was a total lie, and we're going to start again with this on Monday and I'm going to tell you why everything I said was all wrong and how we have to think about this work very differently."[28]

Although here Krauss dates her conversion to a lecture given in 1970, the position statement in which she took a stance against Greenberg, "A View of Modernism," was published in *Artforum* in

1972. In it, she rejected what she characterized as Greenberg's absolutist, objective historical voice in favor of a more provisional, critical, personal one, and one, she emphasized, better suited to her younger generational perspective.[29]

Others too were challenging Greenberg's judgments by the late 1960s, as people sensed a void to fill, given his rejection of new art. Even while Fried defended Greenberg's dismissal of Minimalism and celebration of color field painting, on rather technical grounds, a panoply of critics including Krauss, Jack Burnham, Lucy Lippard, and Robert Pincus-Witten, for different reasons, sought to obviate his choice of artists and his criteria for art.[30] Most of them in some way anticipated some aspect or version of what came to be called postmodernism, an artistic orientation towards images and experiences, away from materiality. As Burnham put it, "We are now in transition from an object-oriented to a systems-oriented culture."[31]

Although it came to be identified with the recognition of a supposed seismic shift in social history—the end of "modern society"—the deeper aspect of postmodernism as a mode of struggle for critical dominance in New York can be seen in the evolution of the concept, directed not by a theoretical imperative but by changing art world issues. Starting in the late 1960s as "post-formalism," it coalesced into a declaration of something new in sculpture that broke from studio production and/or conventional gallery display. This was replaced by an orientation to the cultural landscape rather than to artistic invention, and passed through theoretical concerns like "free semiotic play" and "representation without reference to the real" to more socially oriented explanations, such as a shift of the economy's center of gravity from production to consumption.[32] In 1984 literary critic Fredric Jameson explained postmodernism as the cultural expression of what Trotskyist economist Ernest Mandel called late capitalism, and Krauss and others later bowed to his idea (and perhaps Jameson's celebrity), while adjusting his dates. Krauss first located postmodernism in the late 1960s, with the advent of important young artists of her generation whose work seemed different from Abstract Expressionism—differences which she strenuously magnified, and

which today have faded. Later, she moved the shift from "modern" to "post" to the mid-1970s—a quite different moment socially, defined by the disappointments suffered by the social movements of the previous decade, and marked by the end of both economic prosperity and America's political dominance, as signaled by the failure to conquer even the small, poorly armed nation of Vietnam. Now the end of modernism meant the rise of artistic pluralism. This conception is perhaps close to the truth: that "postmodernism" meant above all a decline in the gate-keeping power of critics in shaping what counted as the mainstream of art. This too had its roots in the shift of the center of artistic production to the United States, where the ideological and marketing structures of the avant-garde, with its associated ideal of a higher culture, ahead of its time and in need of interpreting, were not native, and did not really "take." Instead of the far-sighted few, America featured the many of the audience, the collectors, and even, eventually, the artists themselves.

Seen as marking a shift to an entirely new kind of art, the idea of postmodernism is unconvincing. Continuity is at least as important as difference in the art of the postwar world. New ideas, feelings, and forms appear, of course, but there are deep connections between the art of the 1940s (and often, that of earlier periods) and that of the present. The perception of a shift away from the optimism generated by American victory and the end of World War II is more tangible and plausible—the postwar economic "Golden Age" did come to an end in the early 1970s— although many, including most artists, had not shared in the general optimism of the 1950s. Accordingly, we might see many of the characteristics ascribed to postmodernism (irony, decline, pessimism, the end of progress) as belonging to a particularly American social and economic moment; many of its forms, similarly, were particular to American popular cultural production. The global dominance of the American economy and culture explains in part why these characteristics seem, to a degree, global. Paradoxically, the definition of postmodernism as neo-liberalism is also in some ways related to the shift towards a world dominated by America and its version of entrepreneurial, speculative capitalism.

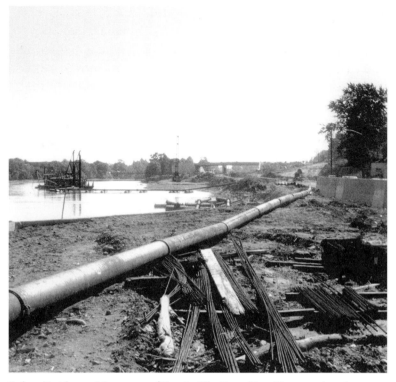

Robert Smithson, *Monuments of Passaic (The Great Pipes Monument)*, 1967,
Instamatic snapshot.

Finally, as detailed above, the promotion of modern in opposition
to postmodern values was generational and competitive. But just
as artistic postmodernism is best understood as a local, even
provincial phenomenon, the general mood of cultural decline was
an old story in the United States. Ruin was always already there,
lurking on the other side of the American coin from its early
promise and later sunny affluence, even, as we have seen, at the
moment of the greatest triumph itself.

The historical context for Tony Smith's road trip is thus,
ultimately, 1945, with its specifically American aspects stretching
out in both temporal directions from that date—and, aesthetically,
beyond the narrow group of canonized artists on whom debates
about modernism and postmodernism usually rest. In the same
issue of *Artforum* where he replied to Fried's essay, Smithson

published "A Tour of the Monuments of Passaic," an account of a
tour of that New Jersey city, accompanied by photographs of
industrial sites, bridges, and factories. Smithson's experience of the
New Jersey landscape was close to Smith's: he saw it as "a kind of
destroyed [or] derelict California."[33] California had always repre-
sented the farthest reach of the frontier, a place of the future, of
almost biblical promise, not of decline. Both scholarly and popular
authors have often considered the West the *real* America, the place
that fulfilled and extended the covenant of New England, ruined
by its subsumption by industry, capitalism, European tradition,
and, most generally, history. The very fact that so many theorists
of postmodernism—Jameson, Jean Baudrillard, even Guy Debord
insofar as he can be included in this group—located its epicenter
in Los Angeles should have tipped people off to the fundamentally
American character of postmodernism. Whether its essence was
discovered in the architecture of the Bonaventure Hotel, in
Disneyland, or in the movies, the focus was not so much on the
machinery for an international postmodernist image industry as
on a peculiarly American phenomenon. And so even Smithson,
talking about the ruin of an East Coast state in reiterating Smith's
trip on its unfinished highway, connects it to California.

The idea that by leaving the corrupt city the independent
homesteader could create a truer democracy, based on individual
freedom and opportunity, is an old one in American history. It exists
not only as popular fantasy, but in the theories about American
society referred to by historians as the frontier thesis.[34] First
enunciated by Frederick Jackson Turner in the late nineteenth
century, this was the idea that the enormous geographic expanse
of the United States offered infinite opportunity for individuals
oppressed and teetering on the edge of failure in cities in the
already settled parts of the nation. The West thus represented the
lost hope of the East, too mired in old European ways (although
Turner recognized that Thoreau's New England of the 1830s had
broken from the elitist tradition of the colonies, and was in
sympathy with the radical democracy of the West).[35] Long after
the close of the actual frontier, as Turner marked it in 1890, this
idea had an afterlife in the 1960s, when California, the youngest

part of America, with its highway culture and pure pop, was also an epicenter of the wish to reject everything modern and dangerous and move back to the land. Smithson's phrase showed us the real future of California rather than its imagined infinite possibility: the submission of the West to civilization, and the revelation of the truth about America, embodied in California.

Dave Hickey, an art critic and a devoted Westerner, wrote about Earth art in 1971, questioning the critical representation of it as an attack on the market and the museum and presciently pointing out its friendliness to the magazine, to reporting and photodocumentation. He related projects by Smithson, Heizer, and others to myths of the West, to the cowboy and the tall tales he told, and to the contemporary long-distance trucker—all the attempts of the individual to match the scale of the emptiness around him. Even the point of view such earthworks demanded was a familiar one: "for most Westerners, this translation from man-high ground view into an aerial mapping is a cultural reflex."[36] Although he is never discussed in relation to the debate initiated by Smith, Fried, and Smithson about Minimalism and postmodernism, Hickey offered an important perspective on the seriality basic to much work subsumed under these labels. While Fried complained about Minimalism's endless repetition of units, Hickey saw repetition (L.A.-oriented, he uses Edward Ruscha's photo series as his example) as another version of the endless expanse of earthworks, the mapping and parsing of swimming pools, city blocks, or parking lots a related way to indicate and master enormous spaces.

James Turrell, a Los Angeles artist occupied at the time with perceptions of light and space primarily in the context of built environments rather than earth art or photography, tells a story that gives a good sense of what Hickey was talking about. Turrell won a Guggenheim Fellowship in the mid-1970s, and used it, not to photograph or to hit the road in a car, like so many before and after him, but to buy gasoline for his airplane (his father was in aeronautics, and he supported himself in the early '70s working on vintage airplanes). He needed the extra fuel to fly back and forth across the desert, looking for an outdoor alternative to his lost

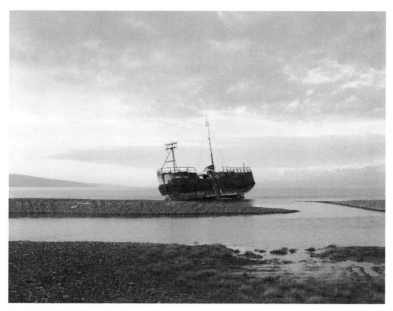

Joel Sternfeld, *Abandoned Freighter, Homer, Alaska, July 1984*, digital C-print.

studio space in L.A., "a process that could have gone on forever," according to the artist, and one that was profoundly disorienting spatially as well as temporally indefinite.[37] The endlessness of seriality in photography here is tied firmly to the endlessness of the landscape, at least in California.

Ten years after Smithson's "Tour," in 1978, photographer Joel Sternfeld received a Guggenheim grant to continue the street photography he had been practicing in New York City, and used it instead for his own roadtrip. Sternfeld took the money, packed a VW camper, and headed out into America. He followed autumn as it crept south from New York to Florida, and then traveled with the spring as the warm weather rolled up the West coast. Over the next several years, Sternfeld made many shorter trips, adding to the images he made on the original journey, and creating what would become *American Prospects*. He wasn't alone in his drive to get out of the city—New York was falling apart, and people were fleeing the rotten apple, as they were leaving other metropolitan areas, if not for the frontier, to get back to the land, to get a job, to get good schools for their kids and a park for the dog. By the time

he reached California, Sternfeld found the West now corrupted too, in its own spectacular fashion. An American driving across France or Italy notices that the materials for the buildings in each old town—stone, wood, brick—come from its particular region, and occupy the landscape with proprietary belonging. When Sternfeld drove across the U.S., he saw uniform materials everywhere: vinyl siding, metal, and glass, used in structures that had no particular relationship with the landscape, but were scattered like so much trash across the land. *American Prospects* tolled the death knell of both city and country—the end of so many nineteenth-century ideas and ideals, places, and ways of life.

What replaced these old ways? The suburbs that were the product of postwar prosperity, the edge city, and the office park that by the late 1970s had begun to supplant dying urban communities such as the Bronx and Troy as places not only to live but to work. Seemingly in the middle of nowhere, housing developments and glassy modernist towers sprung up, like the Manville Corporation headquarters in rural Colorado, recently transplanted from New York City and its identity as a bankrupt asbestos manufacturer.[38] Surveying this brave new world, Sternfeld noted the role of the car in creating it: you can't live and work in

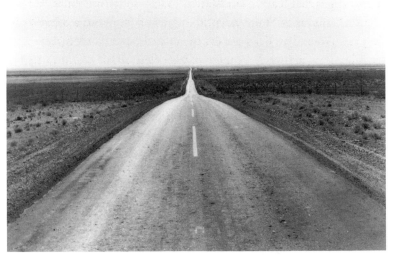

Dorothea Lange, *The Road West*, 1938, gelatin silver print.

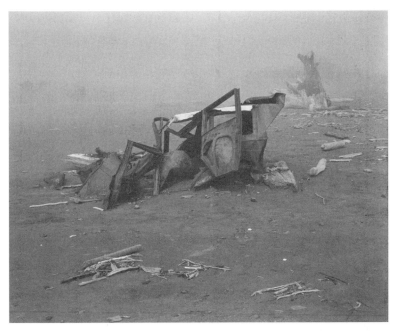

Edward Weston, *Wrecked Auto in Fog, Crescent City*, 1939, gelatin silver print.

these places without spending a good part of the day sitting in your car. Sternfeld took pleasure in the road and in America, but saw it as a ruin as much as an Eden, cheering the car's demise in two images that feature landslides of decrepit automobiles. He ended his book with apocalyptic images of the West: a blind man in his wild garden, dead whales on a beach, an abandoned freighter run aground. In these pictures we see the world in ruins, as if from the future. From the future, 1945 seems the start of a continuing process of ruination. While Sternfeld doesn't figure in the many narratives of postmodernism, this early photographic project suggests the deep Americanness of those narratives of banality and decline, rather than the supposedly anonymous, general disappointment with utopic, no-place modernism.

Sternfeld's series was another chapter of that peculiarly American tale, the road trip. Dorothea Lange in *An American Exodus: A Record of Human Erosion* photographed job seekers traveling highways westward in the 1930s; the final chapter, "Last West," showed the betrayal of the promise that drew those migrants to the West.[39]

Later photographers foregrounded their own transformative experience of the road. Both Robert Frank and Sternfeld, like Smithson, started their journeys in New Jersey, which represents, not quite the cosmopolitan quality of New York City, but something more tainted and figured than the pure Americanness and naturalism of California, although their California is ruined too. The California narrative of Edward Weston, in 1937 the first Guggenheim fellow in photography, could have been ghostwritten by Smithson, if he had been old enough to write it. Weston saw "Wrecked automobiles and abandoned service stations in the desert, deserted cabins in the high Sierras, the ruins of Rhyolite, ghost lumber towns on the bleak north coast, a pair of high-buttoned shoes in an abandoned soda works . . ."[40]

Years later, Southern writer Eudora Welty made a similar list to describe the work of another photographer, William Eggleston: "old tyres, Dr Pepper machines, discarded air-conditioners, vending machines, empty and dirty Coca-Cola bottles, torn posters, power poles and power wires, street barricades, one-way signs, detour signs, No Parking signs, parking meters and palm trees crowding the same curb."[41] In these lists, the brand new and the already trashed begin to blur together, both equally the waste products of American culture—the vaunted vacancy of the American novelty always already carrying the ghost of its ruin. Should we be surprised that Eggleston titled a collection of pictures gleaned from trips made between 1965 and 1974 from the Southeast to the West *Los Alamos*, after the secret laboratory that made possible a quantum leap in destruction?

That book features a famous photograph of a bag boy pushing a line of grocery carts in a supermarket parking lot in Los Alamos. Eggleston gives us the young man in profile, with the sun raking low across his body and casting a strong shadow on the white brick wall behind him. The poignant shot casts the cart as a kind of stand-in for the real power and mobility of the car, with shopping as a poor and curtailed substitute for true freedom. Twenty years later, Cady Noland tied the two together in works like her assemblage sculpture *A Cart Full of Action* (1986), featuring a small grocery cart loaded with car parts and other metal junk.

The "action" of the title might be driving around drinking and throwing cans out of a moving car—littering is one of the pastimes Noland marks as American, with its own perverse pleasures—or "action painting," Harold Rosenberg's preferred name for Abstract Expressionist painting.

More than a decade after Sternfeld's road trip and almost 40 years after Tony Smith's, Noland described a later version of Smith's highway experience:

> The highway is dotted with piles of metal and other materials. It's difficult to tell . . . if they are left over, or if they represent "some project" in progress. The state of being temporary or in progress is tolerated in the U.S. and we sympathize with the intentions to complete. In a way, the temporary is really our own vernacular and the permanent always seems a little phony on Americans, as if we were trying to "put on" European airs.[42]

For Noland, in the late 1980s and early '90s, the unfinished is no longer purely and unambiguously positive and lively, although it is certainly American. While Smith was exhilarated by his experience, for Noland it isn't clear whether the American project is yet finished, leaving open the possibility of growth and life, or in a state of ruin and decline, one that will remain unfinished. Reflecting this uncertainty, her own sculptural installations use scaffolding and other rectilinear metal forms surrounded by piles of objects to suggest the tension between the possibility that an accumulation of stuff could be made into something and the possibility that it is just debris. She draws together the sense of movement, mobility, and the unfinished with that of the extremely finished, with junk. Action, too, is the ideal of American mental health and self-realization, the will to be and move and do, in contrast to that of depression, the twentieth-century counterpart to neurasthenia in its ubiquity and pathology.[43]

Robert Gober was invited to represent the United States at the 2001 Venice Biennale, where the ersatz, miniature Monticello that serves as the U.S. national pavilion was the perfect setting for this very American artist. The exhibition consisted primarily of the

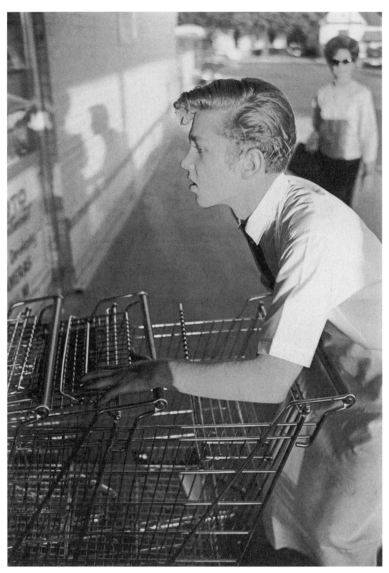

William Eggleston, "Untitled (Supermarket boy with carts)," from the *Los Alamos* Portfolio, 1965–74, dye transfer print.

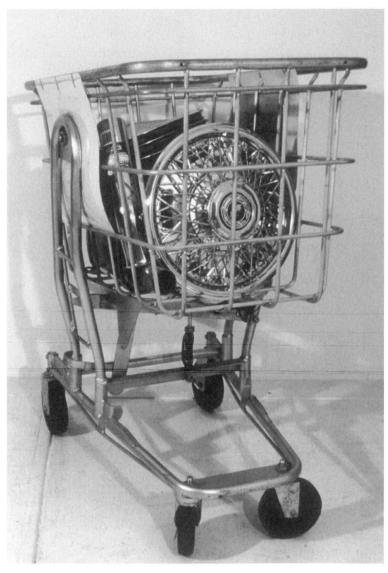

Cady Noland, *Cart Full of Action*, 1986, painted and chrome plated and other metals, glass mirror, various plastics, petroleum-based automotive products.

sculptures that, along with drawing, have been his primary artistic focus: modeled after ordinary objects like a laundry basket, and Americana such as a butter churn. In the entranceway to the odd structure was a photograph of a highway tunnel, labeled "West Rock Tunnel, 1949, digitally enhanced black-and-white photograph. Archives of the Connecticut Department of Transportation, Record Group 89, Item 30, The West Rock Tunnel on the Wilbur Cross Parkway, New Haven, 1948–49, State Archives, Connecticut State Library, Hartford, Connecticut." A parkway built in the years immediately after World War II, the Wilbur Cross goes through a natural rock formation; a feat of engineering of the same can-do era as the New Jersey Turnpike, it also, like Smithson's New Jersey, evoked Gober's childhood, leading backward in time and space.

For the Biennale, the artist also made a major photographic series that explored an expanse of time as well as space in the tradition of the American road trip. Gober combined images from a 1978 car trip from New York City to Jones Beach on Long Island with photographs shot in 2000 on the beach of the North Fork of Long Island, where he then lived. These photographs were superimposed and reshot together, interwoven with newspaper clippings, printed as a photographic series and an artist's book. The artist said of the project, "I guess it was both the literal journey and the metaphor of the journey—my journey as an artist and a man—that interested me . . ."—much like de Kooning's continuously shifting and reworked painting. "The first story was the trip to Jones Beach in 1978, the second story was the close-up pictures of contemporary debris from 2000, and these news clippings were the third story." These photographs also share the subjects of the earlier photographers' American roadtrips: junk washed up on the beach, cars and scenes shot from cars.

Among the clippings was a news story about Billy Jack Gaither, who was brutally murdered by men who suspected he was gay, his body burned on a pile of tires. The tires are also connected to the roadtrip to the beach that Gober took as a young man. When the artist later moved to Long Island, hating the plastic trash that washed up on the beach, he would collect it and haul it

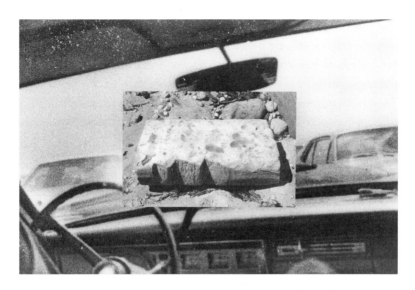

Robert Gober, details from *1978–2000*, 1978–2000, set of 22 gelatin silver prints.

away to the dump. By 2000, he had come to appreciate the debris, to see the plastic as the new form of "sea glass," the older form of trash washed and worn by the ocean and made aesthetic. He photographed the trash rather than discarding it, seeing in it no longer the ruination of Edenic America, but the expanse of archaeological time as well as the hidden spaces of the ocean. Amidst the plastic was a holdover from an earlier moment: "And one morning, I found an American flag half buried in wet sand. It was attached to a small teak pole so it probably fell from a boat. It was beautiful, slightly faded and a little tattered but carefully made and embroidered." Continuing his interest in the theme of American mistakes, Gober here took the long view of America's wasting, even perhaps the view *after* the end, but as redeemed, made beautiful and even peaceful.

The temporariness that Noland restages—a vision of "created worlds without tradition," in Tony Smith's words—is a quality of flux that implies freedom, but also a lack of historical grounding and even shoddy construction. She defines the "American gestalt" as one of extremes, found everywhere "both as an ideal and its opposite," its ruin.[44] No doubt the American celebration of flexibility and open-endedness is in full accord with the needs of a business society. But it's also about not sticking with things you know, accepting life off-balance, with a sense that things could go either way. This is the American version of the modern—the contemporary, the temporary—that it has exported to the rest of the world. Despite the effort of historians—art historians anyway—to assimilate the contemporary to familiar narratives of modernism, to locate and repeat beginnings and endings, the history of art since 1945 is unfinished, unframed, without a predetermined direction or end. This is a valuable contribution because, in fact, social history does not have a predetermined shape.

End

With every disaster, the all-or-nothing, apocalyptic rhetoric of America's founding recurs, often through the new layer of the

once-and-future apocalypse of the atomic bomb. One major
example is the AIDS crisis. Not unusually, Andrew Holleran, an
early writer taking on the subject, titled his 1988 essay collection
Ground Zero, using the term invented for Hiroshima and Nagasaki,
and extended the post-bomb metaphor to depict the "ghost town"
of Manhattan.[45] He characterized the experience of writing about
AIDS as being like "staring at the sun," a common metaphor as
well for the impossibility of looking directly into an atomic blast.[46]
Others chose the example of the survivor of Hiroshima and her
psychological trajectory as the model for those gay men still living
even as so many were dying. AIDS, of course, brought out an
undertone of end-time thinking absent from writing about
postmodernism: the biblical advent of Armaggedon, and the
possibility, for evangelical Protestants, that this plague warned of
an incipient end, if the United States did not change course.

The bombing of New York's World Trade Center in 2001
renewed more than the rhetoric of the bomb, as in the use, once
again, of "Ground Zero" to name the site. It also renewed the
Cold War discourse that ensued after the events of 1945. History
was once more portrayed by the government and its spokesmen
as a worldwide struggle for domination or freedom (despite its
putative end in 1989), with even more New Testament rhetoric
marshalled than previously, as the current war is one not just
between God and godless Communism but between the American
Protestant God and the Muslim one. A dominant theme of the
flood of writing after World War II trying to comprehend the new
weapon was anxiety or uncertainty as the new psychological state
of individuals, particularly Americans, who could imagine the
bomb being used on them. This uncertainty, which has reappeared
again and again in the past 50 years, made a major comeback in
art and politics after 2001, when threats of more terrorism were
wielded relentlessly by the Bush administration, and alleged
jihadist plans for nuclear terrorism were disseminated by
conservative political forces in the U.S. who advertised the
"American Hiroshima," a plan supposedly picked up in CIA
eavesdropping.[47] (As James Reston wrote in the *New York Times*
in 1945, "In that terrible flash 10,000 miles away, men have seen

not only the fate of Japan, but have glimpsed the future of America."[48])

The art world produced few immediate direct responses to 9/11. But a few years later the rhetoric of anxiety registered in a spate of shows such as *The Uncertainty of Objects* and *The Uncertain States of America* (2006). These exhibitions, the art they assembled, and the writing they generated revived the language of Paul Tillich and W. H. Auden in speaking of anxiety and uncertainty, the former being perhaps the dominant term of intellectuals describing the psychological reality behind the apparent affluence and ease of the 1950s. After "the decade-long 'holiday from history,' from the fall of the Wall to the fall of the Twin Towers," the threat of World War III had returned, with a focus on Islamic terrorists or small gangster capitalist outfits with atomic bombs.[49] This time around, however, America no longer truly runs the world, although it still intervenes violently around the globe and exercises disproportionate control over many putatively international institutions. Perhaps it is easier now to see its national peculiarities, its combination of glory and ruin. It is clear in any case that the achievement and threat of 1945 definitively shaped art in a period dominated by a culture suspended between beginning and end.

2: Black and White

Annihilate-Illuminate
—Claes Oldenburg[1]

Moby-Dick may or may not have been one of Jackson Pollock's favorite books—he did name his dog Ahab. Whether or not Pollock actually read the novel, Clement Greenberg linked Pollock to Herman Melville, as well as to Nathaniel Hawthorne and Edgar Allan Poe (and artist Albert Pinkham Ryder) as explorers of a harsh, peculiarly American brand of aesthetic and psychological extremes. He later invoked Faulkner as well, constructing a tradition that he saw as both "Gothic" and "radically American": "Faulkner and Melville can be called in as witnesses to the native-ness of such violence, exasperation and stridency."[2] In addition to "gothic," Greenberg used the awkward phrase "American chiaro-scuro" to refer to this effect, a phrase also used by a few other mid-century intellectuals to describe stark contrasts in nineteenth-century painting and literature.[3] The twentieth-century addition of Faulkner to the list highlights the missing element of race in this American chiaroscuro, but it was, in fact, already there. Melville's books are full of race, particularly *Benito Cereno*, but *Moby-Dick* too, as many have noted, is a catalogue of Africans, native peoples, and other variations on the not-white.[4]

Melville was the most obvious of touchstones at mid-century: there was a major Melville revival in the late 1940s and '50s, as part of constructing a usable past, a history and culture for the newly dominant America. F. O. Matthiessen's *American Renaissance: Art and Expression in the Age of Emerson and Whitman* (1941) stipulated Melville (along with Emerson, Whitman, Thoreau, and Hawthorne) as the basis for an American literary tradition struggling to find its identity. Related to Transcendentalism, but

more violent and pessimistic, Melville and Faulkner recount stories of doomed individuals like Ahab and Joe Christmas set against a vast American nature or an implacable and cruel society. These qualities—enormous scale, a harsh life—along with a particular racial conflict define the American gothic and American culture, one that never entirely disappeared, but resurfaced with a vengeance, or was newly relevant and elaborated in the 1940s.

Melville appeared regularly as a reference for the major art critics of the day, including not only Greenberg but Harold Rosenberg and Thomas Hess. Hess's important book of 1951, *Abstract Painting: Background and American Phase*, the first major publication to collect and understand (although notably not to label) the phenomenon we now call Abstract Expressionism, took its epigraph from Melville's *The Confidence Man*. Hess quoted Meville's description of the Mississippi River as a metaphor for the American will to reconcile divergent realities—"uniting the streams of the most distant and opposite zones"—seeing this

Albert Pinkham Ryder, *Under a Cloud*, ca. 1900, oil on canvas.

spirit in contemporary artists who refused manifestos or singular ideological positions.[5] Although this was not Hess's focus, the quotation implied the most opposite zones of North and South and so, black and white. (Nineteenth-century writers used the enormous distance traversed by the Mississippi to underline the fundamentally conflicted nature of the ironically named "United States" and, before the Civil War, as an argument for *not* uniting.[6])

Of course it was another of Melville's books that dominated the revival: *Moby-Dick* was the obvious candidate for the great American novel; the 1930 version sold through the Book of the Month Club and the Modern Library edition of 1944 were enormously popular. Both were copiously illustrated with astonishingly beautiful black and white Rockwell Kent prints. *Moby-Dick* is filled with vivid descriptions and stark imagery (and even contains a whole chapter devoted to the description of a painting), lending itself to thinking about painting and space.[7] A very partial list of post-war artists whose titles reference the book would include sculptor Theodore Roszak, Jackson Pollock, Ellsworth Kelly, William Baziotes, and Sam Francis.[8]

Moby-Dick's central image also fueled Harold Rosenberg's signature essay on action painting : "The American vanguard painter took to the white expanse of the canvas as Melville's Ishmael took to the sea."[9] Although existentialism, broadly written, is more often invoked with respect to Rosenberg, his reference to Ishmael casts the painter's quest as a transcendental one, that of a soul searching for meaning. Rosenberg's metaphor is also pictorially ambiguous, with the expanse of the ground conflating sea and whale, and the painter setting out on a quest almost without object, or with an object both so elusive and so pervasive as not to be visible. The painter must make his mark on this ground, an image still compelling, even if grandiose to our eyes today.

A related but less familiar version of this vision opens the first book published by poet Charles Olson, a poet who taught with de Kooning, Kline, Motherwell, and Aaron Siskind at Black Mountain, where he encountered Robert Rauschenberg and Cy Twombly as students, and who was friendly with many other Abstract Expressionists. Olson began *Call Me Ishmael*, his 1947

Cy Twombly, *Untitled*, 1951, bitumen and emulsion.

prose poem study of *Moby-Dick*, with the image of space as foundationally American: "I take SPACE to be the central fact to man born in America, from Folsom cave to now. I spell it large because it comes large here. Large and without mercy."[10] A few years later, in an essay on Twombly, Olson implicitly referred to Melville: "There came a man who dealt with whiteness. And with space. He was an American."[11]

Whiteout/Noiseless Flash

Olson wrote of American painting that now "all perspective as aid gone, the whole Renaissance. Even line gone. And maybe color— too easy." Instead, what takes their place is *light*, "without use or reference of any object."[12] The problem of the artist's relationship to the canvas is one of light: "Take it flatly, a plane. On it, how

can a man throw his shadow, make this the illumination of his experience, how put his weight exactly—there?"[13]

This concept of whiteness as space against which a man measured and declared himself was exhilarating and also potentially terrifying. Joan Mitchell, speaking of white, traced a set of associations: "It's death. It's hospitals. It's my horrible nurses. You can add in Melville, *Moby-Dick*, a chapter on white. White is absolute horror, just horror. It is the worst."[14] The chapter on the whiteness of the whale grabbed the imagination of many artists and visually oriented writers. Lewis Mumford and D. H. Lawrence (conflating natural with social forces) argued that the whale represents the power of the universe. Lawrence specifically connected Ahab's nemesis to race: "the deepest blood-being of the white race; he is our deepest blood-nature."[15] In *Native Son* (1940) Richard Wright described white society as itself a terrible force of nature, not unlike the whale or the sea: "to Bigger and his kind white people were not really people; they were a sort of great natural force, like a stormy sky looming overhead, or like a deep swirling river stretching suddenly at one's feet in the dark."[16]

The natural force that writers and authors most often used to depict whiteness was snow, the frozen expanse of the north. And here too, race was at the least a tacit backdrop. Melville's imagery probably looked back to Edgar Allan Poe's Antarctic stories, "MS. Found in a Bottle" (1833) and *The Narrative of Arthur Gordon Pym of Nantucket* (1838).[17] The latter tells the story of a hole in the North Pole that leads to a land occupied by black natives terrified of the color white; ultimately the narrator runs into a giant white being looming in a white sea and a white fog, who presumably kills him, as the book ends there. Some interpret this figure as a kind of white shadow, an emanation of the writer's own soul. A white figure blends into the landscape as well in Wallace Stevens's 1921 poem, "The Snow Man": "nothing himself, beholds/ Nothing that is not there and the nothing that is."[18] The white figure that represents emptiness or silence merged with his surroundings is a recurrent image in Stevens, most famously in 1936's "The American Sublime": "The empty spirit/In vacant space." For Barnett Newman, whiteout too was the sublime,

terrible but also fantastic. As art historian Richard Shiff has
written,

> From the limitless four horizons of the tundra, Newman
> imagined the no-horizon of whiteout. Hess once attributed
> the title of Newman's *Tundra* to the time when the artist,
> accompanied by Pollock, saw the black and white film *Valley of
> the Eagles*, which was set in Lapland . . . Whatever its narrative
> and cinematic merits, the film did convey the essence of
> whiteout: atmospheric conditions in which one is unable to
> see any horizon at all, the tundra effect at its extreme—utterly
> disorienting visual blankness, no relations, no external
> indicators of direction.[19]

The image of the unpopulated Northern (or Southern) extreme,
of snow and ice, could be found throughout the postwar culture.
To take only one example: Saul Bellow's 1959 *Henderson the
Rain King* ends with Henderson dancing on a field of ice in
Newfoundland: "I guess I felt it was my turn to move, and so
went running—leaping, leaping, pounding, and tingling over the
pure white lining of the gray Arctic silence."[20]

The conditions of blindness and silence recurred often in the
dialogue around white. Ralph Ellison's 1952 novel *Invisible Man*
(begun in the summer of 1945) featured a black man living in a
basement surrounded by 1,369 light bulbs, making his "hole" the
brightest place in New York: blindingly bright.[21] The reversal of
the dominant social hierarchy of light and dark is one theme:
"I now can see the darkness of lightness."[22] Blindness recurs as
another, as in the "Battle Royal" section in which black boxers
are blindfolded to fight for the amusement of the white audience.
Ellison's hero eventually gets a job in the boiler room of a factory,
Liberty Paints, specializing in the color Optic White.

Around the time Ellison was finishing his novel, emptiness and
ecstasy came together in Robert Rauschenberg's *White Paintings*
(1950–51), panels of uninflected white-painted canvas. Undertaken
after "a short-lived religious period," the artist described them in a
combination of beat poetry and his evangelical upbringing: "1 white

Willem de Kooning, *Light in August*, 1946, oil and enamel on paper, mounted on canvas.

as 1 GOD." Close friend and admirer John Cage, who had his
own religious period, ended a statement about Rauschenberg by
exulting, "Hallelujah! the blind can see again; the water's fine."²³
The ecstatic tone, ironically echoing evangelical Christianity and
baptism, invokes whiteness as ambivalently blindness and the
restoration of sight, as well as the water that you swim in. Both
imply enveloping conditions, and the condition of whiteout. The
experience of disorientation, of white as taking away traditional
markers of place, is figured in *White Painting with Numbers* (1949),
a white painting with numbers scratched in all different directions,
creating a visual field with no clear up or down, left or right.²⁴

White needs black. Optic White had ten drops of "dead black"
in every batch, and Rauschenberg's white paintings welcomed
shadows; Cage called them "airports for the lights, shadows, and
particles," and his statement on the 1953 show of the work at
Stable, after his famous list of NOs, stipulates that the paintings
"are not destroyed by the action of shadows."²⁵ Far from it:
Rauschenberg described the white paintings as functioning as "a
very limited kind of clock"—you could look at them and see how
many people were in the room or what time of day it was. Both
of these functions are served by shadow, the length of the shadows
of individual bodies, like those on a sundial, indicating whether it
was noon or dusk.

The most common use of white in painting, however, did not
just imply black but incorporated it. In the summer of 1946 de
Kooning began a group of striking black and white paintings
(often cited as the first black and white works among the Abstract
Expressionists, and highly influential), titling the first *Light in
August*. Characteristic of de Kooning's postwar painting, it mixes
abstract lines and forms with hints of figuration—a female bust,
perhaps, a sun or moon, a tablet or curved window. The painting
was ostensibly named after William Faulkner's novel, one of the
artist's favorites, in which a mixed-race child incarnates the light in
August, a glimmer of hope for the future amidst a ruined society.²⁶
The artist may have also been thinking of the previous August, and
a different kind of light, that of the atomic blasts in Hiroshima
and Nagasaki.

Yorozuyo Bridge: Closeup .6-Mile SW of Zero Point shows where pedestrian stood at time of explosion thus shielding pavement (no date given), black and white photograph.

In 1951, de Kooning spoke on abstract art at MoMA:

Today, some people think that the light of the atom bomb will change the concept of painting once and for all. The eyes that actually saw the light melted out of sheer ecstasy. For one instant, everybody was the same color. It made angels out of everybody. A truly Christian light, painful but forgiving.[27]

Echoing the ecstasy of Rauschenberg and Cage, de Kooning also seems to have read the description of the horrific event in John Hersey's *Hiroshima*, "There were about thirty men . . . all in exactly the same nightmarish state: Their faces were wholly burned; their eye sockets were hollow; the fluid from their melted eyes had run down their cheeks."[28] Before the book was published an extended excerpt was run, one year after the United States dropped the bombs on Hiroshima and Nagasaki, in the August 31, 1946 issue of the *New Yorker*, which sold out immediately and was very widely read, as well as broadcast to millions on the radio. Hersey's story was subtitled "A Noiseless Flash." Here, silence amidst whiteness—the absence of sound registered by the bomb's victims together with

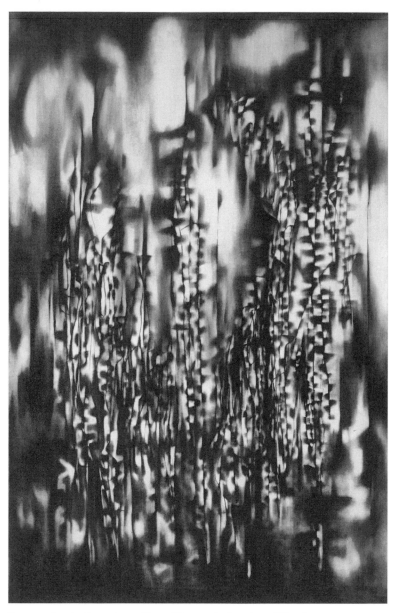

Norman Lewis, *Every Atom Glows: Electrons in Luminous Vibration*, 1951, oil on canvas.

the most intense light imaginable—finds a new iteration, follow-
ing the silence of the sublime and the unoccupied territory of the
north (and looking forward to the sign reading "SILENCE" in
Andy Warhol's *Electric Chair*). "Flash" also evokes the images,
both in Hersey's text and in actual photographs, made after the
bomb, showing black or white "shadows" of people and buildings
burnt into the sidewalks of Hiroshima by the blast, giving a more
ominous inflection to photography's old ambition to fix a shadow.
(As some theorists have pointed out, these were less shadows than
photograms of objects and people that had been there a moment
earlier.[29]) In producing these effects, as in burning the patterns
of women's dresses onto their flesh, the bomb functioned like a
camera's flash.

Many of de Kooning's titles from 1946–48 emphasized
religious themes, such as *Judgment Day* and *Black Friday*. His
appreciation of Faulkner's novel, which ends with the crucifixion
of the mixed-race protagonist, Joe Christmas, was allied to his
lifelong interest in the Crucifixion, which he would draw repeatedly
in the 1960s. Newman, too, connected timeless or mythical
Christianity with contemporary violence. Speaking of his own
black and white series, *Stations of the Cross* (1958–64), he said that
the sufferings of Hiroshima or Vietnam were much worse than
those suffered by Christ at the Crucifixion.[30] Earlier intimations of
the sublime, the terrible, and now the tragic mixed with the actual
experience of unfolding history. Explaining why he made the series
in black and white, in a conversation at the Guggenheim in 1966
Newman said that "a large tragic theme of this kind," like Picasso's
Guernica, could not be done in color: "I mean you wouldn't want
me to make a purple Jesus or something like that? It had to be
black and white—I was compelled to work this way."[31] *Guernica*
had been enormously compelling to his generation of artists when
shown in New York in the late 1930s, its restriction to black, gray,
and white a mark of the seriousness of its subject, the fascist terror
bombing of the Spanish town, along with strength of expression.
Newman also invoked the familiar tropes of "the white flash" and
"the white light," tacitly invoking the bomb in the language of
Hersey and de Kooning.[32]

The most explicit reference to the atomic bomb in black and white painting was probably Norman Lewis's *Every Atom Glows: Electrons in Luminous Vibration* (1951). Lewis belonged to the artistic and social milieu of de Kooning and Newman and the other Abstract Expressionists, although he also moved in the uptown world of black artists and intellectuals, including Ralph Ellison and Romare Bearden. *Every Atom Glows* features vertical black and white forms stitched together by a dry brush moving through wet paint, creating the effect of pulsing energy. Lewis's painting shares de Kooning's ambiguity and ecstasy, and his girlfriend of the time has stated that the work addressed the artist's ambivalence— common to their generation—about Einstein and the bomb.[33] (Work by his peers Mark Tobey and Bradley Walker Tomlin also referenced the cosmos, uniting the transcendence and the materiality of new scientific discoveries, especially in physics, which captured the imagination of many of the artists.) Lewis's title may even refer specifically to a central scientific problem of the late 1930s: how do stars shine? The answer—thermonuclear fusion, like that of the H-bomb—linked the wondrous and the disastrous.

Black Out

Lewis did not apparently connect the use of the atomic bomb and race, but many others did. It was a common complaint in black publications and institutions after the war that the U.S. government had waited for victory in Europe to use the violent new technology, so that they would be absolved of the mass murder of white people. As Langston Hughes wrote, in a newspaper column in which he spoke in the voice of "Simple," the common-sense man in the street, "So they wait until the war is over in Europe to try them out on colored folks. Japs is colored."[34] (Both whiteness and blackness are relative conditions, as this chapter will claim.) During the Cold War years, it was not unusual for people to move metonymically from one of these subjects to the other, connecting American violence directed towards other countries and that visited on its own subjects. When in St. Louis more than 1,000

mostly black families were moved out of the Mill Creek slums, which were bulldozed in 1960 in one of the most infamous cases of "urban renewal," locals called the devastated site "Hiroshima Flats."[35]

In the 1961 catalog for the *Art of Assemblage* exhibition at MoMA, curator William Seitz elaborated on the "dark" subjects that assemblage artists touched on, such as "the images of charred bodies that keep Hiroshima and Nagasaki before our eyes; the confrontation of democratic platitudes with the Negro's disenfranchisement."[36] The elision coasted on the image of dark bodies, but also the problematic metaphorical tendency to render disturbing subjects in dark colors. While Rauschenberg was dismayed by the association of his *Black Paintings* of the early 1950s with nihilism, Frank Stella courted such readings of his work later in the same decade. He referred to his black and white striped paintings (made with black paint on bare canvas) not as paintings in black and white, but as *Black* paintings. The titles, which the young artist thought up with his friend Hollis Frampton, referenced mostly black housing projects in New York, as well as suicidal artists, an insane asylum, and various aspects of Nazism, such as concentration camps.[37] Stella related the work to a "downbeat" frame of mind, a degraded or low state he obviously in some way associated with the projects in the Bedford Stuyvesant area of Brooklyn (where he had worked as a house painter) and a bar that was ambiguously black or gay, conflating them with an insane asylum (*Bethlehem's Hospital*) and a concentration camp. Interpretations of the titles, in the rather blank face of the paintings, have been perhaps overdone, but however ironic or offhand Stella might have claimed them to be, they point to blackness as a metaphor for death (*Getty Tomb* and references to suicide) and race, and as an embodiment of absolute, obdurate materiality. The titles certainly represent difficult and harsh slices of modern life, and in part, more specifically, the increasing identification of the American city with blackness, as whites, especially whites with money, moved to the suburbs. (The euphemism of "urban"—as in music, fashion, etc.—for African-American or black is still operative today.)

The city (both major cities generally and New York, "The City," in particular), with its crumbling, derelict quality and vague racial overtones, was a subject for other artists at the time of Stella's series, though his work received more attention than others'. Claes Oldenburg moved to New York from Chicago in 1956; as he wrote of his arrival, "I was entirely on my own. I was only looking for the experience of the city; I spent a lot of time walking and drawing on the streets."[38] The artist says, "I turned my vision *down*—the paper become a metaphor for the pavement, its walls (gutter and fences) . . ." The drawing at this time takes on an "'ugliness' which is a mimicry of the scrawls and patterns of street graffiti."[39] Oldenburg was describing something very close to the experience of the Abstract Expressionists fifteen years before, many of whom, especially de Kooning, Kline, and Lewis, stayed up all night, walking around the city (if only to flaunt their non-normative work hours). The interest in graffiti was shared by photographer Aaron Siskind, a close friend of Kline and other abstract painters (and a friend and teacher of Rauschenberg and

Lee Bontecou, *Untitled,* 1958, welded steel, muslin, soot, and wire.

Twombly at Black Mountain), who often photographed marking on walls and sidewalks in New York and Chicago. If Siskind did not influence the look of the Abstract Expressionist marks, often called "handwriting," and their textural surfaces, often compared to rough walls, he was certainly in sympathy with their aesthetic. A close friend of de Kooning, Edwin Denby wrote a 1948 poem, "The Silence at Night", which described "The designs on the sidewalk Bill [de Kooning] pointed out." "The sidewalk cracks gumspots, the water, the bits of refuse,/They reach out and bloom under arclight, neonlight."[40] Oldenburg's interests echoed the older artist's famous love for and aesthetic sensitivity to ordinary, apparently crummy urban incident: "I am for the art of scratchings in the asphalt, daubing at the walls."[41]

Oldenburg was living on East Fourth Street, in a part of the city that was being gentrified or "renewed," its old tenements and improvised residences torn down. His writing at the time was both critical and celebratory: "The city is a landscape well worth enjoying—damn necessary if you live in the city. Dirt has depth and beauty. I love soot and scorching."[42] The heavy presence of soot in New York, dusting everything like malevolent sugar sprinkles, is one of the most characteristic facts of life in the city, and artists noticed it. Lee Bontecou, in particular, who lived in Oldenburg's neighborhood around the same time even made soot drawings and sculptures, using it instead of charcoal (itself burnt material, after all), creating the soot for her beautiful, velvety abstractions with a blowtorch. Bontecou also picked up relief and sculpture materials from refuse on Canal Street (much like Louise Nevelson, whose usually black monochrome sculptures are made from cast-off scraps), and it lent her work an air of toughness and latent violence.[43] Sometimes this air was not so latent, as in the reliefs in which she made war her explicit subject.

For *The Street*, Oldenburg's first major New York show in early 1960, he too scavenged materials, appropriately, from the street, citing cost effectiveness as well as realism. He used cardboard, burlap, wood, newspaper, heavy grey-brown paper, and black paint, and felt that the work was black and white in spirit; "our study of asphalt," he called it in 1961, contrasting it to the

Claes Oldenburg, *Snapshots from the City*, performance in "The Street" (exhibition) at the Judson Gallery, Judson Memorial Church, New York, February 29–March 2, 1960.

"excellent representations provided for us in full color"—the consumer goods and ads—to which he was then moving on.[44] Like Newman, Oldenburg referred to *Guernica*, which he called "the only metamorphic mural," explaining *The Street* as an attempt to create something similar, an "everyday agony" of poverty.[45] When he began thinking about the large sculptural installation, he wrote in his notebook that it would be "a set on American death."[46]

Oldenburg's installation recreated the city, particularly the part he lived in, focusing on its marginal characters and gutter-spaces. The texture of the rough materials is the opposite of the shiny smooth surface of Pop, and the figures, like *MUG*, a cardboard figure of a bum in the shape of a mug, had little interior detail, and were edged in black paint. He played on positive and negative space, using both the white walls and the real space of the Judson Gallery to connote empty space around the figures, who often seem to be silhouettes or shadows, because of their lack of detail and strong outlined form. In his proposal for *The Street* he stipulated that, along with "heroes and bums . . . cats and doggys" it would have "stoplights and shadows . . . bright light and darkness."[47] In its attention to dualism of light and dark, *The Street* echoes Denby's poem and also evokes black and white photography, at the glorious moment of American street photography marked by the 1959 publication of Robert Frank's *The Americans* and the early Lee Friedlander. One of the performances or Happenings Oldenburg put on in *The Street* at Judson Gallery was called "Snapshots from the City," which is also the title of Stan Vanderbeek's short, five-minute film of it. In Vanderbeek's film, the characters performed in the installation with moments of dark screen courtesy of Lucas Samaras, who was turning the lights on and off to produce the effect of illuminating a photographer's flash.

Vanderbeek's *Snapshots from the City* features the characters "Ragman" and "Streetchick," played by Oldenburg and his partner Pat Muschinski. The male character is a bum who picks rags, spits, pisses, whistles, fights, drinks, and dies, according to Oldenburg's schematic script for the performance. There are underlying hints of race, perhaps reinforced by the "contemporary primitivism"

Oldenburg speaks of, here represented by the African-ish mask worn by the Streetchick and a reference to Egyptian mummy wrappings in the rags of the Ragman.[48] Was the mask a reference to Picasso's *Desmoiselles*, itself based on a primitivizing interest in the non-white, or to the African-American identity of the "Streetchick" (or, of course, to both)? The racial character of New York, clearly referenced by Stella, is not obvious in Oldenburg's urban types—streetchick and ragman, "heroes and bums"—which relate broadly to the dereliction of the depressed area of the city, and the tough nature of the Lower East Side.[49]

Black and white, however, remained inescapable terms of contrast. Whether they referenced race explicitly or not, artists were using black to embody the materiality of dirt, of life in the city, and also to imply a sensibility they described as "dark." While Oldenburg and Bontecou embraced the texture of that material location, the grit, and the corresponding strong, even caricatured emotion, Stella's flat surfaces pointed to a new attitude.

Minimal Affect

The graphic quality of black and white came to the surface in the mid-1960s, bringing with it the coolness of design and self-conscious style. A pivotal change in the meaning of black and white can be identified in the contrast of the *Black and White* exhibition at the Jewish Museum of 1963, which used black and white expressively, with Samuel Wagstaff's 1964 *Black, White, and Gray*, at the Wadsworth Atheneum, often cast as proto-Minimalist.[50] Most works in the Jewish Museum used black and white expressively to evoke elementality and harshness, while Wagstaff chose work that embodied what he called "simplicity and discipline," spelled out aesthetically as rigor, refusal, and restraint. There was considerable overlap between the exhibitions in their choice of artists: Wagstaff included some older artists, but added younger figures like Stella and Robert Morris, as well as artists like Rauschenberg who were an awkward fit for his thesis. In adding work by these artists, he argued for the importance of a new

attitude of flatness of affect. This was indicated already in the title of his exhibition, which added the color gray, never included in black and white shows, and which for many in that decade represented the neutralizing of expressive extremes.[51]

Arguably this move accurately, if broadly, fingered the connotations of physicality, or literal materiality, as well as the refusal of expressiveness that gray had for artists like Jasper Johns and Robert Morris. For the curator, it also meant something else: black, white, and gray together were "severe," refusing "to please or ingratiate"—the restricted palette was chic. *Vogue* magazine shot a black and white feature in the exhibition, and Wagstaff enthusiastically endorsed this use of the works as a backdrop, appreciating the association with fashion and commerce (of the right sort, not the cheap, lurid candy-coloring of Oldenburg's *Store*). Gray represented not just the neutralizing or mediating of the extremes of color or black and white together, but the reality of reproduction. The look of newspapers and television was not high value contrast black and white, but a kind of gray blur. Mechanical reproduction, although not the subject of the exhibition, thus lurked around its edges.

Black, White, and Gray seemed to embody a reversal of the attitude of older artists who reviled commercialism, as well as design. But in fact photography and reproduction lurked in the background even of that earlier art. It's interesting to read the description of a field trip that Wagstaff, the curator at the Atheneum, took with some Trinity College students to New York to look at art. As Richard Tuttle tells the story:

> The first thing we did on this trip to New York was go up to Baruch College to see the show, "The New York School." . . . In that show at Baruch College, there was one wall with a Pollock, a Kline, a De Kooning and a Newman—they were all black and white. It was remarkable to see that each artist had his own black . . . I made a joke about Franz Kline, because you could see, amongst those four artists, that his black had a kind of elegance and stylishness, where he would be the one to make the liaison with fashion. Tony Smith once told me that

among all those tough New York artists, Kline was the one to seek out the editors of "Vogue" to make the 10th Street–Conde Nast link. His black had that swank elegance . . .[52]

Kline, most known for his black and white work, had used a Bell Opticon opaque projector to enlarge small sketches to the size of large canvases. They nonetheless appeared tough and architectonic to the critics and artists who were his peers, but they could also look magazine-ready, chic, even, to a younger artist like Tuttle, and perhaps to his mentor Wagstaff as well. Different elements of artistic practice take on different degrees of prominence with changes in generational preference and perspective.

Newspapers and magazines feature the hottest subjects, but produce, as many commentators have noticed (most famously Susan Sontag) a cooling effect on those hot topics. Newspapers, particularly the New York tabloids, are masters of the screaming headline that nonetheless appears flat rather than expressive; the form is uniform and repetitive by nature. The medium's black and white calls for extreme emotion, while at the same time exemplifying flatness of affect as a carrier of information. The black and white value contrast that conveyed charged emotional content in painting became matter of fact on the printed page. Rauschenberg and Johns had both used newspaper as a ground for their paintings and mixed media work, not highlighting its content, but its mere existence as a kind of uninflected map, as Rauschenberg put it, already overlaid onto the blank surface. Oldenburg too, who had worked for a newspaper in Chicago, incorporated the material into *The Street*, writing in his notes that "newspaper = *The Street*," and performing as a character called The Newspaper Man as one of his characters.

The artist who first put the newspaper and the photograph in the foreground of his work was, of course, Warhol. His earliest "mature" paintings included headlines announcing a plane crash and a knife attack on Martin Luther King, Jr., along with royal dating escapades; others reproduced self-improvement advertisements. It was as if he wished to prove Dwight Macdonald's 1953 claim that magazines and newspapers banalize tragedy and world

politics by reducing them to consumerism's lowest common denominator, homogenizing their contents.[53] Employing Wagstaff's new aesthetic of chicness glossing an anti-humanist, neutral position, Warhol had two *White Disaster* paintings in the Wadsworth show; many of the *Disaster* series were in black and white or silver, underlining their strong connection to the photograph, particularly the newspaper photo. They all depicted "hot" topics: car crashes, poisoning, suicides, murder, execution, and even the atomic bomb, at the series' conclusion in 1965. Perhaps the hottest were the *Race Riot* paintings made in 1963.[54] They were based on photographs by photographer and activist Charles Moore published in *Life* that year, not of riots, as many have pointed out, but of police attacks with dogs on peaceful protestors in Alabama. They are unlike most of the images in Warhol's series, which relies mostly on press photos rejected by the press as too graphic, and which thus emphasized arbitrary and anonymous violence. The *Race Riot* paintings, along with the *Electric Chair* paintings and *Atom Bomb*, describe official, state-organized violence, and are all the more horrifying for that, even though (unlike the images of car crashes) they don't directly depict death. Warhol once discussed them in an interview with Claes Oldenburg, who stated, "When I see you repeat a race riot . . . I don't see it as a political statement but rather as an expression of indifference to your subject." Warhol replied, "It is indifference." The interviewer, Bruce Glaser then pushed, "Isn't it significant that you chose that particular photograph rather than a thousand others?" Warhol again deadpanned, "It just caught my eye," denying that he chose it because it was a "hot" photograph. Oldenburg concluded, "The choice of these 'hot' subjects and the way they are used actually brings the cold attitude more into relief."[55] Like Stella's invocation of fascism and race, Warhol's subject seems particularly chosen both for its facticity and the contrast the subject provided for a neutralizing artistic treatment.

Blackness Visible

There was a third black and white exhibition in the mid-1960s that is usually omitted from histories of the subject. In 1963, the year of the March on Washington, a group of fifteen black artists (including Norman Lewis) gathered in Romare Bearden's Canal Street loft to discuss possible artistic reactions to the civil rights movement. There they founded the Spiral Group, which in 1965 organized an exhibition of their work at the Christopher Street Gallery. Originally intended to be called *Mississippi, 1964*, either Lewis or Bearden (there are conflicting accounts), suggested the title be changed to *Black and White*, allowing artists to choose whether or not to address social issues directly. Despite the option for artists to take "black and white" in purely formal terms, these

Romare Bearden, *Other Mysteries*, 1964, photomontage projection.

David Hammons, *Moving to the Other Side*, 1969, screenprint.

words suggested racial symbolism, the tension between opposing political camps with no visible middle ground, and also the wish of some artists, like Bearden, to reference documentary photography.[56] Bearden had initially proposed that the group work collectively on a large collage modeled on *Guernica*; when this failed, Bearden realized the project in the shape of the important photomontage series *Projections* of 1964 which often contained flashes of city life that were more positive, or at least multi-faceted than the referents of Stella and Oldenburg. In 1960, Lewis had turned to more explicitly figurative and political work for the first time since the Depression, inspired in part by the African-American students refused service in the Alabama state capitol cafeteria, an event that triggered enormous demonstrations. *Alabama* and *Post Mortem* of 1960 feature a cluster of white forms on a black ground, which read as loosely notated figures, and in *Post*

Mortem seem to wear the peaked hoods of the Ku Klux Klan.
But even then, black and white had no fixed meaning for him:
Processional, painted in 1964 and included in the 1965 show, uses
white to represent Civil Rights marchers.

Lewis was not alone in being pushed by historical events to
more socially referential uses of black and white. Younger African-
American artists tackled race with a new spirit of direct confronta-
tion. In 1967–69, Faith Ringgold meant her *Black Light* series to
express a positive valuation of blackness, "replacing the chiaroscuro
method of using white pigment to create 'light' with a system that
utilized black pigment to the same end."[57] Her starting point was
no longer the blank white canvas, and the lighter parts of the
composition no longer came forward into prominence. Ringgold
was influenced by Reinhardt; for her, his black paintings were not
nihilistic, but infinitely nuanced readings of black. In fact, unlike
Stella, Reinhardt was very particular about his black paints, with
their distinguishing qualities of warmth and coolness, and was
specific in his concern that the paint surface be matte, not reflective
but absorptive of light.[58] Ringgold writes of the series,

> I had noticed that black artists tended to use a darker palette.
> White and light colors are used sparingly and relegated to
> contrasting color in African-American, South African, and
> East African art—and used as a "mood" color in African
> supernatural and death masks. In Western art, however, white
> and light influence the entire palette, thereby creating a
> preponderance of white, pastel colors, and light-and-shade, or
> chiaroscuro . . . As a young art student, I tried feverishly to
> paint black portraits using light and shade. I became frustrated
> because dark-skinned images painted this way lose their
> luminosity and therefore look better painted in flat color.[59]

Her solution was that "Black Art must use its own color black to
create its light."[60] Some paintings from the series, like *Big Black*
and *Man*, both 1967, seem obviously related to Reinhardt's work,
beginning with a ground of a three-by-three grid of differently
toned black squares on top of which she painted a stylized, mask-

Jasper Johns, *Study for Skin I*, 1962, charcoal on drafting paper.

like face. Slightly later works depict race not by means of the black–white dichotomy of chiaroscuro, but with a scale of tones: *The American Spectrum* (1969) shows a horizontal run of faces ranging from deep brown to cream; *US America Black* (1969) is a pinwheel of browns and blacks.

A link between black skin and black pigment was explicit in the work of many African-American artists. Starting at the end of the 1960s, David Hammons made large monoprints using human bodies as printing devices. Hammons applied a transparent greasy medium—margarine—to a person (usually the artist himself), who was then pressed against a piece of paper. He then sprinkled dark powdered pigment on the paper, which adhered only to the oily area of the surface. The black figure on a white ground recalls Olson's concept of throwing a shadow, but Hammons fixes the shadow, captured as a silhouette. By means of such simple forms of image-making as the silhouette and the monoprint, Hammons blurred the line between the ancient indexicality of drawing and the modern one of photographic reproduction, while effortlessly evoking the American racial divide. The results look like a photographic negative or photogram, a kind of reverse photograph (an effect that Romare Bearden also experimented with in his

Andy Warhol, *Myths: The Shadow*, 1981, screenprint with diamond dust.

Projections, for which he used reverse photostats). The reversal by referencing black skin plays with the paired cultural hierarchies of negative/positive and black/white.

The confinement and compression of the image in these pictures also relates to Johns's 1962 *Study for Skin*, four monoprints the artist made by rubbing baby oil on his face and hands, which he then pressed or rolled onto or across paper, across which he then stroked charcoal (*Number 1* from this series was in Wagstaff's show).[61] Johns's picture has been described as representing a floating face, or skin that is separate from the self, an exterior that might be slipped off in an act of self-transformation, as in his later *Cicada* works.[62] In Hammons's prints (including those very like Johns's study in the performativity of the artist rolling his face across the paper), the artist appears to be trapped beneath glass, pressing his face against the transparent surface, a formal analogue

to Hammons's social imprisonment. The suggestion of imprison-
ment was put to particularly powerful use in *Injustice Case* of
1970, based on the newspaper image of Bobby Seale bound and
gagged at the trial of the Chicago 7. Do critics read Johns's and
Hammons's works differently because they know the artists' racial
identities? Perhaps the differences between them obscure the
psychological and artistic similarities. It is worth noting that both
artists also made works with window shades, referring to what is
visible and what is not to be seen, light shining in darkness from
within or without.[63]

The relation of the visible to the invisible man was later to be
raised again by Warhol, whose 1981 *Myth* series featuring Superman,
Mickey Mouse, and other media creations, included a self-portrait.
Warhol depicted himself as *The Shadow*, the mysterious title
character of the eponymous radio serial, thus an explicitly non-
visual experience.[64] In half-profile, both his face and his shadow
are visible: the latter is both unreal—an image, as in Plato—but
also a faint impression of the former self, a shadow on the way to
being a shade. As an index of a person, the shadow prefigures the
photograph (which is the actual source of Warhol's image, of
course). To cast one's shadow on a plane as an affirmation of
one's existence, as Olson wished, for the painter and poet, and as
Rauschenberg allowed the viewer, here seems frightening in the
implied absence of the real body, as in the permanent shadows left
at Hiroshima.

A year earlier Kerry James Marshall had made what was to be,
for him, a foundational painting: his *Portrait of the Artist as a
Shadow of His Former Self* (1981). In this painting, following a vow
to paint only black people from then on, he first used a broad,
almost unmodeled flat black paint to depict a human figure:

> The initial development of that unequivocally black, emphati-
> cally black, figure was so that I would use them as figures that
> function rhetorically in the painting. That kind of extreme is a
> rhetorical device that you go to when you want to emphasize
> or highlight a certain point.[65]

The *Portrait* draws on minstrel imagery to depict a grinning figure with broad features, including bright white eyes, in old-fashioned clothing. Marshall's self-portrait, with its generalized outline and non-specific features, plays with the idea of the type, and the complicated connections between the outline, the shadow, and the profile—both literally, the shape of a figure against a ground, and, metaphorically, the stereotyping of a racially defined group of people. The black profile has a history: in Faulkner's books, for example, black people are repeatedly referred to as shadows, even by whites who are their ostensible champions. The shadow is both the mark of real presence and the lack of it, something broadly figured, lacking in detail as well as substance. As Bearden had written of the impetus for his own *Projections*, about the concrete complexities of black life, "I felt the Negro was becoming too much of an abstraction."[66] Ellison's catalog essay for a 1968 Bearden exhibition praises the artist's correction of the generalizing of even the well-intentioned liberal press: "He has sought here to reveal a world long hidden by the clichés of sociology and rendered cloudy by the distortions of newsprint . . . television and much documentary photography."[67]

Marshall read Ellison's *Invisible Man* around the time he painted the *Portrait*, and, like many other artists, was moved by its very visual articulation of race in America:

> The condition of invisibility that Ralph Ellison describes is not a kind of transparency, but it's a psychological invisibility. It's where the presence of black people was often not wanted and denied in the American mindset. And so what I set out to do was to develop a figure or a form that would represent that condition of invisibility, where you had an incredible presence, but there was a way in which you could sometimes be seen and not seen at the same time. And what I started with was an image that was a black figure against a black ground, where there was only the slightest variation between the value of the figure and the value of the brown of the ground that it was painted against.[68]

Kerry James Marshall, *Portrait of the Artist as a Shadow of his Former Self*, 1981, egg tempera on paper.

Marshall's *Two Invisible Men Naked* (1985) pairs a white and a black panel, each purportedly depicting an invisible man. The white panel appears to be simply white—we can't discern a figure, as in the old cartoons about abstraction in which an apparently blank (or all white) canvas is labeled "snowman in the tundra," or some such. The black panel shows eyes and teeth shining out of the darkness, recalling early twentieth-century caricatures of black men. Like Ringgold's works of the late 1960s, Marshall's paintings for the next twenty years or so worked with contrasts of warm/cold or slight changes in hue, skewing away from the normative range of value contrast towards visual representations that are oriented towards blackness rather than whiteness. Exploring the minimum conditions necessary to render a black person visible, Marshall both played on the dominant social meaning of the color black and undid it by revaluing its power. Here racial consciousness meets an issue famously raised by the monochrome tradition of black or white, the problem that all-white or all-black paintings are "utterly unreproducible," as Robert Ryman's white paintings and Ad Reinhardt's black paintings are repeatedly said to be.[69]

White Pictures

Bearden's *Projections* were made from magazine and art history reproductions collaged together in small paintings from which he then made large-scale Photostats, reproductions of reproductions. Bearden and others of his generation grew up with photography: *Life* magazine photo essays, newspaper photojournalism, and the street photography of Frank, Roy DeCarava, and Friedlander, the meditative work of Siskind, the more formally oriented street photography of Rudy Burckhardt. For Bearden, black and white signified an activist documentary turn, responding to social conditions. For some younger artists, black and white signified neutral facticity, concept, and information. Other artists connected black and white to photography and film, but from the vantage point of the 1970s, that interest was nostalgic, or at least second-hand.

Cindy Sherman, *Untitled Film Still*, 1978, black and white photograph.

In the art work of the late 1970s and early 1980s another photographic avatar of black and white came more and more to the foreground: film and television, particularly those of the past. The coolness of affect that Wagstaff highlighted could combine reproduction with a camp attitude that flirted with nostalgia. The noir sensibility that some have ascribed to Abstract Expressionism was actually much stronger in the late 1970s, when the film culture widespread in America spanned the distance from a camp interest

Laurie Simmons, *Chair / Dining Table / Foyer*, 1976, gelatin silver print.

in American classic movies to an enthusiasm for more sophisticated, experimental European film. Cindy Sherman (in whose bizarre early pictures the most extreme transformation she could imagine was into a black person) has said that without television her art never would have existed, and her film stills certainly reference the black and white B-movies of late-night TV.[70] Robert Longo, Sherman, and David Salle drew on film noir more directly than movies of their own time.[71] French New Wave cinema, an inspiration for Salle, was itself deeply engaged with the past, and particularly with the "B-grade sensibility, or film noir" Salle valued. Salle was also interested in "the movies of Douglas Sirk and, to a lesser extent, of Sam Fuller and Fassbinder."[72] Sherrie Levine also loved Sirk, even teaching a class on his movies.

The black and white element borrowed from old movies also referenced "the 50s" more generally, as in the photographs of the suburbs made by James Casebere and Laurie Simmons, both of whom photographed bland dollhouse set-ups in black and white. This was truly middle-class art, the art of people who grew up in Long Island and Connecticut playing cowboys and Indians, dolls and dress-up, and watching old movies on television—black and

James Casebere,
Cotton Mill, 1983,
gelatin silver print.

white television. Simmons, explaining her work, talks about
growing up in Connecticut watching movies like *The Man in the
Gray Flannel Suit*, and the version of the suburbs in her work is
filtered through film and television representations. The whiteness
of the suburbs (contrasting the blackness of the city) colored main-
stream media imagery, as Lucy Lippard hinted in early hostile
reviews of these artists, whose kitschy "retro" style Lippard and
others saw as implicitly nostalgic for a white middle-class utopia,
Reaganism before Reagan, a roll-back to before the 1960s desired
by white liberals as well as conservatives, for whom that experi-
mental decade was, respectively, a failure or a disruption.[73] From
Lippard's perspective, this meant a fond look back to the broadest,
most sinister cultural forms of pre-civil rights era America. In at
least some cases, the artists were not casual or unthinking about
the undercurrents of their suburban references; Casebere's black
and white photographs included constructed images of earlier
American buildings, including, pointedly, *Cotton Mill*, 1983

(shown in the 1985 Whitney Biennial). Casebere had a long-standing interest in American history, evident in his early constructions and writing.

Robert Longo's series *Men in the Cities* had movies in mind (Rainer Werner Fassbinder and Sam Peckinpah being favorite early inspirations for his freeze-frame drawings), but this artist's black and white aesthetic, like that of Sherman and Simmons, was anchored in television, which he had been raised on in a suburban Long Island childhood (and continued to watch constantly as an adult). The large scale drawings of jerking figures have often been tied by critics to the late 1970s New Wave music scene, in which Longo participated as a fan and an occasional producer, but the artist ties the men in suits and ties and the women in skirts and heels to the 1950s. His friend novelist Richard Price described them as "silhouettes on Hiroshima walls, as we all increasingly dance to the ticking of the nuclear clock," referring to another 1950s revival of the 1980s: the Cold War specter of nuclear terror.[74]

Longo specifically identified his subject as white, as opposed to "ethnic groupings." He titled one 1982 series of work depicting struggling, fighting male and female figures *White Riot*, presumably after the Clash anthem urging docile whites to take up some of the

Robert Longo, *Men in the Cities—Men Trapped in Ice*, 1980, charcoal and graphite on paper, 3 panels.

bravery demonstrated by black protesters and join the social revolution. But while the song referred to working-class white interests, Longo's drawings are of people in business suits, "the people who built the buildings that would eventually fall on them."[75] He also said about his protagonists, "If I took the clothes off the people in my drawings, all I'd get would be white paper."[76] Here "the suit" as a reference to a stuffy, soulless businessman again raises the specter of the invisible man, Steven's snowman, with the transcendental aspect replaced by a sense of emptiness.

Longo's focus on whiteness recalls Charles Olson's sardonic description of "That famous thing, the White Man," as "the ultimate paleface, the noncorruptible, the Good, the thing that runs this country, or that is this country."[77] The 1980s saw a reinvention of this sentiment in the relatively new idea that whiteness, not blackness, is invisible because it represents the dominant social power, and so colors the ideological water we swim in. This understanding, spurred by Richard Dyer and also by scholars turning the lessons and methodologies of "identity politics," originally focused on marginal groups, towards dominant social categories, led to the invention of white studies.[78] The category exploded, in both the academy and popular venues like *Time* magazine, in the late 1980s and early '90s, at around the same time that masculinity (explored in the next chapter of this book) became a similar object of study. Just as the latter turn was spurred by women's studies in the academy, the study of white identity developed in response to the earlier study of people of color. Criticized by some as yet another expression of social narcissism, this study was more importantly an attempt to de-normalize whiteness—to reveal whiteness, like maleness, as a particular identity rather than simply the default or normal human condition. In the U.S., whiteness has always been defined tacitly against blackness. The most important historical work to emerge from these studies established the shifting, provisional (rather than biological) basis of whiteness, invented to give predominantly poor and working-class people a stake in not identifying with slaves or, later, black workers.[79] It is interesting to note that artists have always been equally sensitive to white as a color, a material fact in relation to black, even if this eluded art

Above and facing page: Mike Kelley, *The Trajectory of Light in Plato's Cave*, 1985/1996, mixed media, installation views, Art in the Anchorage, The Brooklyn Bridge Anchorage, New York, 1985.

critics. Franz Kline: "I paint the white as well as the black, and the white is just as important."[80] Kara Walker says something similar, but with the aspect of race made explicit: "I'm not really about blackness, per se, but about blackness and whiteness, and what they mean and how they interact with one another."[81]

Critic Jerry Saltz's 1987 *Black and White* exhibition included many of these artists working with television and film imagery, as well as others like Peter Halley and Annette Messager. While Saltz's catalog essay focused on the artist's interest in information carried by print or photographic media, he did mention briefly the "symbolic value" of black and white, alluding to race, and cited the work of Tim Rollins and K.O.S., *The Whiteness of the Whale* (1987, included in the show), as an example of "unraveling . . . the enormity of the meaning of white and being white in this society."[82] For this painting, Rollins and his workshop of New York City students, many black and Latino, used printed pages from the chapter of *Moby-Dick* on the subject of the color white as a ground, on top of which they put a cloud of white paint. This work, with its explicit attention to race, belongs as well to the

mid-1980s revival of America as a subject, amidst Reagan's nation-
alist aggression, with an attendant revival of references to Melville.
Jean-Michel Basquiat, for example, quoted *Moby-Dick* in his work,
rewriting the table of contents, and listing the synonyms that the
text used to name the whale.[83] There was also a rash of exhibitions
at the time exploring the condition of whiteness, of the catalogs
for which included squirm-inducing personal mea culpas by white
critics alongside art work that sometimes fell into un-nuanced
didacticism.

The artist who perhaps addresses white America in its fullest
range of social and psychological states is Mike Kelley, who asked
himself, amidst the flood of works in the 1980s about artists'
marginal identity, why he shouldn't take his own white, Detroit
working-class identity as a subject. As a young man Kelley was
interested in the White Panther Party, a counterculture political
group that emulated the radicality of the Black Panthers, although
it featured freak-outs more than protests, and in his art career he
has been one of the few artists to use, rather than repress, his
personal history as a child of the white working class. He addresses
whiteness most explicitly in *Snowflake (Center and Peripheries #3)*
(1990), a small group of black and white paintings that feature the
image of a black man along with a trash bag, a toy rabbit head and

other "peripheral" things around the central painting, a white monochrome. Here Rosenberg's endless sea is recast as a social center with a limited horizon.

Kelley folded race into one of his most important and ambitious works, *Plato's Cave, Rothko's Chapel, Lincoln's Profile*, a 1985 project originally done in the Anchorage underneath the Brooklyn Bridge, and reconstructed and continued by the artist at later moments. It included black and white photographs of cave formations in the U.S., ten black and white cartoon-style paintings/ drawings, and monochrome paintings hung within a cave installation papered with fake brick print and lit by artificial fireplaces. The viewer was forced to crawl into the installation via a small entranceway underneath one of the drawings. The monochromes in white, yellow, red, and brown (colors tied to racial indentity) were made with commercial colors chosen for their flowery names, the artist's way out of an earlier decision to paint only in black and white. These paintings were titled with the names of bodily fluids and racial designations: "Caucasian," "Oriental," "Indian," and "Negroid."[84] Kelley intertwines this obvious racial content with shadow, light, and darkness. *Plato's Cave* is a classical allegory about prisoners unable to look directly into the light, and so forced to see the world through shadows on a cave wall, still a common metaphor for representation. Sheets hung from the ceiling tied the bloodstain left by Rothko's suicide (done by cutting his arms) to Kelley's own indexical portrait as Christ on the Shroud of Turin. Lincoln's profile mimicked that on the penny, and certainly

Kara Walker, *Gone, An Historical Romance of a Civil War as it Occurred Between the Dusky Thighs of One Young Negress and Her Heart*, 1994, cut paper.

referred, ironically, to his character as the Great Emancipator. The profile or silhouette, the stain, and the shadow were all dark and explicitly indexical marks, intimately connected to the nature of representation, to death or oppression, and to race (as well as religion and capitalism). In a leaping, imaginative text, Kelley associated the blind cavefish found in various Southern states, which he described as white, even albino, with the blindness of white supremacy.

Reviews and critical accounts of Kelley's project have most often focused on its so-called abject element—quoting, for example, a drawing over the work's low entranceway that read, "Crawl, worm!"—at the expense of its social aspects. The reverse is true of the critical reception of Kara Walker, who shares with Kelley an interest in bodily functions and the repressed or hidden aspects of sexuality, the perverted underbelly of cliché representations of culture. Like Kelly and Oldenburg, throughout her oeuvre to date Walker has created a charged nexus of stereotype, outline or profile, shadow, and index. Like Oldenburg, she is drawn to melodrama, the broad comedy and tragedy of social type. Her first major work, *Gone, An Historical Romance of a Civil War as It Occurred Between the Dusky Thighs of One Young Negress and Her Heart*, shown at the Drawing Center in New York in 1994, emerged in some ways from *Gone With the Wind*, a ridiculous, racist account of the Civil War seen through the eyes of a single, spoiled white woman. Sensing that despite the book's obviously absurd history and bad writing, something powerful must account for its enormous popularity, Walker focused on its undercurrent of forbidden sexuality, twined with violence and bodily and social transgression. Her large-scale wall works also draw on another Southern source, a cyclorama she saw in Atlanta. The cyclorama anticipated the movies, and its primitive techniques of image making, such as its use of silhouettes, tied it also to broad stereo-types, blackface, and early physiognomic racial science. Silhouettes use black and white reductively, but in a different way than Sam Wagstaff's elegant minimalism, although the two are related in their stark visuality. Walker's employment of the silhouette uses formal reduction to convey the effect of social stereotyping, with

its erasure of particularities of identity. For Walker, her silhouettes are a way to "encapsulate, to simplify complicated things."

The silhouettes also are a way to make figurative art that is totally imaginative, using stereotypes like puppets in her imagined plays: "I think these figures are phantom-like. They're fantasies. They don't represent anything real."[85] The shadow is a figure for the fantastic, the latent, underground world of our imaginations, where the artist and perhaps the viewer, are liberated to act out the unspeakable: "the shadow speaks about so much of our psyche. You can play out different roles when you're rendered black, or halfway invisible."[86] It is also a substitute for the real thing that may be too powerful to be confronted or seen head-on, like an eclipse: "The silhouette lends itself to avoidance of the subject, not being able to look at it directly."[87] Slavery and its aftermath, like Hiroshima and like the concentration camps of World War II, live on in images so horrific that they are hard to see, as well as a more general legacy some would prefer not to confront. But while the silhouette, like its photographic descendants, implies absence, it also guarantees presence: it cannot be made without the solid figure whose shadow it preserves. Thus Walker's panoramas imply that all the terrible things whose shadows we see, however fantastic (inflated phalluses, multiple breasts) or repulsive (beatings, rape, torture), really did happen. Walker disdains the writers and museum educators who try to tie every one of her forms to a specific pictorial source, but their existence as shadows quietly floats the possibility of their social reality.

Gothic/Goth

Walker's work touches an American tradition, Southern Gothic, that is more Faulkner than Melville.[88] Unusual for recent art, the terror and desire in her work gives shape to the most primal of emotions. The artist locates the emotional melodrama of Southern Gothic in opposing desires, saying, "A lot of what . . . I have been doing [in my work], has been about the unexpected situation of wanting to be the heroine and yet wanting to kill the heroine at

the same time, and that kind of dilemma, that push and pull, is the basis that I bring to each of the pieces that I make."[89] While black alone or white alone sometimes surfaces, together they represent the tension and extreme of their coexistence. And so while black has always been associated with the extreme, it needs white. This is true even for the Gothic, in its neo-Romantic association with death, in implicit contrast to the normal preference for light, sunshine, life. In a reincarnation of the American strain Greenberg complained about in the 1940s, the gothic, small "g," enjoyed an enormous vogue in American contemporary art of the 1990s and 2000s, inspired at least in part by the art (and posthumous vogue) of Steven Parrino, who died in a motorcycle accident on January 1, 2005. He is best known for paintings made primarily in black and white or silver, abstractions that were often torn, crumpled, or broken, in which the entire canvas, not just the surface, embodied some kind of struggle or event.[90] Parrino's exuberant, violent abstract painting, sculpture, and films drew on his love for motor-cycles and loud music, as well as on the art of Stella, Warhol, and Smithson. In making his subcultural interests, tied to the white working class, the inspiration for his art, Parrino was not unlike Mike Kelly. But while Kelly has an ambivalent Oedipal relation with Abstract Expressionism, Parrino saw his art—in both its popular and high art aspects—as rooted in the art of Pollock, Kline, and others. He told Jack Goldstein (an artist friend) that his paintings were the direct articulation of what was tacit or abstract in Abstract Expressionism, its transcendent, metaphysical content.[91] Against the dominant art-critical tendency to connect the black square and a pessimistic outlook to Europeans like Nietzsche and Adorno, Parrino saw his work as purely American.[92] He said, "New York is ground zero, from Abstract Expressionism, Beat Poetry to the birth of Punk Rock and Rap. Punk was conceived in the 40's out of the chaos of the atomic blast."[93] Like Walker, Parrino saw apocalyptic violence as a distinguishing characteristic of American culture.

The artist most associated with Parrino as a peer is Cady Noland, whose scattered sculptural installations also relied largely on black and aluminum, the latter coming not from paint but

Steven Parrino, *Untitled*, 1997, enamel on canvas.

from industrial metal, the dull shine of grocery carts, walking
aids and scaffolding. Lane Relyea has pointed out the extreme
Americanness of chrome or aluminum, the cheap shiny metal that
surfaces cars and flimsy buildings, polished but insubstantial (an
attraction for Koons as well in his most important series from
the mid-1980s). Perhaps most brilliantly, Noland made Puritan
stockades that shone with an aluminum, rather than wooden,
finish, implying the currency of a culture of public excoriation and
punishment. *Stockade* (1987–88) uses orthopedic walkers, metal
poles, and wire shelving to evoke office culture and entrapment.
Noland differentiated between different kinds of silver—chrome
and aluminum, for example—with the eye of a connoisseur, much
as Ringgold was sensitive to different blacks.[94] To this sculptural
black and white/silver, she added black and white photography
from newspapers (as in *Celebrity Trash Spill*, 1989), and also from

television, such as the famously broadcast assassination of Lee
Harvey Oswald and the image of Patty Hearst captured by a
security camera in her terrorist costume.

Though Parrino and Noland (who stopped showing her work
publicly around 1999) did their most influential work in the early
1990s, recently many young American (and European) artists who
work primarily in black and metallic finishes similarly reference
heavy metal music, drawing on the bleakest images and historical
facts of the recent past—murder, mayhem, teenage alienation,
meaningless destruction—to combine hot content and a cool
finish. A number of important exhibitions took this kind of work
as their basis, including the 2006 Whitney Biennial, titled *Day For
Night*, and widely known as the black and silver biennial. This
show included the recently deceased Parrino, as well as younger
admirers like Banks Violette, who amplified Parrino's interest in
extreme heavy metal, Smithson, and, above all, death, which
seemed particularly present in the exhibition (Poe's *The Raven*
was reprinted in the catalog, without explanation). With less of a
historical feel, this gothic art nonetheless reflected a particularly
dim evaluation of its historical moment, at the height (or nadir)
of the second Bush administration, in an atmosphere of disaster
(explored in the last chapter of this book) and violence. The "dark"
imagery can seem like a dumbed-down version of politics, a
superficial expression of the zeitgeist; as Newman admonished
in 1968, revolution is not a nihilist happening. But history has
moved along since 1945, and even 1968; at those earlier moments,
many people still envisioned an alternative to a society that they
did not like. Today, that alternative is harder to imagine: if you
don't like society, nihilism seems almost inevitable.

Critics who put down this art as too fashionably nihilistic
have overlooked its inclusion of light as well as dark. In 2006,
another admirer and friend of Parrino, Amy Granat, showed a
group of black and white 16 mm films made by scratching and
manipulating film stock; the work also included photograms and
was lit by dramatic spotlights. The statement she wrote for the
show, titled *Stars Way Out*, placed the films emphatically in a
historical context that embraces almost all of the aspects of black

Amy Granat, *Stars Way Out* (projection detail), 2006, 16 mm film, black and white, sound, infinite loop.

and white of the past fifty or so years, with the exception of race. Granat wrote:

> Georgia O'Keeffe picking up bones and holding them up to the sun—I don't see death, I see beauty. I see black and white light/shadow. Movies. New York City as nature. Landscape as metaphor—these films were made in the desert. Up to Utah. Promontory. Golden Spike. Lucin—a town that wasn't, then was, then wasn't again.[95]

The reference to O'Keeffe is pointedly to an American (female) modernist, who made a fantastic black and white abstraction very early on, in 1930, as well as being the subject of black and white photographs by her husband, Alfred Stieglitz. Granat's image brings life to the cliché of the Southwest and Charles Olson's "tomahawk" sun, as well as connecting O'Keeffe forward to Smithson and backward into American history: the Spiral Jetty was deliberately sited near Golden Spike, where in 1869 tracks laid

from the two coasts were joined with an actual golden spike to create a transcontinental railroad. Lucin was a railroad town, moved to accommodate a new rail route at the turn of the century, abandoned and resettled mid-century, and a ghost town once again today—appearing and disappearing as if slowly flickering. The harsh light of the Southwest sits together with the neon noir city of Kline and de Kooning, Bearden and Oldenburg, and Bontecou and Stella. The shadows of painting and photography as well are reconciled, as Granat's film recalls the photograms of Man Ray, the presence and absence of Rauschenberg and Warhol, and the old movie imagery of Sherman and Longo. All of these things produce the complicated American black and white. Is it any wonder "race" is left out—that the tracks still don't meet?

Together, we might say that Walker and Granat are products as well as manipulators of two hundred years of American black and white. Between them, they cover the many conflicting elements of black and white: melodrama, the thing that is all too real, that cannot be seen, the stereotype, pure materiality, light, shadow, race, and, most of all, a swing between hot and cool, hysteria and realism. If Granat, like Parrino and others, seems to make too much of her abstractions, her black and white marks, it is no more than the Abstract Expressionists made of their own black and white marks, and why not? Greenberg chastised them in 1947, "In the face of current events, painting feels, apparently, that it must be more than itself: it must be epic poetry, it must be theatre, it must be an atomic bomb, it must be the rights of Man."[96] And why not?

3: Success and Failure

Here a book tends to be either a best seller or nothing, as a writer is either a Success or a Failure.
—Dwight Macdonald[1]

There's no success like failure, and that failure's no success at all.
—Bob Dylan[2]

For the American artist of mid-century, the enemy wasn't so much academic art as the expanse of society itself: less the rules prescribed for art by a central authority than the lack of any real place for it. The conflict of modern art and American social values was described by Franz Kline: "Coming from a country where you eat Shredded Wheat and you're supposed to grow up and become successful, it's rather difficult to find out just where and what art is."[3] The artist's invocation of the cereal recalls the ads of the time that promised young boys and businessmen alike a successful, productive day: this was not merely capitalism, but mass-produced, freeze-dried, cheerfully 'attaboy capitalism. A world that did not so much reject the artist (raised on images of bohemia) as ignore him; even collectors did not come around to American art until the later 1950s. What would the model be for the artist in America, where success and work were so different from Europe—and so much more central? Without a lingering aristocracy to fuel the avant-garde disavowal of money, American artists borrowed an array of different roles and attitudes to make a place for themselves in a world divided into successes and failures. Women were largely excluded from both the possibilities and pressures of this dialectic.

Somebody

The artist's freedom from society involved not just liberating his creativity but also the will to "abandon his plastic bank-book," as Rothko put it.[4] The pull quotes from artists' statements of the

1940s and '50s invoke the independence of the individual self, not social reformation ("Make cathedrals out of ourselves" "We don't have to go outside ourselves for a subject"). In 1954, a few years before he began to make a living from selling his art, Rothko was fired from Brooklyn College for his inability to teach a required Bauhaus color and design course, and the "inflexibility" he showed in his reluctance to teach advertising and other commercial arts. Rothko appealed the decision in 1956. He reconstructed the interview in his personal notes: "I was not brought into the department because I am primarily a teacher or an advertising man or a textile man. I was asked to join the department because I am Mark Rothko and the lifelong integrity and intensity which my work represents."[5] That is, for being a whole person across a whole lifetime, not for being a product or producer.[6] Not for being a professional technician who produced other professional technicians— a teacher—or commercial goods the advertising man being the prime example of this, the very thing the artist did not want to become.[7] In contrast, the letters written by the department chair and other professors for the appeal process emphasized that they needed teachers, not people who thought they were great painters.

Rothko was speaking against the Bauhaus and the instrumentalism of its philosophy (something de Kooning inveighed against as well), but also against teaching commercial art and advertising, against art as profession, instrumental for the individual. The end of World War II saw the rise of the corporation and with it, what came to be called the "professional managerial class": a new group who neither produced objects nor owned the companies that produced them, but managed, administered, and promoted both products and people. Both positive and negative images of this group were everywhere, as the man in the grey flannel suit and the white-collar worker. The rise of this group expanded the range of jobs that could be considered professions; together with the postwar explosion of college education in the U.S., it spread the ideal of professionalization—institutionalized by post-graduate training and jobs with social prestige—that further encouraged the idea that all Americans were "middle class."

The modern artist has practically defined himself as anti-middle class; his exemption from professionalization was part of Rothko's assertion of independence and independent value. But the vision of the successful professional did affect art and art training. Even an artist like Rothko, who a few years after losing his bid to keep his teaching job and ten years after his declaration of independence from a hostile society was, like other Abstract Expressionists, beginning to be able to make a living selling his art, both to private collectors and to museums. The increased attention and reward brought the satisfaction of recognition, the comfort of not dodging the landlord, the pleasure of being able to afford oil paint. If Rothko did not want to become a kind of technician, neither did he want to play bohemian; as many photographs testify, Rothko and his friend Adolph Gottlieb dressed in nice suits and ties (Newman went them one better with a monocle).

While he valued the artists' search for integral individuality in their work, Harold Rosenberg also warned that the struggle for an individual "signature style" risked hardening into something else: "Since there is nothing to be 'communicated,' a unique signature comes to seem the equivalent of a new plastic language. In a single stroke the painter exists as a Somebody—at least on a wall."[8] Not just "somebody," but "a Somebody." The capital "S" has a particular valence in America: "Somebody" is a public self. It can be genuine, as in the African-American wish to "be Somebody," to be acknowledged legally and socially as fully human, or as in Thoreau's desire to use self-development, as opposed to monetary gain, as the measure of value: "The real business of life" (as opposed to making a living) is "to invent something, to be some-body—i.e., to invent and get a patent for himself—so that all may see his originality."[9] But to be Somebody was also the object of twentieth-century American success manuals. To be someone who mattered in the great crowd of American nobodies (as Marlon Brando would lament in *On the Waterfront* two years after Rosenberg's 1952 essay, "I could have been somebody").[10] Or, as Fats Domino sang in a 1959 hit, "I'm gonna be a wheel someday. I'm gonna be somebody." There is a parallel shift (much described by scholars of American studies) from the Puritan focus on inner

strength and independence—character—to a later, particularly twentieth-century emphasis on the external *representation* of self, usually called personality.[11] Rosenberg was in essence saying that the painter's wish to find his original, unique character in his work risked creating a personality for others to see. In fact, Rosenberg made fun—serious fun—of the artist's wish to be somebody, to matter socially, to make it.

The artists he championed, despite their rejection of much of the content of European art, had the avant-garde model of artistic success fixed in their heads, one that promised true and lasting cultural recognition in the future. In some ways, therefore, the Abstract Expressionists did not truly understand the situation they were in. They did not see that when success came, it would be American success, the kind Kline found so alien to art; not an intellectual meeting of the minds, but money, publicity, and celebrity. Yet they began to realize that, even though their work was being bought and collected, it still was not being understood. It was being promoted simplistically as American, used to celebrate a triumphant nationalism, and had become fashionable for collectors' homes in a way that they had thought the art's radical illegibility would never allow. The late 1950s was, as critic Eleanor Munro wrote in a review of Robert Goodnough, Paul Brach, Joan Mitchell, and Michael Goldberg (all "second generation" Abstract Expressionists), "the quivering moment when a style is crystallizing into a formula for success."[12]

The uneasiness of older artists with success often pushed them to seek privacy and even to withdraw. Famously, despite his fondness for nice clothes, Rothko withdrew from his mural commission for the Four Seasons restaurant in 1959, returning the fee, repulsed by the paintings' proposed role as background music for upper-class chit-chat and business lunches. More insistently than his peers, Clyfford Still voiced his irritation and contempt for society, even, and perhaps particularly, as represented by the collectors and curators interested in his work. He also had contempt for most other artists, whom he saw as selling out for the price of a "flunky's handout," both before and after his own success as an artist.[13] Still gave up on New York in 1961, moving back to the West.

As painter Milton Resnick used to tell his students about the downfall-by-success of Abstract Expressionism, "the ladder was forced under us."[14] Resnick may have had sour grapes about his own limited reputation, but even the most successful of the Abstract Expressionists experienced ambivalence about their new social status, well before that success was usurped by Pop. The already conservative but not yet irrelevant critic Hilton Kramer put it rather nastily in 1959: "The man in the coonskin cap has a dry martini in his hand."[15] Kramer was obviously invoking the "redskin" or Daniel Boone identification of the Abstract Expressionists (discussed at greater length in Chapter 5), coupling it with the cocktail that most emphatically signaled not only the beginning of heavy drinking in the art world (which had not begun in earnest until success arrived in the 1950s), and not only Americanness, but also specifically the life of the upper middle class, the comfy and civilized. A chart published in *Life* magazine in 1949 named the martini the drink of the upper middlebrow. What that chart and writer Russell Lynes called "upper middle-brow" meant something like the new professional, C. Wright Mills's white-collar worker. This was a man who was not exactly or not yet wealthy, but occupied a permanently aspirational social position, and concomitantly took an interest in modern culture— art, but also sophisticated food, music, etc.—as marking his connection to what signaled being above the ordinary at that moment. According to critics then (and now), this very contemporaneity, this socialization could all too easily become a weakness, an over-awareness of the regard of others.

Man of the World

One particularly visible sector of the newly ubiquitous professional and salaried work was in comics, graphic design, and, most of all, advertising, which seemed to be everywhere, newly central to American culture. The commercial artist—particularly the advertising artist—appeared as a central character everywhere from Sloan Wilson's novel *The Man in the Gray Flannel Suit* (1955) to

movies like *North by Northwest* (1959). Not surprisingly, this representation of a putatively creative person caught the attention of so-called fine artists; for older artists like Rothko, it was anathema, given what they saw as their purpose. While some of the Abstract Expressionists, as well as Johns and Rauschenberg, did commercial artwork to support themselves, it did not generally touch their own art practice. Just a few years later, however, the Pop artists took rather different attitudes, although it's hard to pin down precisely what those attitudes were towards the advertising and package design they made their subject matter. Oldenburg sounds more sardonic than celebratory as he talks about imitating and parodying various kinds of commercial artists in his work, as well as the roles of manufacturer and pastry chef, because they were more valued in the U.S. than that of fine artist.[16] Warhol mockingly noted the fact that a fine artist could make more than a commercial artist, basing his own career ironically on that claim, and borrowing the design of the Brillo box from an unsuccessful Abstract Expressionist for whom graphic design was a day job.

As Rosenberg had noted, the first project for any artist looking to make a reputation was to find a distinctive painting style. Or, as Resnick once bitterly remarked, "It paid off to be yourself, too. Because collectors were already convinced that the only good art is original art. You've got to have your trademark. You've got to convince everybody that you're different from everybody else."[17] Roy Lichtenstein, who from 1957 onward had painted in an Abstract Expressionist style, told John Coplans in a 1963 interview that "In the summer of 1961 I made a complete break into my current work." Coplans pressed Lichtenstein for some emotional point of difficulty or transformation: "What was the real crisis that precipitated your clean break with the past?" Lichtenstein's reply, while conveying a sense of artistic frustration, sounds primarily career-oriented: "Desperation. There were no spaces left between Milton Resnick and Mike Goldberg."[18] Lichtenstein was being funny, of course, at the expense of the two latter-day Abstract Expressionists, but he was also pointing to the crowded condition of the playing field (as well as the monotony of those imitating the success of others rather than discovering their own brand). There is

something seriously ironic in Lichtenstein's use of the word "desperation," reserved in the previous generation for references to the plight of the artist after Auschwitz and Hiroshima, in the face of radical social indifference, rather than for the sliver of light between two gestural styles.

Even more than Lichtenstein, Warhol typically surveyed his position in the artistic field with self-conscious calculation. While his style may have been shockingly unlike those of painters of previous generations—Adolph Gottlieb, say, or Jane Freilicher—it was not so radically unlike those of his *peers*, who all dabbled in some kind of commercial art: comics, advertising, sign painting. Warhol's early work experimented with comic book subjects, and one afternoon when his friend Ted Carey was in the Castelli Gallery, dealer Ivan Karp showed him some comic book paintings. Carey said, "Oh, it looks like Andy Warhol," only to be told they were by Roy Lichtenstein.[19] Since the two artists couldn't share an stylistic identity, Warhol put his paintings away. He told this story himself, in a discussion of his relationship with Henry Geldzahler:

> I told Henry I was going to quit painting comic strips and he didn't think I should. Ivan had just shown me Lichtenstein's Ben Day dots . . . Right then I decided that since Roy was doing comics so well, that I would just stop doing comics . . . Henry realized, "From the point of view of strategy and military installation, you were of course correct. That territory had been preempted."[20]

Shortly after his brush with Lichtenstein, Warhol visited Claes Oldenburg's installation, *The Store*, at a downtown storefront. Warhol's response? "I'm so depressed."[21] And, after seeing James Rosenquist's early billboard paintings at the Green Gallery he told the enthralled Carey that "If you buy one of those paintings I'll never speak to you again." As artist Allan Kaprow wrote a few years later, "Since 1952, when Rosenberg wrote ["The American Action Painters"], artists have found their identities over and over in that white expanse of canvas, and many of the resulting works

look remarkably alike."[22] Kaprow's remarks are acute, although he, like many others, failed to realize that Rosenberg himself had foreseen this standardization.

Rosenberg's "The American Action Painters" is basically a before and after story (or a "conversion phenomenon" as he calls it), in which the artist is "cut in two," "reborn"—between before and after—not a story of slow rise, but of overnight radical change. Rosenberg's interest in conversion is hardly peculiar to him. Sartre (a major figure in Rosenberg's intellectual life) explored the self's potential for sudden change in response to altered circumstances, but the before and after narrative is also one of the great American themes, the rags to riches story, the Horatio Alger tale or Marilyn Monroe discovery, possible only in a place of self-invention as well as self-reliance, and of at least the image of an open society. This model found particular resonance in postwar America, with its rapid changes and seemingly deracinated, mobile individuals. Talk about the personal discoveries of the Abstract Expressionists was full of Sauls and Pauls; the search for identity figures the stylistic history as well of the Pop artists who also sometimes made sudden change a subtext of their art. Art historian Bradford Collins has argued that Lichtenstein's first comic work, which showed Donald Duck yelling, "Mickey, I've Hooked A Big One!!," represented the artist's own "success fantasy" in terms of art.[23] His first painting in what would become his signature Ben Day dot cartoon style, the 1961 image seems to be an allegory for the artist's discovery of a way of working, one that got him out of the dilemma of searching for room in the crowded Abstract Expressionist arena.

Lichtenstein and Warhol (both of whom hunted around for styles rather than developing techniques) both painted "before and after" pictures; Lichtenstein's, made in 1962, is called *Like New*. It depicts a screen with hole, and then the same screen again, presumably after the hole has been repaired. Warhol's version, taken from a magazine advertisement, depicted the before and after effects of rhinoplasty on a large-nosed woman. It was featured in one of his first exhibitions, a 1961 window display at Bonwit Teller, where it was included along with *Advertisement*, *Little King*, *Saturday's Popeye*, and *Superman*, a kind of convergence

of "metamorphosis and self-transcendence," as curator Kynaston
McShine has aptly said.[24] Some of the advertising images
corresponded to problems Warhol himself felt he had (as a large-
nosed, graying, balding, 90-pound weakling), and many scholars
have commented on these links, often tying them to his masculine
and homosexual identity. We might tie them as well to the theme
of success, which was at least as important to Warhol as glamour
and attractiveness. Warhol was trying to effect not only a physical
makeover, but a self-transformation: he was trying to become a
successful fine artist. As one of the sources for *Advertisements*
asked, "Where's Your Rupture?"[25] The theme of transformation
was present in both that 1961 display and Warhol's images of
Superman and Popeye, figures also painted by Lichtenstein,
emblems of the fantastic power that lurked inside even the most
apparently insignificant of men. Lichtenstein apparently identified
with Popeye, ordinarily slight and mild-mannered, transformed by
anger and spinach, giving a knock-out punch to Bluto, a bully
who for Lichtenstein represented the dominance of seemingly
super-masculine Abstract Expressionism—an object that he
would deck.[26]

Lichtenstein was equally interested in the advertising image
and the role of the commercial artist; as art historian Michael
Lobel has pointed out, his self-image was that of a detached
professional, whether doing commercial work, making art, or
teaching at Rutgers University. When Coplans asked Lichtenstein,
"How do you do your paintings?," he answered simply, "I just *do*
them. I do them as directly as possible."[27] Pollock too had
characterized his practice as "direct" art, stating a preference for
unmediated, experiential painting. Lichtenstein probably meant to
emphasize a lack of mysticism; common to both is the rejection of
what we might call artsy-ness. After detailing his process of using
an opaque projector and recomposing a source, Lichtenstein
mentioned that he had done some industrial design, along with
engineering and drafting work (drafting symbols appear in his
early paintings), and that "the exacting requirements of drafting
have had some influence on my work. It helped me to organize
and simplify."[28] The direct, matter-of-fact touch in Newman's and

Andy Warhol, *Before and After*, 1961, synthetic polymer paint on canvas.

Reinhardt's painting took on a more clearly manual work-related aspect in David Smith's sculpture; the art of younger artists like Stella, Warhol, and Lichtenstein, despite their apparent differences from Abstract Expressionism, continued to manifest this attitude towards handling. And in fact, commercial art *is* work, as much as painting houses, drawing advertisements, and drawing machines (which these three artists did, respectively). As C. Wright Mills wrote, using words strikingly prefiguring Warhol's claim that "art is business," in 1958,

> The American designer is at once a central figure in what I am going to call the cultural apparatus and an important adjunct of a very peculiar kind of economy. His art is a business, but his business is art and curious things have been happening both to the art and to the business—and so to him.[29]

The fine artist himself began to follow the same trajectory as other professionals: training, certification by an institution, looking for a job. Almost none of the Abstract Expressionists held

advanced art degrees; almost all successful young artists do today. Larry Rivers, one of the last heroin-shooting, jazz-playing bohemians, sardonically noted that it became apparent in the early 1960s "that one could go into art as a career the same as law, medicine, or government."[30] Or, as Warhol recounted his disillusioning of a romantic young woman who insisted on the risk-taking nature of art, "Why do people think artists are special? It's just another job."[31] (The different connotations of career and job are worth noting here.) The professional aspects of art-making, like teaching, themselves became more and more central to being an artist: Howard Singerman has documented the transformation of the art teacher from a grudging adjunct slummer at art schools around major cities into a professor ensconced in academia, wedded to its rituals and standards.[32]

In 1963, following the incredibly rapid success of Pop art the previous year, art historian and critic William Seitz, an expert on Abstract Expressionism, devoted an article to "The Rise and Dissolution of the Avant-Garde."[33] Seitz was primarily concerned that the avant-garde as a historical phenomenon had been co-opted by advertising and promotion. The rising market value of Abstract Expressionism had attached it to money and institutions and the process had only accelerated with Jasper Johns and then the Pop artists. As he described the situation in 1963, a phalanx of art teachers, art historians, and museum people surrounded a core of innovation, constituting a "professional avant-garde"; the amusing phrase captured the pretensions and ironies of the situation. These functionaries were themselves surrounded by "fashionable commercialism," an American upper middle class that actively sought to keep up with the cutting edge: "A few years ago the contest between innovation in art and sophisticated taste was a race in which the artists were always ahead; now, for the first time, leaders and followers are neck and neck."[34] Following a rhythm of planned obsolescence rather than rebellion and extension, this race was killing artists; those willing to play the game lost their artistic integrity, while those with the strength to go their own way were condemned to obscurity. The solutions Seitz half-heartedly offered to artists—to go "underground," or to seek refuge in the ivory

towers of the university—were prescient, but not real options for the survival of an avant-garde. The more viable idea was to face the current situation, and create a new artistic paradigm, "to recognize that the isolation of the artist from society has ended, and that the current obsession with novelty is a neurosis brought about by a vulgarized theory of perpetual revolution deduced from the art history of the last century."[35] Seitz was only the first of many critics to see that the avant-garde (both as a general social possibility and as the status of a specific artistic movement, Abstract Expressionism) was in danger or already dead. He was unusual, however, in seeing that this was not necessarily disastrous for contemporary art, which he understood could coexist with success and professionalism in a commercial culture.

The following year, Allan Kaprow went further along the same analytical track, seeing more clearly that the artist should become a "man of the world."[36]

> The men and women of today's generation [of artists] . . . are indistinguishable from the middle-class from which they come and towards whose mores—practicality, security and self-advancement—they tend to gravitate . . . Their actual social life is usually elsewhere [than where they live], with clients, fellow-artists, and agents, an increasingly expedient social life for the sake of career rather than just for pleasure. And in this, they resemble the personnel in other specialized disciplines and industries in America.[37]

That is, he argued that the avant-garde was an obsolete model, and that the artist was no longer a marginal figure. Kaprow, more bluntly even than Seitz, laid out the end of the artist as an inhabitant of a peculiar social role alienated from society; neither bohemian nor worker, he exemplified the new social type of the moment—the professional. Art is an industry, and artists have clients and agents like commercial artists (as if "fine" artists did not seek to sell), such as advertising illustrators or graphic designers. Seitz and Kaprow, we can say, merged the success of Abstract Expressionism with the subject-matter and self-presentation of Pop artists.

How did the new self-conception of this man of the world affect the art he made? Critic Leo Steinberg believed that formalist art, or at least the formalist interpretation of painting, was shaped by a professional ethos. In a talk originally given at MoMA and then published in *Artforum* in 1972, Steinberg critiqued Greenberg's formalism for seeing art in terms of technical problems, tying the formalist history of modern art to the streamlining of industrial design, as if a painting were a car.[38] The analogy was common: Robert Morris wrote disparagingly in 1971 of "static, portable, indoor art" and opined that "one waits for next season's polished metal boxes, stretched tie-dyes and elegantly applied liquitex references to Art Deco with about as much anticipation as one reserves for the look of next year's Oldsmobile—Ford probably has a better idea."[39] Along similar lines, critic Carter Ratcliff has referred to Frank Stella as an "image administrator," and art critic Benjamin Buchloh has linked the tautological thinking of Joseph Kosuth and other artists working with text to the new managerial class and its habits of consumption: "The rights and rationale of a newly established postwar middle class, one which came fully into its own in the 1960s, could assume their aesthetic identity in the very model of the tautology and its accompanying aesthetic of administration."[40] That is, "art about art," art that saw itself as being "the next inevitable step" (as an issue of *Artforum* once put it), was following the model of professionalism as much as that of art-historical Hegelianism.[41] That next step was a socially determined problem to which an individual might choose to apply himself, but that he does not determine or choose.

Popular sociologists like David Riesman (and later Christopher Lasch) associated the professional with "outer-directedness."[42] According to Riesman, after the Industrial Revolution in America, institutions that had flourished within a traditional social frame-work, fostering "inner-directed" individuals, became secondary to daily life. Instead of conforming to traditional values, such as those of organized religion, the family, or other societal institutions, the new middle class gradually became malleable in the way people lived with each other. The increasing ability to consume goods was accompanied by a shift away from social tradition and

inner-directedness. One came to define one's self as a function of the way others lived. This type of personality became indispensable to the institutions that thrived with the growth of industry and culture in America. This is a story of America become civilized and gone soft, having lost its earlier pioneer or Thoreauean model of self-determination. However true this may have been about society in general, it is true that many artists no longer looked inward, but outward to find a way to work, to art history or technical, disciplinary problems (or, still less productively, in a popular complaint, to art magazines).

It was mutual: while artists embraced and emulated commercial pursuits, middle-class life, and self-presentation, society at large warmed to the ideal of the artist as different, independent from society. By the mid-1960s it seemed that society's *non*-indifference to art—its embrace of Pop as well as Ab Ex—was the problem. In a 1965 editorial, Thomas Hess wrote that America now killed its artists not by starving them of food and attention but by "smothering them in kisses."[43] Hess, another partisan of Abstract Expressionism, was complaining about the seemingly inevitable vulgarity of the American treatment of the artist—first as a failure, now as a success. Conversely, the outsider myth had been incorporated into the dominant culture, which celebrated rather than punished non-conformity: the gray flannel suit had become the butt of jokes, in magazines like *Playboy* and the *New Yorker*, in television shows like *Bewitched*, with its hapless adman husband Darrin. The professional's moment in the sun was quite short, if he ever really enjoyed a time without accompanying complaint. Riesman had criticized the professional model as early as 1950, and other popular sociological critiques, novels, and films were piling on by the mid-1950s. The history of contemporary art seems characterized not so much by an alternation between generational ideals of Abstract Expressionism and Pop, or a more radical post-1970s slide into postmodernism, as by a conflict that has existed in America since at least the nineteenth century between the self-made man (whether a "failure" like Thoreau or a success like Andrew Carnegie) and the less than admired, conforming member of society (even in his successful guise as an advertising man or a corporate middle manager).

Dropping Out

Society embraced the successful artists of the 1950s, but the artists themselves had trouble with success. The casualty list for the Abstract Expressionists was long: Pollock and Smith died in accidents facilitated by recklessness and alcohol, Kline and Newman from drinking and ignoring their health. Rothko committed suicide. Others, like Still and Guston, retreated from New York. They had expected not success, but to be avant-garde outsiders; they were initially happy to have social recognition, but desperately disappointed that in the new world of America this translated into money more than into cultural understanding or respect. The Pop artists—professionals that they were—fared better in surviving success. Many younger artists of the late 1960s and early '70s embraced the larger social rebellion against the rat race, as embodied by the radical students who repudiated the values of their successful parents and the wide range of hippies and heirs to transcendentalism who at least temporarily moved to communes or "back to the land" (discussed in Chapter 5). Artists too, despite the imperative to live in the capital of the art world, left the city, disgusted not so much by personal success as by the irrelevance of art in the face of current American politics, as well as by the careerism of New York.

The social phenomenon of dropping out was popularized by guru Timothy Leary, who in a 1966 speech coined the catchphrase "tune in, turn on, drop out" (originally intended to promote LSD use). He exhorted in a 1967 essay, "Drop Out—detach yourself from the external social drama which is as dehydrated and ersatz as TV."[44] Television was Leary's metaphor for "the American game," a social system that was "fake" and entirely commercial, and over which individuals had no control, left to "robot performances" that could only be automatic rather than authentic.[45] While the reference to television tied his ideas generally to contemporary critiques of commercial culture (Debord's *Society of the Spectacle*, for example), Leary, despite his scornful critique of American culture, offered a specifically American antidote. As he explained in his autobiography, "'Drop Out' meant self-reliance, a discovery

of one's singularity, a commitment to mobility, choice, and change."[46] Leary framed his exhortation in the language of Emerson and American individualism, reverting to the pioneer values of dependence on one's own ingenuity rather than the social fabric, and reveling in the freedom thus earned.

Leary specifically targeted the most common American civic activities, exhorting people to quit their job (or school) and not to vote. This certainly had a radical aspect, despite the conservatism of his embrace of self-reliance. In this light, it's particularly amusing to think of his contemporary, the artist Bruce Conner. Conner (also a proponent of the liberatory potential of psychedelic drugs) ran for San Francisco City Supervisor in 1967, the dullest imaginable bureaucratic position. His campaign poster imagery included an elephant elaborately decorated and doodled with the word "LOVE" and a grade-school photograph of himself. That year he also dropped out:

> I quit the art business in 1967 for about three years . . . At that time, whenever I'd get any letters about art related events, I'd send them back or throw them out. Sometimes, I'd write deceased on them. I was listed in *Who's Who in American Art* and I sent back all their correspondence with "Deceased." After three years, *Who's Who* believed me . . . So the artist is definitely dead.[47]

To Conner, of course, the very concept of a professional directory for art was ridiculous. According to his friend, film-maker Stan Brakhage, a New York gallery contracted to represent Conner in the early 1960s required that he conform artistically to more conventional standards.[48] Conner reacted by attending art openings, only to move among the crowd wordlessly pinning buttons that read "I am Bruce Conner" or "I am not Bruce Conner" to people's clothes. After moving to Mexico for a short period, Conner returned to San Francisco and sold beads on Haight Street.

The impetus to drop out in the late 1960s and '70s was a complex mix of a deeply anti-social impulse, a protest against

contemporary American existence, and a mode of adherence to
traditional American values. While many people today associate
America with commercial culture and materialism, there is a long
history of belief that capitalism was a poisonous import from
Europe, a system that betrayed the fundamentally American one
of farmers, artisans, and freeholders. Many American artists were
active in protesting the Vietnam War and in various civil liberties
groups; many also chose to drop out, to leave the art world itself.
Besides Conner, they included Richard Tuttle, in self-exile after
disastrous reviews of his 1975 Whitney show; Peter Young, who
disappeared into Costa Rica in 1969, just as he was having a show
at Leo Castelli's important gallery; and Lee Lozano.

Lozano began painting in a kind of Pop expressionist vein,
moving into abstraction and then Conceptual art projects in a
search for "total personal and private revolution." Her diaries are
full of commentary on the vagaries and conflicts of dealing with
the New York art world (which was almost synonymous with her
social circle), and these feelings became the basis for powerful art
works. In *Money Piece* (1969), she recorded what transpired as she
offered a jar full of money to a range of visitors, including artists
like Keith Sonnier, Dan Graham, and Brice Marden. Some took
money, some refused, and some contributed to the jar. In *General
Strike* (1969), she gradually absented herself from "official or pub-
lic 'uptown' functions or gatherings related to the 'art world,'" as
she wrote in her notebook, inaugurating the action by withdrawing
from a show organized by Richard Bellamy (himself a dealer of
unusual integrity). This action powerfully acknowledged the social
structure of artistic practice, attacking the dominance of business-
making, connections, and competition even in apparently radical
or anti-commercial circles. "I WILL NOT SEEK FAME, PUBLICITY
OR SUCKCESS."[49] Her withdrawal was conflicted, not a perfect,
obdurate fact. In the final note to *General Strike*, she laments
having hurt certain individuals in pursuing her larger artistic
statement, and notes by Bellamy as well as Lozano detail her at-
tempts to connect with him. Ultimately, around 1972, she left not
only the art world but New York as well.[50] Yet later on, living in
Dallas, she still spoke to people in the New York art world, and

Bruce Conner,
BRUCE CONNER FOR SUPERVISOR, 1967, offset lithograph on paper.

**BRUCE CONNER
for SUPERVISOR**

also agreed to participate in exhibitions and arranged for art works to be released to various venues.

Lozano's ambivalence, her determination not to compromise itself sometimes compromised by the lure of connection, is recognizable to anyone who has questioned the cost of social and financial success. The cost of success is compromise of one's own autonomy, in being more closely tied to society and its regard, and sometimes compromise of one's creativity, consciously or unconsciously, as it develops an audience. As Leary wrote, this issue, despite being broadly social in nature, was not one to address through mass political movements, but only individual action: "There is nothing for you to do in a collective political sense. Turn on, tune in, drop out. Discover and nurture your own

divinity and that of your friends and family members."[51] One used to drop out of business—like Gauguin—to become an artist, but now the life of the artist looked less different, a rat race like anything else. With the professionalization of art, and its establishment as an arena for social success, artists were enough like businessmen or other professionals ca. 1970 that they could drop out.

Nobody

As the tumult and dissent of the late 1960s began to ebb, the 1950s and the man in the gray flannel suit resurfaced in an oddly compressed cycle of historical revivalism and nostalgia. In the myriad discussions of the ways in which the 1980s revived or replayed the 1950s, journalists and scholars usually emphasize Ronald Reagan's role. He was the president who brought back "traditional values" (despite his own divorce) and "morning in America," who with his own self-made image rolled America back to before the '60s, at least rhetorically, and philosophically returned to a moment before the New Deal. But two things are missing from this general account. First, that the ground was already well prepared for Reagan's reincarnation of an imaginary 1950s. The revival really began in the late 1960s with the development of the category of "oldies" music, and took off in the 1970s, as in the movie *American Graffiti* and the popularity of the television show *Happy Days*, and rampaged through both seemingly progressive and conservative sectors of the culture. Second, that this revival was in many ways local to American culture and politics, a specificity that would be attached to other histories and turned into postmodernism, the grand theoretical and metahistorical category of academics who framed it as a symptom of modernism's end, the wholesale end of modernist originality and progress, and the concomitant need (borrowed from architectural theory) to recycle styles.

For younger artists—many of whom would come to be associated with postmodernism—the revival was, as observed in

the previous chapter, based on their suburban middle-class
childhoods spent watching old movies on television. The work of
artists Cindy Sherman and Laurie Simmons intersected with the
blur between art and life of East Village artists performing a
re-enactment, ambiguously parodic and nostalgic, of the 1950s.
Downtown New York was occupied not only by the indian chief,
policeman, cowboy, and construction worker archetypes of the
(West) Village People, who debuted in 1977, but by artists and
other club habitués dressed ironically as moms, secretaries, and
office girls, not to mention playing businessman in Goodwill suits
and pompadours. Sherman's characters and Simmons's Fifties'
housewives and single girls in dollhouse interiors channeled the
feminine stereotypes very recently, and vehemently, rejected by
feminists and feminist artists. Eleanor Antin, slightly older, had
a more nuanced early take on the '50s revival, in a 1974
performance titled *Eleanor, 1954*, which brought together personae

Lorraine O'Grady, "Mlle Bourgeoise Noire and her Master of Ceremonies Make
their Entrance," from *Mlle Bourgeoise Noire Goes to the New Museum*, 1980–81,
photodocument.

(like the King and Ballerina) from her current career as a performance artist and publicity photographs from youthful attempts to build an acting career. Antin reflected on her own past, but the younger artists hadn't experienced the 1950s first-hand—if they were nostalgic for anything it was for their parents' childhoods, although that sweetness was tempered by an often twisted, over the top execution, and the content of much of the work was the camp element of stylized gender roles: artificial beauty and domesticity for women, success and failure for men. Perhaps only Lorraine O'Grady explicitly tied feminism to issues of class and success, as well as race, in her perfomances as *Mlle Bourgeoisie Noire, 1955* (1980–83), in which she burst into art events, dressed in a gown made of white gloves and a beauty pageant sash.

Michael Smith debuted his character "Mike" in the 1978 performance *Down in the Rec Room*. Mike was and is someone apparently very close to the artist Michael Smith: his name is undistinguished, as is the man himself, apparently just a guy trying to get by. The artist originally conceived the character with the name "Blandman," and intended him to be shaped by averages and demographic figures; Smith in fact initially "wrote people asking what or who they thought Blandman was."[52] Smith has discussed his fundamentally middle-class background, which provided the bland material he worked with. His choices of scenarios for his performances, videos, and photographs were paradigmatic of that background, and of a grounding in the 1950s, as in a 1983 installation, *Home Fallout Shelter* featuring the outmoded Cold War suburban structure. Wood-paneled and outfitted with a hi-fi system and bar, it promised the continuation of the suburban lifestyle even amidst a nuclear apocalypse.

Mike, despite his fundamentally undistinguished nature, sought success, and Smith's work drew parallels between the political and economic context of the 1980s and the cultural landscape of the '50s. "When Reaganomics was at its height, I thought it appropriate to evoke and pay homage to Arthur Miller's *Death of a Salesman*. I tried getting rights to use the title *Death of a Salesman II*, but was denied. The following fall *Death . . .* opened

on Broadway with Dustin Hoffman."⁵³ Instead, Smith titled his performance *Bill Loman: Master Salesman* (1983). The following year he made *Go For It, Mike* (1984), a music video evoking the Horatio Alger success myth using a combination of 1950s and Reagan-era imagery. Mike the college boy is urged by classmates to "go for it!" and spins through a number of roles—politician, train engineer, real estate developer—all to the tune of a goofy theme song. He ends as a cowboy, and, invoking the frontier myth, rides off into the sunset, like Reagan himself. Smith frames 1987's *Keeping Up with the 80s* as marking the end of an era:

> I think of *Bill Loman* and *Keeping Up* as kind of bookends . . . *Keeping Up* was put on at the end of the Reaganomics era. I thought it ironically appropriate to celebrate the end of the '80s with a musical featuring child actors playing young yuppies looking forward to the '90s as Mike struggles to keep up.⁵⁴

Michael Smith, *Bill Loman, Master Salesman*, 1983, performance at The Kitchen, New York.

In an interview with Smith, his friend Mike Kelley suggested that this work was specifically about the enormous success and money suddenly flooding the art world.[55] Smith insisted that he was only referring generally to the disposable income of the Reagan period's yuppies, and Kelley shrewdly replied that he didn't see much of a difference between the two phenomena. Smith himself alluded to "my father's failing business, my art career at the time, and the small manufacturers in Soho who were forced out," drawing together the broad economic picture and the art world microcosm, as well as the social and the personal.[56] Mike (and Michael Smith as well) belong to an American social landscape in which people are sorted into Somebodies and Nobodies.

Of all the artists jostling in the nightclubs and art studios of downtown New York in the late 1970s, the one who would become most successful was Jeff Koons. Koons came to New York in 1977, fresh from Chicago and trying to fit into the scene, straining to be cool, but always seeming a bit awkward. Tellingly, his unconventionality was manifested by an excess of propriety: photographs and descriptions show Koons wearing not one but two neckties (he was employed at MoMA, not in the traditional artist's job of guard or art handler, but as a membership salesman).[57] His work is superficially very different from Smith's, but the two artists shared the unusual tack of taking middle-class America as their subject, a vast territory that surprisingly few artists have touched. (Both Smith's and Koons's fathers were small businessmen, an American type that is seemingly respected, but that also came to fall in the "loser" category in the era of big entrepreneurs like Ted Turner.) Koons's attempts at avant-garde conformity soon foundered and he dropped them; they are anomalous in the artist's biography, in which even his "before" seems already touched by his "after." Along with the well-known vacuum cleaners enshrined in Plexiglas boxes lit with fluorescent lights, his first major body of work, *The New*, featured *The New Jeff Koons,* a photograph of the artist at four and a half years old, in kindergarten, meticulously groomed and smiling, shown with a box of crayons. Even at this young age he has been emphatically shaped, formed in the image of the perfect young boy, not a hair out of place; poised and self-confident, he

Jeff Koons, *The New Jeff Koons*, 1980, Duratran, fluorescent light box.

looks straight at the camera, wielding a crayon. Far from an
innocent, unconscious moment of creative absorption, this
photograph depicts an unbelievably conscious self-representation.
The relative isolation of the vacuums in their pristine display cases
matches what Koons described as his own need to be independent
at the time, to make whatever work he wanted to make,
irrespective of interest from dealers and collectors. He moved
from MoMA to Wall Street in 1980 in order to make the large
amount of money necessary to fund his work, and he speaks of the
importance that freedom to do what he wanted has always held for
him: "I've always felt self-sufficient; my parents brought me up
that way. As a child, I would go door to door and I would sell
mints and chocolates and wrapping paper."[58] However charmingly
modest, however much this meshes with the image of the small
town businessman, the salesman, the Willy Loman type, Koons
unconsciously and brilliantly connects that little man to the
Emersonian self-reliance that underwrote the figure of American
entrepreneurial super-success. While Julian Schnabel masqueraded
as a bohemian Old Master, a descendant of Old Europe (even as
he became a symbol of careerism), Koons (like Smith) made art
about the American middle class he came from, fusing that myth
with that of super success.

A 1980 article in the *New Yorker* by art critic Calvin Tomkins
titled "Art World: Boom" focused not so much on the rocketing
art market as on its effects on artists. The essay was published a
month after Reagan's election; the money hadn't really rolled back
into the American economy yet, but perhaps there was a sense of
returning, if only by force of belief, to good times. Tomkins noted
that young artists didn't necessarily belong to a single movement
or even "a group of kindred spirits." What distinguished them? For
one thing, professional credentials: "A surprising number of young
artists today have both a bachelor's and a master's degree in art."[59]
(Tomkins's surprise is, of course, comical from today's perspective.)
Beyond their advanced degrees, artists Elizabeth Murray, Jennifer
Bartlett, David Salle, Jonathan Borofsky, and Julian Schnabel had
"all achieved the novel distinction of a waiting list . . . A waiting
list for an artist on the threshold of a career is something new, and

it puts a lot of pressure on the traditional need to take risks, make mistakes, and explore fresh territory."⁶⁰ With so much at stake, they were, apparently, pioneers no more. In the article, Schnabel appears only as the most ambitious among young ambitious artists, the list including many names not usually associated, as Schnabel's soon would be, with unleashed careerism, such as Lynda Benglis and Judy Pfaff. Pfaff herself described the situation with a measure of distaste: "A lot of the younger artists I see talk very knowingly about building a career. They're really professional that way. And very competitive."⁶¹ In fact, both the postmodern "Pictures" artists (the artists associated with Douglas Crimp's exhibition and critical writing addressing appropriation of the late 1970s) and the neo-romantics of what we might call the "Paintings" generation were selling, with the "criticality" of the former positioned as just one sector of the market.

Koons's comprehension of this moment is like Warhol's perceptiveness at the turn of the 1960s. As the stakes became higher, artistic success looked more like real financial success, and consequently getting by on a few sales a year plus bartending or a teaching salary looked like failure. If Warhol claimed to have left commercial art for fine art because that's where the money was, now even what Koons earned from his former career in financial services was dwarfed by art money. His next work focused on attendant issues of social mobility and the possibilities of self-fashioning. For *Equilibrium*, in 1985, he reproduced Nike basketball posters featuring various stars of the NBA. Koons has often explained the exhibition as an elaborate allegory in which Moses Malone and the other athletes functioned as "sirens," an allusion to the temptresses of the *Odyssey*, whose beautiful songs drive sailors to their deaths, luring them to head their ships into the rocks. The posters dangle the idea that, "I'm a star, you can be a star too" in front of young men who have little chance of becoming rich and powerful through sports or any other means. But Koons wasn't just making a point about the limited social options of African-American men; he saw an analogy between the salvation black kids sought in sports and the way that middle-class white kids hoped to use art for social mobility. For the latter, figures like

Schnabel and Anselm Kiefer could be sirens—by the mid-1980s, the art market had heated up, and some artists, particularly the neo-Expressionists, were obtaining very high prices, as well as cultural celebrity status.[62]

Through the mid-1980s, Koons continued to frame art with other luxury goods as part of the image of wealth that by luring threatened the middle class. *Luxury and Degradation*, made the same year as *Equilibrium*, embodied Koons's warning that the American Dream doesn't always uplift, but could rob the ordinary person of his self-worth and even his literal financial well-being. Koons's ambivalence about class mobility—one of the cornerstones of the American Dream—has a personal aspect. The *Travel Bar*, a stainless-steel sculpture that was an element of *Luxury*, is modeled on a travel bar that belonged to Koons's father and that Koons still owns. Growing up in Pennsylvania, "I always felt that my parents were moving up, that they were socially very mobile and one of their symbols, or the greatest symbol that I can come across and remember, is my father's travel bar."[63] The travel bar embodied mobility literally, in that his parents could bring it anywhere they went (on vacations in Puerto Rico for instance) and have a party. It also metaphorized their efforts to move upwards, although never too far: "When I was a child we had a small house and then we moved into a larger house and a larger house and then they would join this club and then they would change to the outdoor country club."[64] The object is not just a general sociological statement, but a poignant symbol of Koons's own class background, and the anxiety about freedom attendant on that class position.

Koons seemed to resolve that anxiety, and to burst out in full, unrepentant glory with *Banality*, shown simultaneously in three galleries in 1986. In the ads he made for the exhibition in *Arts* and *Art in America*, he appears as a swanky, vulgar master of the universe (sporting a robe monogrammed "N" for Napoleon) surrounded by bikini'd babes, animals, and flowers, proclaiming himself the "leader of the art world." In the minds of many in that art world, he represented the ultimate in excess, the natural match for a society politically dominated by Reagan's triumphalist Americanism and economically by a new debt-driven financial

boom ("Just when it looked as if the '80s were finally over," began a 1991 Koons review in the *New York Times*).[65] But the continuity in Koons's stance is as deeply rooted in his changes. Indeed, even larger cultural shifts as dramatic as that between the 1950s and '60s, or the '60s and '80s, while responses to real changes in the economic climate, are linked in enacting a long-term American dialectic of success and failure.

Failure

During his two-term tenure as president, Reagan promoted the spectacularly successful individual businessman as the savior of capitalism—a gambler like entrepreneur Ted Turner, rough and ready to risk everything, and so deserving the enormous rewards he reaped. The opposite of this businessman type was no longer the aristocratic bohemian, as in modern Europe, nor the noble dropout from the rat race. The new dissenter from success simply didn't do *anything*, or failed at everything; he was not forming an alternative society, or learning a new way of life, but just giving up. This model became more culturally significant in the 1980s, but was presciently and notably described by Frederick Exley in his 1968 book *A Fan's Notes*, which centers not on idealistic refusal, like most stories of that moment, but on inadequacy. In a chapter called "Journey on a Davenport," Exley described spending half a year lying on his mother's couch recovering from alcoholism and a nervous breakdown: "In a land where movement is virtue, where the echo of heels clicking rapidly on pavement is inordinately blest, it is a grand, defiant, and edifying gesture to lie down for six months." It's tempting to relate Exley's experience to the precedents of great American do-nothings like Melville's Bartleby and Thoreau, who refused to participate in commerce, in the business that makes America go, in, literally, the constant mobility that at least theoretically shapes the American experience. But while Thoreau sought to do something else that simply wasn't immediately recognized by society, and thereby prove his originality, Exley's withdrawal was Oedipal and defeated, although perhaps

related to that of Bartleby in its passive aggression. It followed personal failure: the recognition that he had not turned out to be Frank Gifford, his former classmate who had become a wealthy and admired NFL star.

"Journey on a Davenport" seems to foreshadow artist Richard Prince's semi-fictional account of his own year spent on a couch before getting kicked out by his girlfriend and heading to L.A. Prince wrote, as the unreliable narrator of his own life:

> For one year he rented movies—VCR videos—and watched them on a twenty-five inch color Sony monitor at her apartment. He watched the movies alone, late at night after she had gone to bed. He watched two-hundred-and-seventy-five movies that year . . .
>
> He had always wanted to go back to a room where he could lie on a couch and watch t.v. and in the t.v. he could put a video movie. She gave him these things. She gave him what he wanted and had never had. And what had happened was, in the end, she wanted to kill him for what she had given him. "I'm sorry", she said, "it happened and you happened in it. If I had seen you one more time on the couch watching movies I would have killed you. I wanted to kill you. I'm sorry, but that's what I felt." I'm sorry too. That's what he said. He said it to himself. He said too, he was still glad; it didn't matter that she felt those "things" turned him into half a person.[66]

Like Exley, Prince sought a couch provided by a woman, and the experience was not only anti-social, but explicitly emasculating: he didn't want to have sex, and he turned, in her eyes, into "half a person." Of course Prince's proneness was fueled by imagery while Exley's pop culture was football, less imagistic than Hollywood movies, and less related to his own work.

Film appeared again as a motif in Prince's autobiographical fiction when he described how he slunk off to Los Angeles in the mid-1980s. It haunted even the ride out there (no noble road trip, but a flight anesthetized by sugary booze and bad culture): "The movie on the plane was 'Country'. Jessica Lange. Sam Shepard.

About sticking it out. Staying put. Fighting for your rights. Fighting for your family and who you are. Fighting for your land. Traditions. Values. Right against wrong."[67] The chance viewing of this particular film (whether it really happened or was concocted by Prince) was especially apt. *Country* is a rugged Western centered on a heroic, brave man taking a stand, the opposite of Prince's own prone position. Once in his L.A. hotel room, Prince hung a "personality poster" of Steve McQueen—like Shepard, a "maverick"—because he was tired of trying to figure himself out, of plumbing his psychological depths and getting straight. Failure here is passivity, even impotence, and related to the consumption of popular culture (rather than active, virile production of something). Exley's book, similarly, was called, "A Fan's Notes," perhaps tacitly a critique of the consumer culture as feminizing, as opposed to that of the football player, the man of action. Prince's failure in New York, his inability to be a professional "man of the world," is expressed in Los Angeles by his wish to be Steve McQueen, "to see himself as a personality instead of as a person": to be Somebody (like Harold Rosenberg's action artist), to be in *Who's Who* (like Bruce Conner), to be, as the title of his info-fiction essay puts it, "Anyone Who Is Anyone."

Paradoxically, an artist like Mike Kelley who seems to embrace failure by rejecting professionalism ("I chose to become an artist because I wanted to be a failure") may also be rejecting the most egregious kind of failure—that of being a professional, even a successful professional, with its limited rewards, rather than a loner, a risk-taker, and therefore potentially not only more free, but (like Kelley himself) wildly successful.[68] The commercial artist—the professional success—becomes more clearly a Nobody in relation to the autonomy and social (as well as often financial) status of the fine artist. But to add further complication, it isn't just Lichtenstein and Warhol, seeking success, who identify with commercial artists, but Kelley and Prince as well. If they don't identify, they at least sympathize. Once he got to Los Angeles, Prince began his joke paintings. The first joke was handwritten, and sometimes the jokes are just text; when there is imagery it is recognizably the semi-anonymous type of *New Yorker* or *Playboy* cartoons. The types in play are the businessman—the organization

man, with suit and tie—the super-buxom, big-haired woman he lusts after, and the occasional terrifying wife. The male protagonists are often cuckolded by their wives, eaten by cannibals, cheated even by their psychoanalysts, in these images torn from the high point in earning and cultural power of the American man. There is a kind of double-identification with the loser, as the illustrations themselves conjure the artist as loser—the illustrator or cartoonist subject to strict genre rules rather than free to break boundaries or express himself, the often anonymous, or at least unappreciated commercial artist grinding it out, unrecognized, forgotten. The punchlines, if one can call them that, evoke that anonymity, with fragments like "I don't have a penny to my name, so I changed my name." A lack of consequence or identity is at work as well in Kelley's *Garbage Drawings*, part of the *Half a Man* project. Taken from the *Sad Sack* comic strip that portrays a dumped-on private in the U.S. army during World War II, Kelley selected the most overlooked part of the strip, the scribbles indicating generalized matter, detritus, garbage in the corners of the comic frames, and blew them up. This unconsidered "business" in the corners recalls the unacknowledged labor of the commercial artist, and the throw-away nature of his product.

In the late 1980s, in the face of the enormous success of some artists, the theme of failure became the explicit content of much art, rather than merely its silent background, and also of film and music that featured the slacker or loser. Critics have often described this development in psychoanalytic terms, speaking of pathos, abjection, and, more recently, melancholy. There is undoubtedly a strong psychological component to the way that the experience of failure is processed and expressed by individual artists. But psychoanalytic explanations glaringly lack a social component, missing the centrality of success and failure to life stories in America. The nineteenth-century European artist—above all, Van Gogh—who went unrecognized was a symptom of society's failure to perceive his brilliance. In America, where each man (I use the word deliberately) is seen as responsible for his own fate, failure is *personal*. The enormous social rewards that seem so available for the taking only highlight the individual nature of failure.

I never had a penny to my name so I changed my name.

Richard Prince, *I Changed My Name*, 1988, acrylic and silkscreen on canvas.

Half a Man

The apparent economic boom years of Reagan's presidency, para-doxically but unsurprisingly, were also the moment that the men's movement, in all of its incarnations and orientations, took off. Much as black political activism and academic studies gave birth to white studies, feminism sparked men's organizing and study. In the 1970s, men's groups, both sympathetic and antagonistic to feminism, convened to discuss the changing role of men in per-sonal relationships and in relation to social issues such as violence, house care, and work. In 1979, the Radical Faeries movement was founded, promoting a new model for men that eschewed traditional masculine virtues in favor of self-expression, play, and aesthetics. The men's movement had a root in a gay culture that rejected mainstream expectations for men, as well as in the struggles of straight men with their changing female partners. Growing out of these disparate sources, the men's movement had its first highly visible incarnation in the encounter groups that Robert Bly initiated in 1981, drawing on fairy tales and mythology, expressive rituals and dance, and confessional therapy. By 1990, the men's

movement had gone mainstream, and Bill Moyers ran a television special on Bly's "tribal" encounter groups. Here, the more conservative facet of the movement rose to the surface, planting the seed later tended by the church-based Promise Keepers.

Bly, like many nominally feminist men, seemingly encouraged men to get in touch with their "feminine side," seeing its inadequate expression as the explanation for the Vietnam War and Reagan's "callousness and brutality."[69] He wrote,

> Back then there was a person we could call the '50s male, who was hard-working, responsible, fairly well-disciplined . . . Reagan still has this personality. The '50s male was vulnerable to collective opinion: if you were a man, you were supposed to like football games, be aggressive, stick up for the United States, never cry, and always provide.[70]

But Bly nonetheless disparaged leaving behind masculinity and the feminization of men, arguing that traditional values had been replaced by the desire to please women: "He's a nice boy who now not only pleases his mother but also the young woman he is living with."[71] Much as conservative critics would in ensuing years, Bly was reacting against the soft, Alan Alda-style masculinity that had replaced that of John Wayne. As an alternative to both current patriarchal culture and feminist correctives, Bly suggested the mission to discover a "deep male" who was in contact with his natural self. The prototype for this man was Iron John, a "Wildman," who referenced Pan and Dionysos (see Chapter 5 for the primitivist aspect of this ideal), a return to a much earlier Emersonian wild man, independent and free.

Although feminism was certainly a new episode in the story of masculine types, the critique of socially dominant values as seemingly oppressively masculine but actually secretly feminizing predated it, as Bly reiterated notions of the 1950s. Riesman and Whyte, as well as a series of *Look* magazine articles on the domination of men by women, had made many of the same complaints.[72] Even amidst a culture of work and success amidst economic plenty, the most popular books, such as *The Organization*

Man and *The Man in the Gray Flannel Suit*, were cautionary tales about the perils of success. And underlying their warnings about the outward orientation of the professional was the specter of feminization. Office-enforced conformity, even for the successful executive, was emasculating; working for others went against the independent, entrepreneurial, American type, free to take risks, not tied down by the need to compete in the consumption of material goods. Perhaps counter-intuitively, over the years critics of very different stripes have cited both feminism and professionalism as emasculating, feminizing, based on conformity and consumption, on pleasing others rather than asserting oneself.[73]

Much of the 1950s revival in the 1980s (as opposed to the 1970s) seemed to directly enact the damage the '50s nuclear family did to men. And some of the art has the complicated resonances of tangling with feminism as well as the prevailing culture; the artists don't take Bly's positions, but they do deal with many of the same issues. Prince, Conner, Koons, and Smith (as Baby Ikky) all used the image of the young child as an alter ego or ironic self-depiction. Kelley, who has explored the theme of demasculinization and failure from the beginning of his career, dedicated a project to the proposal. *Half a Man* (1987) included felt banners, stuffed animals, and afghan assemblages, and painted dressers, all referring to craft, and to a feminizing mode for the young man. *Half a Man* seems to be about being cowed by the other kind of overpowering 1950s masculinity, as represented aesthetically by heroic abstraction.[74]

As a phrase, "half a man" can mean someone young, someone inadequate, and/or someone effeminate. The little man, the boy who perhaps symbolically failed his father in some way, can be found throughout the art of the early 1990s. Charles Ray's *Self-portrait* of 1990 presents him as an everyman, in a sculpture that vacillates between the most anonymous of mass-produced mannequins and the particularities of his features. Some of the men seem entangled in an Oedipal relation with mom, like Ray's giant (eight feet tall) woman of *Fall '91* (1992)—power-suited and looming over the artist in an installation shot. The little boy struggling to free himself from his mother is the real hero of Bly's

story of Iron John; he is initiated into manhood by the hairy, ancient man who teaches him to defy his mother.

Jim Shaw, a Los Angeles peer of Kelley and Ray, draws from many of the same sources in his work. Shaw, who could not stand being a commercial artist himself (he worked in film, advertising, and video), has mimicked the style of scores of commercial illustrators, cartoonists, and comic-book artists, working for magazines from *MAD* to the *Saturday Evening Post*. Many of these artists used styles unattached to a public name, or house styles for magazines. (Kelley too loves not only cult figure Basil Wolverton of *MAD* magazine, but all of the little-known or completely anonymous artists of popular representations—makers of comics, greeting cards, and inspirational posters.[75]) Shaw elaborated on this anonymity in the *Thrift Store Paintings*, which he began collecting in 1990. His first major project, *My Mirage* (1987–91), was an enormous collection of two-dimensional images, sculptures and videos that tell the story of Billy, an American boy in the 1960s. "Billy, the main character of *My Mirage*, is a failure. He thinks of himself as a martyr, which is a good Christian thing to be, and at various times he's represented by martyr-like characters, such as Charlie Brown, Clark Kent, and Jesus."[76] A pantheon of all-American losers. The reject kid who can't hack it, Shaw's Billy sniffing glue in the basement is the alter ego of the adult male artist who refuses to make it (it's not like these guys are trying to fit in), in a twist on Willy Loman. Billy's story is, quite literally, a conversion story, in which he goes from innocent child to horny adolescent addled by music and psychedelic drugs (another kind of identity-altering transformation) to fanatical Christian convert—a man "reborn," in Rosenberg's words. The rags-to-riches saga that permeates our culture, the Horatio Alger story, is of course the before-and-after conversion story; Shaw parodied it in the face of Billy's failure to transcend, to realize the self.

The title of a painting in *My Mirage*, *The Golden Book of Knowledge*, invokes the series of insipid children's educational books. It depicts two before-and-after characters, Pinocchio and Popeye (noted for the manifestly masculine bulge in his spinach-induced, super-sized arm muscle), rendered in a style that blends

Jim Shaw, *Frontispiece Chapter Two*, 1986, gouache on paper.

children's illustration with the plainspoken *trompe-l'œil* of nineteenth-century American painters like Peto and Harnett. While the humorously apoplectic underdog Popeye appealed to Lichtenstein, H. C. Westermann (and later Koons), Pinocchio was a tragic figure for other artists, particularly L.A. artists in the '90s, including Paul McCarthy and Lari Pittman, along with Shaw. The Disney film (re-released in a new digital version in 1992) was full of morality: the puppet who wants to be a real boy is lured to Pleasure Island and cursed with donkey ears as punishment for his

Lari Pittman, *Untitled #1 (A Decorated Chronology of Insistence and Resignation)*, 1992, acrylic and enamel on wood panel.

pleasures. Pinocchio's wish to be real refracts Hollywood's perceived state of falseness, but also expresses the toy boy's feeling of not being a real man, an aspect of the story particularly pointed up in Pittman's *Untitled #1 (A Decorated Chronology of Insistence and Resignation)* (1992), a loose narrative of life and death at the height of the AIDS crisis. Here the failure to be a real man is that of the humiliated child as well as the gay man, both victims of the dominant culture of masculinity. Pinocchio has also appeared in McCarthy's performances and sculptures since the early 1990s, starring in *Pinocchio Pipenose Household Dilemma* (1994) and referred to in the recent monumental inflatable, *Blockhead* (here with the sexual imagery of a nose that grows, as in Pittman's work, made part of an obvious sexual metaphor).

Mark Bradford's multi-media work *Pinocchio is on Fire* (2010) recasts the character as a '70s soul singer, Pinocchio J. P. Washington, with a secret life in which he is less than macho, based on the life story of Teddy Pendergrass. Like Robert Bly, Bradford sees men as either hard or soft, although he understands this as a social imperative. Bly: "Sometimes when I look out at my audiences, perhaps half the young males are what I'd call soft."[77] Bradford: "In a rough community, you're either hard or you're soft and I was soft."[78] A soft man, his story is in part a personal one, of disappointing upwardly mobile, black bourgeois imperatives with his questionable behavior. It also references a generational or historical rift of the past, between the temporarily possible cultural

anti-heroes of the more open 1970s and the renewed enforcement of male ideals in the late '80s and early '90s, amidst fear of HIV. Bradford's art typically rejects the culture's idea that the soft man is a loser, opting for an aggressive presentation of his specific self in works like *Niagara* (2005), a hypnotizing video of a man walking down the city street with effeminate flair. A black man in America has been just slightly more than half a man—three-fifths to be exact, according to the Constitution—and the calculus for a gay man is uncertain.

Winners and Losers

The economic collapse of 1987 changed the context of failure; it no longer stood as the shameful flipside of a society dominated by success, but seemed the inevitable outcome of the impossibility of success. The strain of men's groups that went mainstream was the more conservative one, prompted by a resentment against perceived eclipses of white male prerogatives by women and minorities, and also by the economic crash. As sociologist Judith Newton describes it, by the late 1980s,

> corporate downsizing, a decline in real wages, and the necessity of two incomes to sustain a middle-class life had visibly hit even white male members of the middle class, for whom they undermined the likelihood of living out a traditional manhood based on primary breadwinning and authority as head of household. Changing gender relations at work and in the home, as well as the modest inclusion of men and women of color in middle-class jobs, deeply challenged the old ideal of national manhood based on white middle-class men's self-interest, economic success, and domestic control.[79]

This situation produced the character of the "angry white man" so popular in the media, with their myriad stories about the anxious and angry acting out of white middle-class American men facing

their own obsolescence. (The specter was revived again in 2010 with talk of the "end of men"). Real men sued over affirmative action in law schools and carried weapons and joined militias; fictional men erupted in movies like 1993's *Falling Down*, in which an unemployed defense worker is driving to violate his ex-wife's restraining order to attend his daughter's birthday party. Hopelessly stuck in a traffic jam, immobilized, he loses control and identity, and goes on a violent rampage across Los Angeles.

The white male of this phenomenon was the professional, middle-management figure who was losing the middle-class status that was his postwar birthright. Parallel to this was the "loser" or "slacker" phenomenon of the same moment, featuring the children of the middle class coming to adulthood at a moment of diminished career prospects. Books like *Generation X* and movies like *Slacker* (both 1991) seemed (at least to journalists) to describe a new type of person, overeducated and underemployed, but perhaps, unlike his father, not unhappily. Artists, located in roughly the same social group, caught the attitude, making self-reflexive work that not only took up the subject of failure but applied it in an autobiographical way. Artists, particularly male artists like Sean Landers and Cary Leibowitz, measured themselves against the social image of the artist as an outsized, heroic genius figure, stressing both the pathos of their delusional ambition and their inevitable shortcomings. Leibowitz painted pie charts of his emotions indicating primarily sadness and produced dishes that proclaimed "i am a bad person. i am superficial. i am lazy."[80] Landers's first major work was a series of letters to his student loan officer, *Dear Miss Gonzales* (1990), in which he careened from grandiosity of ambition to a hysterical parody of resolve and gumption: "I SHALL USE MY FIREY PAIN OF FAILURE TO FILL MY SAILS WITH WIND (OF FEAR) AND TALK TO SUCCESS, AN UNCONDITIONAL WINNER." These expressive monologues, combining the text of Conceptual art with the commercial content of Pop and the melodrama of Expressionism, refer to their own grandiosity and insecurity, the worry that they (and perhaps others as well) might think they don't deserve recognition, pairing success and failure in the same person. As a gay man, and a not

conventionally attractive one, Leibowitz (who took the *nom de plume* Candyass) fretted his failures not only as an artist but as a man, worrying about his weight.

In the early '90s a generally depressed economy, and a depressed art economy in particular—a "correction" to Koons's high times—Matthew Barney's low-tech performance seemed perfectly suited. As so often, performance was seen as a return to more modest means, even to an avant-garde model, after a few years of high-production objects selling for big prices. Barney's early video *Transexualis (Decline)* (1991), shown at Stuart Regen Gallery in Los Angeles and then at a group show in New York that year, featured the artist naked and in a climbing harness, moving around a gallery space and coating himself with Vaseline, and was received as part of the new modestly scaled art, and related to artists toying with abjection. In fact, Barney drew a certain amount of critical ire for borrowing the subjects and styles of women and gay artists, enjoying far greater success with them as a conventionally attractive straight man. But over the long run, his work too has clearly been revealed to be about personal success for men and its relation to gender; like Koons, Barney's art changed with the shifting economic situation and the artist's own success.

The five-part *Cremaster* series of films used the physical descent of the testicles in the maturing male via the cremaster muscle as an allegory for social maturation, and the ensuing conflict between the individual and society. The artist protagonist struggles in the chasm between individual and group identity in a large, loose narrative. The sequence echoes his own move from West to East, against the tide of the pioneer, to describe his arrival in and overcoming of the social world, the art world, rather than the wilderness. The last *Cremaster* film produced, number 3 (they were shot out of sequence, like the *Star Wars* series) featured a symbolic generational demolition between old and new cars, representing Richard Serra (featured in the film) and Barney, and climaxed with the latter's triumphant ascent to the top of the Guggenheim Museum. The film, which also featured the Chrysler Building, featured New York as the City of Ambition, with Barney its big success. If the film that ended the series, *Cremaster 5*, showed an

Matthew Barney, *Cremaster* 3, 2002, production still, installation view from Matthew Barney's *Cremaster* 3, Solomon R. Guggenheim Museum, New York.

operatic death for the (now fully descended and male) protagonist, the lesson was eclipsed by Barney's real-world apotheosis.

By the end of the '90s, far from his initial welcome as heralding back-to-basics art, Barney came to symbolize the celebrity and big money impossibility of what was required of a truly successful artist in the new millennium. He joined Koons, along with Damien Hirst, Takashi Murakami and a few others, in a very small group of artists, almost all male, whose work traded for very big prices among very big collectors. While Barney continued to act like a genuine artist, albeit a rather heroic one, the others blatantly took on the roles of CEOs of sprawling corporations, managing other artists (Murakami), speculating in their own work (Hirst), supervising a factory/workshop of employees (Koons).

But in the face of continuing economic instability, the deprofessionalization of the middle class, and the continuing redistribution of income to the upper-class minority, the picture is very different for most artists, like most people. Today, the salesmen of yesteryear are gone, the admen too, the professionals proletarianized—not returned to manual labor, necessarily, but to the service industry, or simply to a state of precarious employment. Since the 1970s, with ups and downs, the middle class in America,

to the extent it was ever more than a myth, has been dismantled by a speculative economy and politicians intent on redistributing the wealth. The small businessman, even as a figure of failure, even as half a man, is gone. And the picture of the artist who, once a failure, turns out to be successful, is fading as well. The artists who do succeed do so on such an enormous scale that it is difficult for even an ambitious young artist to imagine emulating them. Success perhaps seems less an act of genius than a piece of enormous luck, like winning the lottery.

4: The One and the Many

Art in America is like a patent medicine or a vacuum cleaner. It can hope
for no success until ninety million people know what it is.
—Marsden Hartley, 1921[1]

How many artists are there? Millions of artists, and all pretty good.
—Andy Warhol

One of the major themes of modernity— one of its defining
conditions—is mass or urban society in relation to its dialectical
extreme, the unique individual. The nineteenth-century European
contrast of the individual with the crowd survives in post-1945
American art to a certain extent, but with important differences
as well as congruities. Many historians have pointed out that the
individual has historically been perceived as the primary American
actor, while organized, cultivated society was seen as European.
The American concept of the individual has been inflected by the
eighteenth-century figure of the leatherstocking or pioneer, the
independent frontiersman who doesn't critique or lead society so
much as exist independently. This ideal persisted far into the
twentieth century, where we have seen him incarnated as the
business entrepreneur. The contrasting "many" in this American
construct may have been the conformist, perhaps European-
oriented civilized public left behind in already settled and charted
lands. But the true opposing construct, the one with force,
developed with Jacksonian Democracy, opposed to capitalism and
a society of the elite. The focus of this chapter will be the nature
of that "many" in America and the way that it has conditioned
the reception and production of contemporary art, traditionally
the exclusive province of the special person.

The categories of one and many do not correspond to the
categories of "high" and "mass" culture, despite the fact that
immediate postwar intellectual discourse was preoccupied with the
relationship between these two. This preoccupation characterized
postmodernist theorizations as well: high versus low was equally

prevalent as an intellectual theme in the 1980s and the 1940s. Fredric Jameson and Dwight Macdonald seemingly suffered from the same anxiety disorder, the fear that commercial interests threatened to contaminate high culture, and in doing so, represented not the end to a particular cultural form, but to a larger social hope. To a certain extent, this was a misguided transfer of the European avant-garde model. The "one" in the United States is not an aristocrat but a pioneer, a self-made man, as much opposed to the refined high culture producer and consumer as he is to the masses. That latter term too carried a different valence, meaning not the proletariat or workers, but the middle class, the consumption-oriented construct that in postwar America expanded to enfold much of the working class. These people were, by earlier and even postwar European standards, well paid, sometimes owning their own homes; an increasing number of jobs also included some of the trappings of an expanding professionalism. As the relationship between this particular one and many unfolded, all manner of interesting things happened. Foremost among them was the fading of these initial oppositions, and, if anything, the diminishing differences between the artist and his audience as the implications of a non-avant-garde art system became clear. (In contrast, even as Europe has undergone many of the same developments after 1945, the European mass remains the working class, not the U.S. middle class.)

America lacked a history of aristocratic patronage and artistic production, and so "Europe" defined the cultural status sought by a small number of the upper class into the twentieth century. The dominant ideology, however, was that of democracy, and the public projected for contemporary art in America was, from the beginning, supposed to be a mass public. Thus already in 1936 Holger Cahill spoke of "art for the millions," referring to the WPA project he headed. The variety of tastes differentiating a broad public was the fundamental condition here, and the ongoing conflict between the popular or the plural and the avant-garde as different models of discussions of art and politics was rooted in an argument that opposed American to European cultural models.

The rise of the middle class, the presumption of a mass audience, the effects of mass education and the danger of over-production, together with mass consumption, were the subjects of a great deal of anxiety among academics and (ironically) popular or public intellectuals in the 1950s and '60s, such as Macdonald, Harold Rosenberg, Lionel Trilling, and countless others. They worried that high culture would necessarily be dumbed down to appeal to a mass audience. While a great deal of effort has been expended on forecasting the effect of the mass audience on the tradition of high modernism, few have written about the effect of that audience on the artist, who was just supposed to keep his distance as part of a bohemian stance, or suffer the fate of Norman Rockwell, LeRoy Neiman, and, later, Thomas Kinkade—widely admired, financially rewarded, but critically despised. For both audience and artists, in any case, the basic fact is that these new conditions of mass and middle do not lie on one side or the other of an opposition between high and low culture, but underlie both of them.

Art for the Millions

The question of individual taste springs from the nineteenth century, in which the self-cultivation and self-reliance of Thoreau and Emerson was pitted against a more paternalistic branch of elite disseminators of culture like Frederick Law Olmsted and Charles Eliot Norton, in harmony with Matthew Arnold, who tried to impose standards and rules of decorum on a basically pluralist society, particularly the "lawless classes," as Olmsted referred to the working-class people of New York City.[2] (Complicating this dialectic are the facts that Emerson himself, while promoting individual autonomy, saw the "mob" as incapable of it, while even middlebrow hustlers such as P. T. Barnum often framed their entertainments as morality-instilling.) The later version of this conflict between the individual as an authority, sovereign over himself, and a larger therapeutic culture of the expert has been strong in contemporary art since 1945, particularly

in the institutions of art's presentation and understanding. Robert Henri wrote in a letter of 1916, reprinted in *The Art Spirit*: "If anything can be done to bring the public to a greater consciousness . . . of the part each person plays by exercising and developing his own personal taste and judgment [sic] and not depending on outside 'authority', it would be well."[3] This was in tacit contrast with the American inferiority complex about art, the feeling that art was something outside America, that even the sensitive and the wealthy were somehow uncouth, and needed to look to European models for edification and refinement.

The idea that "everyone" in America was potentially both an artist and an art audience member was especially strong in the WPA program. While today murals and employment projects for artists are its best-known aspects (along with the documentary photography in the FSA), it also had a tremendous project of art education or appreciation. Holger Cahill, a champion of American folk art and director of the WPA's Federal Art Project from 1935 to 1943, was a leading proponent of this version of art. In a speech in honor of John Dewey's eightieth birthday in 1936, Cahill extolled Dewey's vision of a plural, educated public, reflected in the new life of art in America:

> Portfolios of American art of the past and present are now being circulated through our museums, libraries and schools. In the past month, three or four large books on American art, handsomely printed and profusely illustrated in color, have been published . . . In the past week probably tens of thousands of classes in the arts and art appreciation have met in these United States . . . We now have a sweeping renaissance of democratic interest in American art which runs through every level of our society, from the richest to the poorest.[4]

Cahill emphasized that this democratic community participation in art was not implicit in modern European society, and that even many American museum directors and artists, still looking to Europe, considered themselves politically liberal but held an elitist, authoritative vision of art.

The WPA aimed to produce both a mass audience and art for it. This aim also, ironically, played a large role in producing what appeared to be its successor, even vanquisher, and ideological opposite: Abstract Expressionism, so full of individuals and great works, so (initially) isolated from society. The major figures of Abstract Expressionism, with the exception of Barnett Newman, had been employed by the WPA, and these artists together (despite their individuality) became the first successful American art movement. Despite their eventual lionization, they began with disdain for an uninterested and uncomprehending public, apparently recreating the European avant-garde. Many art professionals in the late 1940s and '50s still complained that the new American art was resistant to understanding by non-experts, who found symbolic representation and abstraction impenetrable. At a 1948 roundtable on modern art in *Life* magazine convened "to clarify the strange art of today," critics, curators, a university dean, and museum directors were shown paintings such as William Baziotes's *Cyclops* and Theodore Stamos's *Sounds in the Rock*.[5] They criticized the work as difficult, opaque, and above all, too focused on personal symbols and gestures; it is actually rather astonishing today to read the extent to which art professionals objected to an art based on individual sensations and concerns.

The conflict between high art and the American public was at the heart of more theoretical musing as well in the late 1940s and early '50s, as Macdonald, Trilling, and others pondered the fate of high art in a mass society with no cultural elite. The problem inspired Clement Greenberg's 1947 essay, "Present Prospects for American Painting and Sculpture." He could not see the way to creating a genuine high art culture, one he could only imagine (barring socialism, perhaps) following the European model of a small, genuinely sophisticated elite audience with money. The critic was horrified by the false sophistication of the United States, a "general levelling [*sic*] out of culture" represented by middlebrow institutions such as the *New Yorker* that attempted to bring high art to a broad audience.[6] The genuine advanced artist was ignored, unsupported, socially isolated, and impoverished. As Greenberg put it, "What can fifty do against a hundred and forty million?"[7]

Worse, the initial relationship between artists like Pollock, Rothko, and de Kooning and American society was only deceptively like that of the avant-garde in Europe, in that the artists lacked the characteristic small wealthy coterie of investors, supporters, admirers.

By the mid-1950s, however, educational and democratic impulses overtook the elite aims of art in America (even as the New Deal and wartime economies gave way to the full flush of capitalist revival), even for Greenberg himself, who by the mid-1950s saw, approvingly, abstract art becoming a middle-class art (and then, quickly, in a series of essays in the 1960s, being too vigorously embraced by a middlebrow public "breathing down its neck").[8] Before the war, American Scene boosterism of artists like Thomas Hart Benton and others took the form of representational scenes of "real" Americans like farmers and cowboys, often themselves painted in a folksy style. The drive for a unique national art was transformed in postwar America; it was channeled into a new, cosmopolitan image of America's importance in the world, reflected by the greatness of American culture, as in *The New American Painting* exhibition that MoMA sent around Europe in 1958–59. Perhaps less often discussed is the more general condition of American cultural confidence in American, rather than European values, which meant that contemporary culture and art would be anchored by a different concept of what art was and who art was for. The initially puzzling emphasis on individual expression and innovation was quickly, as so many have pointed out, reframed as an achievement and a national image appropriate to a nation of risk-takers and inventors. And at the same time, Cahill's Deweyian belief in the broad audience, the idea that everyone could appreciate art also remained, albeit with less complete parity or mutual exchange between artist and audience. Abstract Expressionist art, as it came to be called, was thus assimilated to American values, despite the fact that artists like Pollock and Newman were ambivalent about the possibility or even desirability of the artist in close relation to society. Even though they disdained the decadence of Europe, they were shaped by the model of the alienated avant-garde artist. On the other hand, the artists and institutions that were generated after World

War II (rather than living through it as adults, their lives "cut in half," as Rosenberg put it) tended to be more entirely rooted in the new social conditions of the mass audience, if often no less conflicted about America.

Some cultural critics of the 1950s, like Macdonald, continued to fret over the philistinism of the mass audience and the absence of a small elite audience to support the artists. Nonetheless, art began to be popularized by mass-market magazines such as *Life* (and later *Time*) and in museums; even if general audiences weren't sufficiently sophisticated in the view of specialized critics, they were increasingly being directed towards fine art. And fine art was increasingly American and contemporary. The mainstay of many museums, the cast collections of reproductions of the masterpieces of Western sculpture, had begun to fall from fashion in the early twentieth century, when originals had assumed a new importance in the growing marketplace, and great art institutions like the Metropolitan sought to replace dutiful study with aesthetic uplift as their mission.[9] A few decades later, the casts had become an out-of-date embarrassment, and were thrown out in favor of room less for authentic archaeological objects or Renaissance masterpieces than for temporary exhibitions.

The postwar increase in art audiences was in part a continuation of the initiatives of the WPA; even as some art centers closed, others became museums proper. This meant that earlier designs for unchanging display conditions emphasizing permanent collections were rethought to accommodate offices, work rooms, and other spaces necessary to temporary exhibitions. Over the decades, bathrooms, restaurants, cloakrooms, and stores were added to accommodate, educate (and later, to entertain) a larger public, as well as increasing accommodations as well for children and public school trips.[10] Some art professionals or insiders complained about art's popularization and the way it blunted and dumbed down art's power. Others, such as D. S. Defenbacher, director of the Walker Art Center and frequent editorialist in its magazine *Everyday Art Quarterly*, begun in 1946, hoped that strategies such as dramatic exhibition design could make even the most difficult art—abstract art—accessible: "Aren't we all aware that, with some of inherited

inhibitions discarded, a definitive exhibition on abstract art, for example, might reach a larger audience?"[11] At the same time, Defenbacher primarily vigorously promoted well-designed objects for daily life, again in a Deweyian vein, as "everyday art" in the quarterly magazine and the Walker. The intersection of these two philosophies—educating the masses and the authority of the individual—produced the cultural expansion often called "middlebrow."

Part of the phenomenon of the mass audience meant not only the distribution of authority to each individual, but the release of the businessman from his bad conscience, and his consequent elevation. The vulgar collector or consumer no longer needed to feel shamed, if not purified or edified, by the critic as the voice of the avant-garde. At least one historian suggests that this transfer of authority came about in mid-century: "Status, one might conclude, belonged not to those refined, dutiful individuals detached from commercial pursuits but to those in business, literate or not, whose 'know-how' showed them to be the masters of modern conditions."[12] And in fact, the first collectors of Abstract Expressionism were not the old money families with a history of collecting and donating to museums, but (following other artists and friends) the moderately or newly moneyed, who were more likely to buy American art rather than the more expensive and, even early after the war, still more prestigious European modernism.[13] Later, Pop art seemed to embody this new attitude, not only in its subject matter—ordinary, familiar, and commercial—but in its immediate appeal to collectors. As Sidney Tillim—the only art critic to immediately appreciate Pop—wrote, the new American collector could forget about Europe and abstraction, and "roll out the American flag"; collectors like the Kraushaars and Sculls could have fun, be themselves. They were overthrowing an establishment—not the ruling class, but the descendants of Norton and others who had held up standards of difficult, improving art.

Here, the idea of art for the masses was joined by its apparent structural opposite, art for the upper classes. These upper classes were not aristocrats but the newly rich who were happy to be vulgar, free of the burden of high-mindedness. The atmosphere

of American success and excess encouraged both upper- and the mass middle-class audiences to validate an American past and contemporary American society, and to embrace the value of self-reliance. In the European system of academic and avant-garde art, the truly important critic was the special one with the insight into the greatness of an artist, like Gauguin or Picasso, whose art seemed outrageous or even merely bad to most, especially the staid upper-class art audience. Greenberg's support for Pollock seemed to follow this model. But by the early 1960s, everyone was his or her own authority, in the purer Emersonian sense, as British critic (and Pop art partisan) Lawrence Alloway argued, citing arts education professor Edmund Burke Feldman's description of the American postwar situation as a "Democratization of taste . . . a shift of authority about manners and morals from the few to the many."[14] If each man was his own authority, the critic was a kind of avant-garde cruise director, a "middle man," in Allan Kaprow's words, whose services were no longer needed, either by the artist (who could run his own PR) or the audience (including both collectors and the general museum audience).

By the early 1970s, this new condition had crystallized into a problem. Lucy Lippard, with characteristic generosity as a critic, wrote in 1974:

> I think that pluralism is the only choice at the moment—lots of different ideas thrown out, and the audience at least being made to think for itself enough so that it has to choose something . . . now is a healthy time to make art because there isn't *one* thing you *have* to do . . . Art should depart from the established monolith—each area could have its own community of artists, critics, and public.[15]

Lippard argued for pluralism as local and community-based, a stance not unlike Cahill's argument for the regional art center, founded on participation and self-governance. She connected the artistic pluralism of the 1970s firmly, if tacitly, to the American tradition of anti-authoritarian art-making, and the concept of America as a collection of communities. Rosalind Krauss, who

emerged around the same time as representative of the opposing view, argued for reinstating the special position of the critic, needed to discipline what was described as a "flood" of art (Robert Morris) or "a million little puddles" (Mel Bochner) into that oddly American amalgam, a mainstream avant-garde movement.[16] In the 1980s, Krauss's followers Benjamin Buchloh and Hal Foster increasingly saw the empowerment of the audience as a market condition, a false openness and diversity that mimicked the un-free free market. Pluralism suddenly seemed difficult to distinguish from the end of the modernist progressive march that Kraussian postmodernism had so fervently sought. Foster spoke of the expansion of both the market and art schools as the condition for pluralism (the "bad" postmodernism), presciently, for these two institutions would come to dominate discussions of contemporary art in the late 1990s. In reality, of course, Foster's affirmative, the academic critic with a firm line and a small canon, is equally the creature of the market and the academy. He rightly noted that there was a "crisis in criticism" in the 1970s; this was the crisis faced by the critic raised on the idea of his or her authority to legitimate. As Foster wrote, "In its wake we have had much advocacy but no theory with any collective consent."[17] The next year, in his preface to his anthology, *The Anti-Aesthetic*, he again insisted—against philosopher Arthur Danto, among others—that "postmodernism is not pluralism."[18]

Interestingly, while earlier critics like Harold Rosenberg had feared a middlebrow "Modern Art" aimed at secretaries, and those of the 1970s and '80s looked with horror at a democratic art world, even pro-market American critics at the turn of the century, notably Dave Hickey, Peter Schjeldahl, and Jerry Saltz, were haunted by the specter of the newly minted wealthy, the young hedge-fund guys filling MoMA dinners (at least until the economic crisis of 2008, which brought a "welcome correction" to the art world, a return to "meaning" and "values" and talk of the avant-garde). These newest *nouveaux riches*, like the collectors of Pop, were freer from the need to follow authority; the American elite, as I pointed out earlier, is not separate from the mass audience in taste. Schjeldahl put his finger on it when he acknowledged, in a brief essay, more plaint

than review, that Christo's 2005 public project in New York City, *The Gates*, just didn't need him. The artist and his collaborator, Jeanne-Claude, filled Central Park with thousands of yards of billowing bright fabric, meant to be enjoyed, not analyzed or related to art history. Schjeldahl saw that the (millions, literally, of) art lovers in the park could parse the difference between saffron and orange on their own.[19] Recent art that makes everyone an expert, like the museums that draw an increasingly broad audience in for a fun experience, doesn't need the critic.

Work by Tom Friedman, Sarah Sze, and Tim Hawkinson— handmade, quotidian, and yet often astonishing in their totality— embodies the art this situation can produce. Friedman in particular emerged in the mid-1990s, and experienced a rapid rise without academic support or the backing of a very powerful gallery. Making sculpture out of everyday materials such as construction paper, modeling clay, and sugar-cubes, taken to astonishing physical extremes, he draws connections between the sense of home, the everyday, and self-determination: "I like [my work] to have a sense of being at home . . . I like the connection to everyday materials, things just sitting around the house. For me, home just means 'being yourself'. You don't have to go outside to know more; you already have everything you need."[20] You don't need to reference art history or other improving, edifying subjects. Friedman linked the widespread interest in popular culture and the everyday to the sense of an independent and sufficient self. His remarks, harking back to Emerson and Thoreau, recast Pollock's often-quoted phrase, "We don't need to go outside ourselves for subjects" as modest rather than self-aggrandizing.

The legitimacy of the ordinary individual that makes up the mass audience was increasingly recognized by museums, which not only continued their immediate prewar reorientation towards education, but added entertainment. Museums have, as many have remarked, become increasingly popular destinations, featuring shops, restaurants, and, most recently, stunning, adventurous architecture—not to mention cocktail parties, jazz nights, and children's workshops. Run like businesses, counting on ticket sales along with corporate and individual support to replace public

funding, and genuinely wanting to make art available to more people, museums have become more and more crowded, thanks also to the return of the upper-middle class from the suburbs to the cities of America, the rise of international tourism, and perhaps even simple population growth.

Today, museum exhibitions draw enormous crowds, even to shows of contemporary art (to which museums increasingly devote money and square footage). People going to museums in the last twenty years will probably not realize how different now is the experience compared with even the recent past. As artist Alfred Leslie put it, remembering the old MoMA,

> My memories of the museum from the period between the 40's and the 50's was that it was like an extension of an artist's studio; it was an intellectual destination . . . And then when you went inside it was like noble isolation, because there was no one there. It was really an empty place; it wasn't crowded.[21]

Increasingly, even historical refuges like the National Gallery of Art and the Metropolitan Museum have begun to show contemporary art. Because museums have moved closer to the commercial entertainment condition that characterizes most of contemporary cultural life, they are also *more* public in that they aim to draw broader audiences, not just the specialist art lover.

Even as the American museum moved away from the community center of the WPA to contemporary art, it has not necessarily meant the full embrace of art as "high," as transcendent, distant, opaque, difficult. It is true that many American art institutions in recent decades have been converted from local art centers—geared towards local artists, crafts, and participatory arts appreciation—into contemporary art museums showing nationally and internationally recognized artists. A story from Wisconsin is typical: in 1980, the Milwaukee Art Center morphed into the architecturally and programmatically sophisticated Milwaukee Art Museum (MAM), as part of the hoped-for transformation of one of the most famously and intractably blue-collar cities into moneyed modernity. A local reporter unhappily related MAM's new image to a similar change

when the "Art Center" in nearby Madison became "MMoCA" (Madison Museum of Contemporary Art), which he saw as an abandonment of "amateur fripperies: basket weaving, pot throwing, Sunday painting and the like. Hence, the new name—and the initials, MMoCA. The Madison Art Center was unique, endearing and, in my view, irreplaceable, whereas MoCA is rapidly becoming a generic term."[22] These amateur fripperies were of course precisely those once encouraged by the WPA community art center, and memorialized in the American Index of Design. This is framed as big city elites telling the locals to drop their baskets and duck watercolors in favor of a more edifying and sophisticated diet. But while these local crafts have sometimes been replaced by high, European, Conceptual art—"curators' art" as one critic recently called it—they have also been replaced by touring exhibitions of expensive consumer goods, setting off a familiar complaint among art professionals that motorcycles, Italian suits, and celebrity portraits are replacing real art in the contemporary *box populi*.

Millions of Objects

Alexis de Tocqueville once described American taste in art and American art production as fundamentally centered on imitation. He tried on the idea that instead of making high-quality things for a few aristocrats (like the European artist), American artists made relatively low quality things—often blatantly, copies—for an audience of many as a way to make money. "Aristocracies produce a few great pictures, democracies a multitude of little ones. The one makes statues of bronze, the other of plaster."[23] Tocqueville slid from the production of mediocre watches to fake diamonds to low-quality, imitative art:

> Something analogous to what I have already pointed out in the useful arts then takes place in the fine arts; the productions of artists are more numerous, but the merit of each production is diminished. No longer able to soar to what is great . . . appearance is more attended to than reality.[24]

Tocqueville eschewed the more familiar modern European characterization of America as the home of humble materials and folk traditions, a rough but sometimes charming production without history or sophistication. Rather, he cast it as the home of *imitation*, as the result both of its absent aristocratic tradition, and the related fact that America was on the cutting edge of capitalism and industry. It's perhaps too easy to cast one's net backwards into Tocqueville's capacious writing and find precedents for contemporary America; nonetheless, he put his finger on plaster, beginning to draw us into thinking about how Americans formed their ideas about what art was—plaster cast museums. While many look to folk traditions for a "usable past" (in Van Wyck Brooks's phrase), it is equally clear that "real art" was formed almost entirely in the image of European art, and in imitations of it, whether through synthesizing or adopting its conventions, or through outright reproduction. America wasn't ready to produce its own art. As one nineteenth-century critic said about the related field of writing, "The special work of America at the present moment . . . is not to create, but to diffuse; not to produce literature, but to distribute the spelling book."[25]

There was no grand Academy at which to study art in eighteenth-century America, although there was a certain amount of sculpture and particularly architecture that, in refurbishing classical styles, tried to give the nation a sense of history and an identity. When Napoleon gathered ancient sculptures together in Paris, it provided the opportunity to create cast collections, which came to New York and Philadelphia at the beginning of the nineteenth century. Museums formed around these collections, and early on had a threefold mission to create (at least the appearance of) a national patrimony, to elevate public taste, and to train new artists, so many museums had a school attached. Copies of or stylistic imitation of vaguely "European" subjects or neo-classical sculpture were also popular objects for the middle class. John Rogers, a popular nineteenth-century artist/entrepreneur manufactured sculptural multiples in New York City (amusingly, in a loft that would later become the site of Warhol's Factory), producing both plaster copies of European masterworks and scenes of "ordinary"

American life that he invented (although that hewed closely to sentimental, neo-classical convention).[26]

Even the celebration of an American achievement was sometimes ironically couched in terms of neo-classical, European origins. For the 1909 Metropolitan Museum of Art exhibition celebrating the 300th anniversary of the discovery of the Hudson River, the catalogue preface quoted William Dunlap, author of a very early (1834) account, *A History of the Rise and Progress of the Arts of Design in the United States*:

> Probably many of the pioneers who led the way, and opened a path for the arts in our country, had little merit as artists, but they are objects of curious inquiry to us in the present day; for as we earnestly desire to know every particular relative to the first settlers who raised the standard of civilization in the wilderness, so the same rational desire is felt, especially by artists, to learn who were their predecessors, who raised and who supported the standard of taste, and decorated the social column with its Corinthian capital.[27]

The dominance of classical and pseudo-classical objects in American museums and private art collections disturbed those promoting an American contemporary art with American historical origins. They bemoaned the fact that even collectors who could afford to buy original art bought the shards of ancient civilizations, rather than the original products of their own. Cahill typically complained that American collectors bought "aesthetic fragments lost from their contexts" by dead Europeans, rather than supporting live Americans.[28] He put down the category of the "masterpiece," so central to art institutions like the Metropolitan, as perhaps not the American purview, and in any case the product of "commercial magnifications," copies and PR that promoted these singled-out objects.

Walker Evans's *American Photographs*, originally published in 1938 (reprinted in 1962), was one of the great appreciations of native American art, found in the vernacular. Less commented on is Evans's sensitivity to the other side of American taste, the veneer

Walker Evans, *Stamped and Crushed Tin Architectural Fragment of Ionic Capital and Acanthus Leaf Motifs*, 1929, film negative.

of civilization based on European styles amidst the homemade signs and plain cabins. Lincoln Kirstein wrote the Foreword to the book, a gently humorous take on America's naïve, but increasingly grandiose imitation and bastardization of European architectural and artistic style:

By 1850 we could afford ourselves the bold appropriation of every past style . . . later we were given the neo-gothic Woolworth Tower and the degradation of the collegiate style at New Haven and Princeton, the neo-colonial at Harvard. Only Evans has completely caught the purest examples of this corrupt homage—innocent and touching in its earlier manifestations . . . His eye is on symbolic fragments of nineteenth century American taste, crumpled, pressed-tin Corinthian capitals, debased baroque ornament, wooden rustication and cracked cast-iron molding, survivals of our early imperialistic expansion . . . Such ornament, logical for its place and its time, indigenous to Syracuse in Sicily, or London

in England, was pure fantasy in Syracuse, New York, or New London, Connecticut.[29]

1945 disrupted all this. Painter Jack Tworkov wrote in his journal about the tendency to copy European art:

The old world, the world of aristocratic dreaming, has been shaken to bits; nothing but memories and pieces lie around like broken columns. It's a nuisance when we speak of culture to speak of the pieces we inherited—however noble the pieces . . . Only our own main drives belong to our culture. Not the man who quotes—but the man who speaks out of himself for himself.[30]

Tworkov, though one of the most accepting and non-dogmatic of the Abstract Expressionists, was very clear about the rejection of European forms. His reference to "broken columns" is fascinating in light of Evans's photographs: do they represent a shattered European civilization, or the American veneration and imitation of it? "The man who quotes." Those very broken columns would come to be the most common signifier of postmodernism in architecture and painting. One could even describe the native American historicism of Kirstein, Evans, et al. as a presentiment of postmodernism in terms of the failure of European civilization, not just of twentieth-century modernism, and an understanding particularly American in seeing that civilization as a false identity for the New World, which could only borrow, or to use a later buzzword, appropriate it.

The condition of imitation was also related to dissemination, to the sheer numbers of the broad audience for art, and the number of objects required to reach them. Cahill saw Dewey's vision as an alternative plan for a future that would not overemphasize individual expression at the expense of a truly social, democratic art. In addition to all the murals and documentary photographs, the Federal Arts Project produced 15,300 lantern slides, 850,000 "reproductions of posters," and a Community Art Center program that served six million people.[31] Cahill, as a government man, was promoting an America First attitude, but his constant citation of

statistics also indicates something particular about the nature of America, as he saw it: the huge push for reproduction, teaching, numbers. Ironically, although he disdained the imitation or reproduction of European art, he saw reproduction as fundamental to American art programming and promotion.

One imagines the banker's wife of Russell Lynes's *The Taste-makers*, in the early 1950s, thrown into a tizzy by her choice between early American or French provincial, or really any decorative scheme she chose. Lynes's anecdote speaks of a generally pluralist situation, but these two choices are particularly telling: we can find them again in Jeff Koons's father's interior decoration shop, with its constantly changing displays and styles, including French provincial. The *House and Garden* advice to the anxious home-owner and would-be collector was to be safe and follow the pre-ratified "real" art, as in this tip from 1953:

> Original works have a special charm because they are one of a kind, however, it is wiser to hang the reproduction of a worthy painting than to display a poorly executed original. Some reproduction processes are so excellent they faithfully duplicate even the lightest brush mark. The best of these you will be able to purchase through art museums and shops.[32]

Ten years later, President John F. Kennedy, while not providing actual decorating tips, similarly endorsed the ideal suburban home as the repository of the finest mass-produced culture: "On the table lie paper-bound reprints of the best books of the ages. By the phonograph is a shelf of recordings of the classics of music. On the wall hang reproductions of the masterpieces of art."[33]

JFK and his wife, of course, believed in the acquisition and digestion of the best of European culture as a matter of American pride. But again, there was also the principle of reproduction, not merely of the "best" high art but of more ordinary images (again, high and low are less opposed than underwritten by the same conditions). Or even the ordinary, sentimental image, not borrowed from Europe, as in Mark Twain's *A Connecticut Yankee*, where the hero in his spare medieval lodgings laments,

It made me homesick to look around over this proud and
gaudy but heartless barrenness and remember that in our
house in East Hartford, all unpretending as it was, you
couldn't go into a room but you would find an insurance
chromo, or at least a three-color God-Bless-Our-Home over
the door; and in the parlor we had nine.

Robert Rauschenberg combined the two in his many combines
and large-scale prints, the Rokeby *Venus* and "calendar art" both
reproduced and reproducible. He connected them not only to the
horizontal surface and what Leo Steinberg called the flatbed
picture plane (to commercial reproduction and work) but also to
the domestic wall, the wallpaper and frames featured in combines
of the early 1960s such as *Johanson's Painting* and *Hymnal*.[34]

George Segal's stark white plaster casts made in the 1960s recall
the apocalyptic, deathly figures of Pompeii (as many reviewers
have pointed out), and also the "dusty old plaster-casts that used
to fill museums and studios," here notably, as in Pompeii, immor-
talizing ordinary people in everyday tasks rather than the great
masterworks of history.[35] (Jasper Johns, a few years earlier, had
included plaster-casts of body parts in *Target with Plaster Casts*,
1955, but despite the connotations of "fragments" of sculpture
parts lying around the studio, according to the artist, their bright
colors broke the association with the plaster cast collections of the
nineteenth century.)

Later artists like Schnabel and Koons had a sense of themselves
as provincial Americans, not just as latecomers to the modernist party,
but as locating sophistication in European historical precedents.
Allan McCollum's *Plaster Surrogates*, dating from around 1982,
seem to point at this directly. Although in the mid-1980s they
were often discussed in a psychoanalytic discourse, their nature
matches Tocqueville's description. Cast in plaster, including frame,
mat, and "picture," these small works (most under sixteen inches
high) were hung in large groups; at Marian Goodman in 1983, he
showed more than 500. While critics frequently termed these
exhibition hangings "salon-style," the artist saw the art works as
the objects proper to the average suburban house, art and also

Allan McCollum, *Surrogates on Location,* snapshot from television screen, 1982–84.

photographs, anything a family might hang on the walls. In his production *Surrogates on Location* of 1982–84, he showed snapshots of television screens broadcasting scenes in which a painting was visible in the background of a domestic interior. He posits the museum as a place of deception and seduction, one that draws us away from our own tastes and things, inveighing us to emulate the official taste of the upper class, as represented in *Perfect Vehicles,* Chinese ginger jars for "the Art & Antiques crowd." Sounding much like Koons, from whom he otherwise seems quite different, McCollum warns about the lure of the elite, pointing, like Kaprow, to the way art is really used in daily social life.

Not surprisingly, many postwar artists, including Vija Celmins, Chuck Close, and Sherrie Levine, have spoken in interviews about the importance of the fact that they first saw art in reproduction, in black and white photographs in magazines. Levine's own work rests on the simple fact that we are used to "seeing every-thing through magazines and books."[36] Like Elaine Sturtevant before her, she has tied her interests to Duchamp, the universally

sophisticated and self-flattering as well as obvious precedent
almost all artists, including Koons, cite. But we might usefully
connect Levine's interest in the reproduction and circulation of art
to this history of American art appreciation, starting notably with
Cahill's countless slides and posters. Levine's early work clearly
places her in relation to an American history, with silhouettes of
American presidents first painted and then cut out to frame ideal-
ized media images of women. The later, better-known work also
reflects a certain Americanism; Levine's *After Edward Weston* is a
photograph of Weston's photo of the torso of his son Neil, printed
in high contrast black and white that renders the boy much like
(a Roman copy of) an ancient Greek statue. If Rosalind Krauss
smartly linked Levine's work to the insight that modernism holds
not just originals but copies, she missed the social context of the
cast and of the reproduction in Levine's own history as well as in
American history. The cast museum had a particular role: as a
reproduction, but also as the means of disseminating "real" culture
in America, as the producers and keepers of American society tried
to integrate into the great Western tradition. When Levine made
Duchamp's *Fountain* in 1991, she converted its everyday material
(ceramic) into bronze, reversing the usual trajectory of high to low,
European-to-American interpretation. Levine might have been,
hopelessly, perhaps, in her own mind, "after"—not only as a woman,
but as an American, not just copying the masterpieces, simply later.
As critic Valentin Tatransky wrote of her early in her career, "Very few
Americans appreciate the aesthetic of her culture. Levine does."[37]

McCollum is worth attending to on how high culture penetrates
individual psyches, and makes us, in effect, copy it:

> Do you know about the Nelson Rockefeller Collection Gallery
> up on 57th Street? Where you can buy hand-made copies of
> art-objects in the Nelson Rockefeller collection? We think this
> is really funny, of course, because we think we are above all
> that—but isn't this just a gallery which is just a little more
> honest than usual? To see this gallery as an aberration only
> normalizes those other institutions—like the Museum of
> Modern Art, for instance—which work to accomplish very

Sherrie Levine, *Untitled (President: 5)*, 1979, collage on paper.

similar ends, really. The museum's board of acquisitions collects artworks from a certain very narrow spectrum of art activity (most of which might never even have been created if it weren't for the possibility of such an institution collecting it), and is therefore very handily involved in what comes to be considered "art" in our culture. In this way, a really influential institution affects the very subjectivity we experience as our own. Our so-called "unconscious" is conventionalized, and artists reproduce museum-type art all over the country, if not all over the world. We produce our own hand-made copies.[38]

On the surface, this is a strong complaint about the negative internalization of dominant culture. But we could also see in that last phrase—"our own hand-made copies"—a certain *deviance* from that past that we also see in Koons, the deformed and handmade aspect of even the insecure emulation art appreciation forces upon us.

Alongside the reproduction and the subject of art appreciation was strangely its seeming opposite, the humble, homemade American object, perhaps lacking in sophistication, but compensating with authenticity. As part of the WPA, Cahill also headed a project intended to record native traditions of object making:

The Index of American Design represents an endeavor to recover a usable past in the decorative, folk, and popular arts of our country. This record of the arts of our people is an accompaniment to the widespread movement that has been going forward in literature and in music to awaken a realistic and vivid appreciation of the American past. The Index is rediscovering a rich native design heritage which we had all but forgotten in our frantic and fashionable search for the aesthetic fragments of European and Asiatic civilizations . . . The enthusiasm and surprise which has greeted exhibitions of Index material throughout the country reveals that our people have a deep affection for these arts of the common man. They seem to recognize that these arts fit very closely into the context of our democratic life, as, for instance, the thought of Thomas Jefferson fits into the context of our democratic ideals.[39]

The Index variously illustrated Shaker baskets, Southwestern retablos, a Pennsylvanian hooked rug, cigar store Indians, and a thousand other things made by "unknown and humble artisans." It was a collection that contained the DIY impulse, the valuation of the unique object, and the ideal of self-reliance, in a blurring of making and consuming. While these objects were singular in each being handmade, not mass produced, and not even held to a single standard of manufacture or design, together they presented art as an enormously multiple and plural category because of the sheer number of things included within it.

An appreciation for everyday useful things (as opposed to academic art or even the aesthetics of stylized design) would leak into contemporary art as well. Allan Kaprow proposed that the new collector, a rather ordinary person, drew art close to himself, to his real life, rather than seeking to transcend the everyday and the commercial through art:

> At one time, modern art, on its way from the gallery to the museum, stopped off at a collector home, and there it looked out of place because it was *lived* with. Now it is the reverse. "Kitchen-Sink" art, "Pop," "Common-Object" art, "Assemblage," "Junk-Culture," "Rearrangeables," "Multiples," and "Environments," united in their appeal to, and often literal involvement in, the themes and space of daily existence, appear absurd and out-of-kilter in museums where they *cannot* be lived with.[40]

The home, primary among the spaces of everyday life, was a dominant feature of this art of the early 1960s. Kaprow was connecting disparately grouped art and artists, including his own Happenings, the assemblage sculpture of someone like Mark di Suvero, and a Pop artist like Tom Wesselmann who depicted middle-class interiors mixing mass-produced food and design with reproductions of European modern art. (Judd, too, in a 1964 review commented on the fact that so much art at that moment resembled household objects, and in particular, was "simultaneously modern and early American. This is a prevalent taste."[41])

This is in particular contrast to the modernist disdain for the domestic, and could be seen as well not only in MoMA's promotion of the modern home in its *Good Design* exhibitions, begun in 1950, but "the growing wave of exhibitions and educational activities in the Everyday Arts—the design of everyday things—throughout the country."[42] *Everyday Art Quarterly*, the periodical issued by the Walker Art Center in Minnesota, which started an "Everyday Art Gallery" in 1944, often focused on the home (for example, a special issue on "Knife/Fork/Spoon" in 1951). The home was the opposite of the museum, or at least the older incarnation of the museum as a temple of higher sentiments, which was obsolete, ultimately because of this new art, born of a different social and patronage system. As Kaprow wrote, "Middle-class money, both public and private, should be spent on middle-class art, not on fantasies of good taste and noble sentiment . . . Phony class is always repulsive; but even the sweet dream of yesteryear is getting harder to evoke as time separates us from our origins overseas."[43]

Museums, of course, in no way became obsolete, but Kaprow was prescient in seeing the connection of professionalism, class, and postwar art, as well as domesticity, and almost alone in speaking about the middle class in relation to art, at least in any way that was not disparaging or nostalgic for the avant-garde dichotomy of high/low. While Kaprow has been cast as a champion of the avant-garde, a father of performance art, and an early evader of the gallery system, he was no advocate of the bohemian playing poor, of art that pretended to be outside the social system or aristocratic and on top of it. Instead, he quite unusually was serious about the idea that America after World War II was a middle-class society, and believed that this radical social fact shaped contemporary art and its institutions.

In the early 1970s, domestic imagery figured centrally to the feminist critique but also the feminist recuperation of women's sphere and work. The most monumental example is *Womanhouse*, a series of installations and performances within and responding to the domestic architecture of a condemned Los Angeles house, made by Faith Wilding, Miriam Schapiro, and the other artists who participated in the 1972 California feminist collective. While

Harmony Hammond, *Floorpiece V*, 1973, fabric and acrylic.

much of this work focused on the separation, the impossible gulf
between the fine art world and the domestic sphere, some femi-
nists sought their commonality. A feminist artist of that generation
in New York, Harmony Hammond worked in the realm between
painting and sculpture, often treating canvas like fabric and
working with it unstretched. While much of her work is abstract,
Hammond's circular *Floorpieces*, installed on the floor, look like
braided and coiled rag rugs, an early American vernacular form
like quilts. By meticulously executing her large paintings/sculptures
in cloth (usually rags collected from friends) and acrylic paint,
Hammond prodded the difference between differently valued
forms of colored cloth, a question raised as well by the painters
associated with Pattern and Decoration art in the 1970s. While that
question was feminist, it was also framed as part of an American
tradition of homemade craftwork.[44] Around the same time, painter
Al Loving moved away from an earlier hard-edge geometric
practice to make collaged paintings using unstretched canvas: "I
felt stuck inside that box. I mean, this was 1968—the Democratic
Convention, this was war—and I'm doing these pictures. The

contradiction between my life at that time and these pictures!"[45] Remembering his grandmother's quilts at a quilt exhibition, he began to hand-dye fabric and sew it together in layers to form irregular, freeform compositions, hanging the finished works from both walls and ceiling.

The designed domestic object had obvious connections to traditional American objects in these craft-oriented works of the 1960s and '70s. It also played a major role in the "New Sculpture," as it was sometimes called, the first major collective development in American sculpture since Minimalism, made by artists who began to show in New York in the 1980s. Robert Gober, Jeff Koons, and Haim Steinbach were often grouped together in exhibitions and critical round-ups.[46] While today they are apparently very different artists, they all turned away from the abstract sculpture that had dominated critical attention since Minimalism, in favor of making or appropriating ordinary goods, sometimes in multiple editions. Koons, Steinbach, and also the now less-known Ronny Cohen showed assemblages made from appliances in the early 1980s—their toasters and lighting fixtures probably owed something to the suburban surrealism of the East Village scene (discussed in Chapter 3), and a campy retro futurism. Steinbach, who had been raised in a tasteful, blond-wood mass-modernist home, in particular focused on garish kitsch, lava lamps, and souvenir mugs; his signature presentation of the objects on a shelf also seemed semi-domestic, disturbing the pedestal/vitrine display of traditional museums, and the tastefully stark no-pedestals of newer sculpture.

Koons's 1986 *Statuary* series included copies of European works, less recognizable masterworks than the kind of subject that would inevitably signal fanciness such as the Pietà, along with figurines typical of an American gift shop. In his next series, *Banality*, a kind of John Rogers sentimentality took over. This work is almost an illustration of the words of a critic who had encouraged the new American attitude at its most extreme, democratic, and all-embracing, right after the war, in a review of two design exhibitions: "The first [major accomplishment of the exhibitions] is the encouragement of an attitude—an attitude which allows the heroic sculptor to acclaim a figurine."[47] Koons's anti-bronze, his

Jeff Koons, *Ushering in Banality*, installation, Galerie Max Hetzler, Berlin, 1988.

more contemporary material, was not plaster but stainless steel, which is cheap like plaster, but announces its ambition to live forever. His work, in small and not unlimited editions, is fantastically expensive; he offers everyday taste for the very wealthy, whom he reassures are perfect just the way they are. This monumentalization of ordinary taste explains, in part, his enormous popularity: the works are an extremely high-class equivalent of the gazing balls that decorate suburban American lawns (Koons collects images of these balls in situ).

Gober began making dollhouses in the mid-1970s, originally to make a living, selling the houses in an Americana store. At some point, they became his art. They are plain, American structures from about 1900, with striped wallpaper and pebble chimneys and wooden porches—"domestic nondescript," as he puts it. Domesticity has continued to be a theme throughout his considerable œuvre, embedded in beds, sinks, and other seemingly innocuous iterations, it stands partly as the scene of the psychic traumas of childhood. The homely also has a positive valuation in his work; Gober's father, a factory worker, built his childhood home, teaching

Jessica Stockholder, *Skin Toned Garden Mapping*, October 1991, installation, The Renaissance Society, Chicago.

himself the necessary elements of planning and construction, and there is a plainness to Gober's aesthetic that connects not only to Minimalism but the utilitarian character of American design. His installations can transform a museum, as in a room he curated within the 1988 exhibition, *Utopia Post-Utopia*, in which he built an ordinary wooden doorframe around the entrance to a museum gallery, and leaned the door itself against the far wall.[48] More recently, he has placed drains in the floor of museum installations, as well as "windows" that open onto peeks at painted sky, pushing us out of the museum into something more home-like.

To take an artist at first sight strikingly different from Gober, Jessica Stockholder gained early recognition in the 1980s for massive installations making vivid, painterly use of a combination of mass-produced domestic and industrial goods, from plastic buckets to car doors, along with paint. The use of wall-to-wall carpet and hanging lights in these formal explosions, while never narrative, sometimes evoked a kind of frenetic, keyed-up domesticity. Alongside this site-specific work, she developed a

smaller-scale practice of sculptural assemblages. Over the years, the two have drawn closer together, as she has installed the smaller works in arrangements that evoked endtables and seating arrangements, complete with seating that welcomed the viewer and encouraged her to feel comfortable in the normally stark gallery space, to relax and take in the art, rather than to pay laser-beamed attention. These artists continued the trend that Kaprow first observed, one of making art that, even if intended for galleries and museums, made those places feel like home.

Millions of Artists

Considering professionals and amateurs together, the art world is naturally pluralist, comprised of many people with no central authority (although at different historical moments people have proposed that critics, curators, or collectors constituted that authority). This is a most American image: William James's influential *A Pluralistic Universe* (1909) and, especially, his *Varieties of Religious Experience* of 1902 inspired students such as Horace Kallen and W.E.B. Du Bois to champion the identities of immigrants (particularly Jews) and African-Americans as quintessentially American.[49] In 1915, Kallen used the term "cultural pluralism" to summarize his point of view, in an essay called "Democracy Versus the Melting Pot," which contested the belief that becoming American meant giving up one's original identity to participate in a homogenous whole.[50] The essay employed the metaphor of the symphony orchestra:

> As in an orchestra every type of instrument has its specific timbre and tonality, founded in its substance and form; as every type has its appropriate theme and melody in the whole symphony, so in society, each ethnic group may be the natural instrument, its temper and culture may be its theme and melody and the harmony and dissonance and discords of them all may make the symphony of civilization.[51]

American identity as so orchestrated was specially and specifically multiple. But this vision has also been shadowed by another concept of America as a unified democracy that tacitly excluded many people actually living in the United States, as in Cahill's phrase, "as inherently American as a New England 'town meeting.'" In the 1990s, this disapproval of cultural pluralism reappeared as a critique of "identity politics" as understood both by the new right (who bemoaned the waning of white dominance) and the old left (who saw it as a threat to the politics of class).

Pluralism in art underlined the decline of the special place of the critic, as already discussed. What about that of the artist in postwar America? When Picasso died in 1973, Robert Motherwell declared him "the last artist in this century . . . who will have been a real king during his lifetime. Now it will become a republic."[52] It's impossible to know precisely what Motherwell was thinking about; perhaps he was lamenting what he saw as the minor, scattershot production of artists in the 1970s, full of doubt about quality, originality, the market, and the role of the artist as an adjunct to consumerism, in a tacit contrast between the possibilities for contemporary art in America with what they once were in Europe. In any case, Motherwell offered an updated version of Tocqueville's assertion that aristocracies produce a few great art works, while democracies produce many small ones—presumably small artists as well as art. Self-repetition, anonymity, role-playing, constant style-shifting, and collectivity are among the artistic strategies for dealing with the same basic situation, the sheer number of artists and the threat that situation poses to the idea of the artist as a special person.

From the 1970s on, pluralism has been driven in part by the explosion of art schools, and the earlier-mentioned "flood" of practitioners and styles. The numbers also included another category of art: the amateur, in a particularly American incarnation. Russell Lynes wrote in the early 1950s:

Since the beginning of the war there has been a rapidly grow-ing number of amateur painters. The gas shortage that kept people at home then may well have had something to do with

this growth as it did with the prosperity that magazine and book publishers enjoyed at the same time. The shorter work week and consequent great increase in leisure time have also contributed to it. Arthur Brown, the proprietor of the biggest art supply company in New York, says that "The WPA art project should have full credit. Murals in post offices, exhibits—they jumped art appreciation no end." To meet and keep ahead of the more than 300,000 amateur painters that the *ArtNews* now estimates spend their spare time at easels and work with their hands sticky with clay, the art suppliers have come up with some remarkable gadgets.[53]

The mass culture consumer is also often a producer in America. As Dwight Eisenhower (or his ghost writer) wrote for a volume celebrating the proposed national center for the performing arts in Washington, DC, "many thousands of Americans are Sunday painters. Many more thousands are avid musicians, sculptors, actors, and craftsmen." It was not just the occasional aristocratic woman who dabbled in flower painting, but *everyone* was an artist, starting with Eisenhower himself. President Kennedy asserted in his paean to American creativity of the early 1960s that almost

Rodney Graham, *The Gifted Amateur, Nov 10th, 1962*, 2007, three painted aluminum light boxes with transmounted chromogenic transparencies.

every fourth American played a musical instrument, excluding tiny babies and the superannuated.

Producing a homemade version of professional art culture by the 1960s, with a new form of the super-autonomy of abstraction, even a homemade modernism, the amateur artist him- or herself is a deeply conventional, "middle class" figure. Here is Rodney Graham on his recent ironic take on that figure, *The Gifted Amateur*:

> He's a fictional character: a professional in the midst of a midlife crisis who has just discovered art. He saw a 1962 Morris Louis exhibition at the Andre Emmerich Gallery and decided, "I'm going to give this a shot. Any idiot could do it." . . . I'm not the craziest Morris Louis fan, but I'm interested in how he used a suburban home as a studio. He painted in a little dining alcove off the living room . . . The guy has a kind of Playboy Mansion bachelor pad . . . There's no trace in the decor of any prior interest in art. The interest is a sudden explosion; there are art books piled up all over the place.[54]

Unlike the Outsider artist, or the untrained Art Brut practitioner favored in Europe, the American amateur is, as in the WPA art appreciation courses, intimately and ironically tied to the copy—the paint-by-numbers satirized by Warhol. His occasional originality is born accidentally and oddly, almost from misunderstanding rather than invention. The desperately odd portraits and landscapes that Jim Shaw collects for his *Thrift Store* paintings are not intended to be unconventional. In the current decade, a broad swath of younger contemporary artists like Aaron Curry conjure a kind of crackpot modernism. Rather than recreating tree paintings they saw made on television, they make paintings and sculptures that look modernist, but seem to have been made by someone who doesn't follow or even know the aesthetic rules of his own proper historical moment. These things feel familiar, like half-learned lessons, supplemented by another half dose of "homemade esthetics," to use a late Greenbergian term (the title for his 1971 Bennington College lectures, collected and published in 1999).

Aaron Curry, *Shack #15*, 2006, painted wood, rope, and resin.

Cahill's Index sought to catalog and celebrate objects designed and made by American craftspeople; he, like many in the 1930s, also valued objects handmade by untrained individuals (discussed in Chapter 5). In a European context, folk or outsider art appealed to the sophisticated connoisseur weary of civilized products. In the U.S., the appreciation of the homemade was differently nuanced in representing the specific legitimacy of American art, which was in some ways fundamentally amateur. Cahill described art education very much in the experiential, Deweyian vein: "The core of the community art center idea is active participation, doing and sharing, and not merely passive seeing . . . The WPA Community Art Centers emphasize learning through doing." His vision was one not of large numbers of people just appreciating but making art—a nation of citizens whose identity as fans, consumers, or amateurs blurred.

H. C. Westermann, *30 Dust Pans*, 1972, various woods and sheet metal.

What we today call DIY is astonishingly ubiquitous in at least some sectors of middle-class America, especially considering that contemporary society is driven by mechanization and mass production. What might be considered to be a minor, reactionary impulse pervades the culture. It shows clearly in some art of the 1960s and '70s. In H. C. Westermann's *30 Dust Pans* (1972) the artist displays a group of metal-and-wood dustpans—perhaps a reference to his constant cleaning up in the shop—in a rack inscribed: "I made each one of these by hand and by that I mean I did not sub-contract them to a factory or pay some guy to make

them for me." Or, as he wrote on the bottom of *Lily Bolero* (1967),
"I made this piece as i make all my pieces. I'm not so precious
i don't have time to do my own work." At a moment when the
domination of the larger culture by mass-production led many
artists to shop out their work, Westermann championed old-
fashioned skill and self-reliance. In technique, his objects are not
so different from the products of the basement woodworker, the
suburban hobbyist in his "shop" (and Westermann's art does seem
intrinsically masculine). And the subject he chose—dustpans—
was by nature useful, deliberately humble or lowly, rather than
artistic. He fits into a tradition in American art that links the self-
taught sign painters of the eighteenth and nineteenth centuries to
sophisticated contemporary artists who refer to folk or regional
traditions such as Kerry James Marshall and the Memphis,
Tennessee sculptor Greely Myatt.

The DIY impulse often centers around imagery of the domestic
and the feminine, terms historically opposed to mass production
and also to modernism, as in the remarks of Kaprow and Tom
Friedman quoted previously. The mid-1990s saw the explosion of
a gluegun mania of crafting, which reached its highest level in the
meticulous work of artists like Sze and Friedman, and in the more
precarious and culturally referential assemblages of Rachel Harrison
(work with an under-recognized relationship to Stockholder's).
The guy or lady in the basement their work evokes is not Henry
Darger, not the truly crazy Outsider artist, but the hobbyist, the
Sunday painter that Eisenhower praised. In an interview with Rob
Pruitt, artist Jonathan Horowitz mused, "Sometimes I wonder if
that whole craft, DIY thing is maybe a desperate way for people to
get back in touch with the world nowadays, to get involved again
by putting your hands on it . . . "[55] In a world dominated by push
buttons and spectacular images, where manual labor has been sent
overseas, and fewer and fewer people cook or build things, the
readers of Martha Stewart's magazine at least imagine themselves
doing domestic crafts. DIY has slightly different implications in
the realm of fashion, where the clothing line Imitation of Christ,
which recut and restyled old clothes in the 1990s, was followed by
many imitators, and where small boutiques perform the service of

Sarah Sze, *Seamless,* 1999, mixed media, installation, "The Carnegie International, 1999–2000," Carnegie Museum of Art, Pittsburgh.

personalising jeans and t-shirts (the most mass-produced of clothing items) with rips and embroidery. Such clothes indicate individuality by being quirky and offbeat, rather than avant-garde in the strict sense of forward-looking; the amateur designer doesn't create something radically different, but instead remakes the status quo. The art of craft is truly the art of the middle class, of Michael's crafting megastores and Home Depot. It is interesting along these lines to note that the bohemias of yesterday's East Village and today's Williamsburg, Brooklyn, both based on suburban middle classes of different eras, share a predilection for vintage clothing and outmoded crafts, thanks to nostalgia for the 1950s and the 1850s, respectively.

The blurring of the copy and the authentic American object are still with us. Cahill effaced the difference between making and consuming culture, citing Whitman's vision of a close relation between artist and audience. While the related terms of amateur and professional are often opposed, perhaps the more important underlying fact is that *both* categories exploded in numbers after World War II. Along with art schools, MoCAs, and jargon-laden art criticism, there has been enormous growth in popular museum exhibitions and accommodations and education. The basic amateur culture and history of America that Cahill sought to expand upon is also matched by the expansion of professionalism and the American vision of art as a job to be tackled. The number of academically trained artists has been growing exponentially; first with the GI Bill, and then with the increasing professionalization of the artist in the 1960s. Just as the 1970s, '80s, and late '90s saw a vast expansion of the art market, just as every city got its own MoCA, artist graduate school training exploded to over 200 MFA programs.

And the professionals experience a relationship with a range of production that earlier fell clearly outside the realm of art. Take Allan McCollum's description of Allen Ruppersberg's collecting, which is fundamental to his work as an artist:

> After knowing something about Ruppersberg's work, one might not be surprised to discover that in his personal life he always has been a determined collector of printed memorabilia.

By his telling, he owns around 20,000 postcards, 2,000 educational films, every issue of *Life* magazine from 1938 into the 1950s, thousands of slide collections, and hundreds upon hundreds of books, film strips, posters, calendars, comics, and so on. Many times he has used items from his collection in his own work; and many other times he has used his familiarity with these forms to produce printed items of his own. For Ruppersberg, out of this kind of reciprocal discourse between the makers and the consumers of culture, a model of the world can emerge.[56]

In his own art work of the 1960s, Ruppersberg (who would later copy, longhand, the entire text of Thoreau's *Walden*), insisted on an American everyday representation and production, even as his peers delved into primitivism (Earth art) or arcane intellectual exercises (Conceptual art). The important early project *Al's Café, 1969*—a social meeting place and public art installation in Los Angeles—was decorated with calendars, pinups, and celebrity posters and photographs, as well as checkered tablecloths, and served his plain but often inedible cooking (which included rocks, pine needles, and photographs along with cookies and marsh-mallows). A more recent work, *The New Five-Foot Shelf*, from 2001, reworks Harvard President Charles Eliot's *Five Foot Shelf* of 1910, which promised to deliver the equivalent of a Harvard education in the form of required reading. The artist's version is personal and idiosyncratic rather than encyclopedic, a rejection of the improving authority of Eliot (although Ruppersberg reproduces the exterior of Eliot's 50 volumes and reprints Eliot's introduction in the first volume of his own work, before moving on to his own interwoven narratives). Ruppersberg is the best version of an American culture that, as Cahill pointed out much earlier, blurred the line between maker and consumer, professional and amateur, and even combined the seeming antithesis of reproduction and DIY hand-making. This kind of amateur collector (a category that would include Richard Prince as well as Ruppersberg) makes, on his own, something much like Cahill's Index of American Design, though focusing on mass-produced rather than handmade objects.

Allen Ruppersberg, *The New Five-Foot Shelf,* 2001, web project for Dia Art Foundation.

Recognizing the existence and contribution of these image-makers (the anonymous professionals of Chapter 3) has become more commonplace in recent years.

Much of, if not most, contemporary art production—even the most apparently abstract or autonomous, like that of Stockholder and Fred Tomaselli—depends on the labor of, and the objects made by, others. Tomaselli's collage paintings, made by embedding cut-out photomechanical images in paint and lacquer (itself a craft technique) have long drawn on botanical illustration and pharmaceutical bits; paintings like the exquisite *Flowers and Fungi* use the creations of botanical illustrators, naturalists, and fashion photographers. The artist calls these people, with respect to their place in his work, "mini-authors." The importance of their role, and the collaborative aspect of his own practice, has become clearer still in recent work that depicts large human figures made up of many smaller lips, eyes, noses, hands, etc. The allusion to many people making up a larger body politic creates a kind of pluralism that he sees as chaotic and charged: "I like to keep a lot

of information in the work, ideologies, ways of thinking. That kind of maximalism can be called psychedelic."⁵⁷ The different eyes with their different perspectives, the different mouths with their different expressions, represent pluralism's chorus, the deafening density of the world. The clash of ideologies that cannot be reconciled into a single, consensual reality is mind-expanding, creating a multi-dimensional, prismatic reality.

Many deliberately, formally collective or collaborative art practices like that of the Bernadette Corporation and the Bruce High Quality Foundation, fashionable at the turn of the twenty-first century, contrast sharply with earlier collective endeavors such as *Womanhouse* or entities like the Critical Art Ensemble; instead of challenging the commercial culture of the art world, their group synergy and multiple endeavors acknowledge the commercial structures of the larger world. But while artists trying consciously not only to comment on but to succeed in commercial cultures look to corporate identity, unofficial group endeavors remain much more common and prosaic in nature. Long after Nicolas Bourriaud has moved on to greener pastures and newer neologisms, his relational aesthetics has found its greatest popularity among young artists and not-so-young but also not successful artists (struggling perhaps, or perhaps not, to "emerge"). Here, the party, the apartment living performance, the temporarily abandoned building, the sports activity with fanciful rules, the fort-building project that is actually an art installation continue to thrive, as do collectivism and art works that reference one's social connections to other artists. While it's easy to relate these phenomena to new habits of connectivity, social networking and the Internet, this social art also expresses a survival instinct amidst work conditions that foster isolation.

The concept of a crowd of amateurs, as opposed to individual authors and experts, underlies a number of recent popular intellectual tracts: Howard Rheingold's *Smart Mobs* (2002), about networking, connectivity, and socializing via the Internet, James Surowiecki's *The Wisdom of Crowds* (2004), and Clay Shirky's *Here Comes Everybody* (2008). All of these authors, regardless of their political orientation, emphasize direct action, a decentralized social

model of collectivity, and a distrust of authority. How does this globalized version of "everyone" affect art? In participatory art at its most extreme, an Internet group can make art or informational documents by clicking on their thousand mice, each individual surfer correcting and adding to the marks and decisions already made by others (a concept closely related to open-source or cooperative software projects). This kind of art has made surprisingly little headway or impact on the mainstream art market. The Internet has had a bigger impact on commercial art, where crowd sourcing and digital cameras are already forcing out commercial artists; photographers are having a difficult time selling stock images through agencies, since so many perfectly decent ones are available free on the web, or can be taken on the spot by a non-professional photographer.

But the specter of Internet art does raise new questions about how the growing number of artists, and the way the system of gate-keeping and ratification responds to that growth, will change art. Will it have the same impact it has had on popular music? Probably not, since art is still in many ways a rarefied luxury good rather than a mass-produced and distributed one like music. But conditions are changing. Some artists, like Ryan Trecartin, have moved from on-line venues into brick and mortar galleries. The phenomenal popularity of Outsider or non-professional artists like graffiti artist Banksy outshines that of the majority of "real," art world-sanctioned artists, who are increasingly just a slice of an art world that has fewer and fewer centralized authorities. But even more, the amateurism of the Internet strengthens the blurring of making and consuming, of artist and appreciator, that Cahill and Ruppersberg pointed to.

While we put a primarily positive spin on collaboration, placing its origins in politically progressive precedents around the world, or even simple modesty, there is a less flattering genealogical source. Foregrounding the issue of scale as a social force makes it clear that science, and particularly military science, is the dominant model for collaboration in the contemporary world:

Many of the qualities associated with postindustrial society and its subsequent analytical incarnations in fact appeared earlier, in the military-industrial-academic research collaborations of World War II and the cold war. As historians of science have demonstrated, the government-sponsored research projects first created to help win World War II also saw the deployment of systematic knowledge across disciplines on an enormous scale. Tinkers did not design radar technologies or atomic weaponry; these technologies grew out of the gathering of interdisciplinary teams of scientists, engineers, and administrators . . . they worked collaboratively, within a relatively flat social structure.[58]

This analysis of the structure of social knowledge production necessary to make the Bomb sounds very much like a commonplace description of its social effect, like this account in *Time* magazine of 1945:

What the world would remember best of 1945 was the deadly mushroom clouds over Hiroshima and Nagasaki. Here were the force, the threat, the promise of the future. In their giant shadows, 45,000 feet tall, all men were pygmies . . . all men, even Presidents, even Men of the Year, mere foam flecks on the tide.[59]

Both the collective making of the thing and its collective apprehension diminish the individual.

Today, everyone from neo-Marxist theoreticians like Michael Hardt and Antonio Negri to free-market enthusiasts like Surowiecki insists that social decisions should be made by ordinary people, but only collectively: "we are more intelligent together than any one of us is alone."[60] Contemporary art for, about, and by large groups of people, made in large numbers, responds to a world in which the sheer number of people, even in the first world, and the size of the tasks they favor, diminish the scale of each individual, and in which the line between those who take the stage and those who watch them grows fainter by the day.

5: First and Last

We are the last "first" people.
—Charles Olson[1]

Virginity and primitivity are the same value to you guys.
—Jimmie Durham, 1991[2]

In 1947, Isamu Noguchi proposed a monumental public sculpture, a huge human head drawn in the land to be seen from outer space, inspired by Indian mounds. Originally called *Memorial to Man*, the work was inspired by the use of the atomic bomb in 1945, and the threat it represented: the end of the human race, at least on Earth. Noguchi traveled around the world after World War II (when he voluntarily interred in a camp for Japanese-Americans for seven months), visiting Stonehenge and other ancient large-scale works, seeing himself as an Earth artist. His final title for the work (which was never built) was *Sculpture To Be Seen from Mars*. (He made work about the moon and space travel throughout his career as an artist, both before and after humans actually achieved flight into outer space.) Noguchi was in sync with postwar science fiction that ventured space travel not only as exciting exploration, an extension of the American frontier, but as a horrible inevitability when small bands would have to flee a doomed planet.[3]

When he went to Hiroshima in 1951, hoping to participate in the design of the Peace Park there, he found a still-devastated city. Taking part in a discussion about plans for Hiroshima, Noguchi proclaimed it "the most modern city in the world," as the leveling and erasure of the old provided the opportunity to create an entirely new, forward-looking one.[4]

Isamu Noguchi, *Sculpture to be Seen from Mars*, 1947, model in sand (destroyed).

Cavemen (and women) and Indians

Noguchi was certainly not alone in connecting an imagery drawn from the distant past with a sense that a once far-off future was quickly arriving, and might return us in some way to the beginning. In their reaction to the horrors of World War II, many artists of the 1940s, particularly Pollock, Gottlieb, Newman, and Gorky, studied, collected, and emulated the emotional qualities of what they saw as the art of "primitive" cultures. Newman curated exhibitions of Pre-Columbian and Northwest Coast objects, and wrote that, at the most general level, the "first man was an artist," making a broad analogy between contemporary artists and the imaginary caveman evoked in a 1947 essay.[5] Guston too said, "I imagine wanting to paint as a cave man would, when nothing has existed before."[6] Pollock and Gottlieb both put their handprints into paintings, evoking the directness and imagery of cave paintings; they studied images of Lascaux, collected Indian art, haunted the Museum of Natural History in New York. They felt a connection to the primitive man who had no history and whom they imagined accessing powerful feelings and expressions without the dulling veneer of the sophistication, refinement, and even decadence of (European) civilization.

While scholars have recently emphasized the primitivism of these artists in the sense that they romanticized and imitated fantasy versions of "primitive" peoples, conflating the archaic and the indigenous, it is interesting to note that they, like Noguchi, associated these old, even ancient forms with the radically *new*.[7] While de Kooning and his friend Arshile Gorky retained strong connections to Europe in their work, Rothko, Newman, and Pollock broke more radically into totally new styles. Many of the artists of the time expressed the wish to "paint as if painting never existed before," to start over. They found that not only the moment, the aftermath of the war, but the place, America, offered them the opportunity to do this (and no alternative). The artists predicated these feelings on a complex confluence of events, histories, and interpretations of what America meant: the near-extinction of the American Indian; the consequent imagining of America as a blank

Adolph Gottlieb, *Black Hand*, 1943, oil on linen.

slate; and the anticipation of a coming apocalypse. These artists not surprisingly identified with the Native American as well with the caveman when they imagined themselves as first men, rather than as conquering cowboys, despite the wildly exaggerated inter-pretations of Pollock's purported Western macho posturing.

This tangle of ideas also informed much fiction, literary criticism, and the beginnings of what would become American studies. Charles Olson's writing on Twombly, discussed earlier in this book ("There came a man who dealt . . . with space. He was

an American."[8]), was echoed just three years later in R.W.B.
Lewis's *The American Adam*, a study of nineteenth-century fiction.
In it, Lewis turned the phrase "the hero in space" to refer to the
(typically innocent) lone heroes of novels by Cooper, Melville,
and others.[9] The American Adam was "in space" both in the sense
of being outside time—the favored dimension of a heretofore
European modern history—and also in the sense of being alone in
the midst of a great expanse, whether ocean (like Ahab) or prairie
(like the Indian or buffalo).

Newman, Pollock, and others lived in a nation itself defined
not against the primitive but in alignment with it, both from the
exterior, European perspective (which cast America as a savage or at
least vulgar land) and from within. The American story itself, as in
Daniel Boone's "The New Eden," featuring an American Adam in a
virgin land, gave rise to the mythic sensation of being a lone hero.
He took many forms: the hunter, the religious fundamentalist,
the farmer, digger, pioneer, the West-bound hustler, the self-made
man. Many versions of this type, as it recurs in art and literature,
conflate the hunter/pioneer with the Indian in a composite "white
Indian" figure who rejects modern industrial capitalism for an
earlier natural form of life. The archetype is Natty Bumppo, the
hero of James Fenimore Cooper's nineteenth-century series of
adventure books. Known by the book's European settlers as
"Leatherstocking," "La Longue Carabine," and "the trapper," while
the Native Americans called him "Pathfinder," "Deerslayer," and
"Hawkeye," Bumppo was the prototype for that familiar character
in Western movies, the woodsman who "goes native," in sympathy
with the Indian: he might kill them, but also takes on their way of
life, turning his back on polite white civilization. (Later avatars of
the Western, novels and movies about the U.S. invasions of Korea
and Vietnam used both the names and the attributes of Hawkeye
and Deerslayer—recast as the Deer Hunter—to echo Cooper's
themes.)

Thoreau is a prime example of this type, one which has
maintained an exemplary position since the nineteenth century
(enjoying periodic revivals by intellectuals and artists, such as the
renewed attention paid to *Walden* by Stanley Cavell and others in

the 1970s). His passion for natural study was a kind of sublimation of the American love for the hunt. As Emerson wrote of his friend: "His determination on Natural History was organic. He confessed that he sometimes felt like a hound or a panther, and, if born among Indians, would have been a fell hunter."[10] At Walden, even as a landowner near his family home, he wanted to be free to wander like a hunter or a poet, not to be, like a farmer, bound by property. Thoreau also rejected civilized poetry as second-rate, insisting on the wildness or savage truth of "Indian" writing. *Walden*, for him, was the story of man bound and held captive by society, struggling against the deadness of civilization.

Pilgrims, Puritans, and Pioneers

Thoreau's break with contemporary industrial civilization was a fantasy about the Indian; it also recreated the experience of the Puritan/pioneer, living on the frontier of civilization, the verge of absolute nature This retreat gained new popularity and found new forms after World War II, with the war and the atomic bomb casting a still dimmer light on modern urban culture. Perhaps the most popular version was Betty MacDonald's book, *The Egg and I*, a memoir of her move after marriage to a small farm in rural Washington, to fulfill her husband's dream to leave his office job and start a chicken ranch. The book was made into an enormously successful 1947 movie starring Fred MacMurray and Claudette Colbert. The 1954 publication of Helen and Scott Nearing's *Living the Good Life* was another landmark in this territory, although with a rather different slant. The Nearings' book told the story of their move to a hand-built stone house in a rural area of Vermont and their simple, self-sufficient lifestyle; not as broadly popular as *The Egg and I*, it was influential among artists, intellectuals, and people searching for new forms of leftism in Cold War America. The Nearings were Communists, and (like Barnett Newman) combined an interest in international socialism with the peculiarly American project of an independent community peopled by independent individuals, free of government control.

By the 1920s, the exhibition, collection, and archiving of forms of American culture, distinct from European culture but not based on Indian culture, were widespread, part of the famous search for a "usable past." Artists Walker Evans, Bernard Karfiol, Robert Laurent, Charles Sheeler, Yasuo Kuniyoshi, Elie Nadelman and others collected some variant of folk art as well. (There is a parallel today in the collecting of mass-produced ephemera by Allen Ruppersberg, Richard Prince, Mike Kelley, and others.) In the early 1930s, Holger Cahill, influenced by his mentor at the Newark Museum, John Cotton Dana, curated shows both of "American Primitives" (a term for untrained artists coined by a British art historian) and of folk art, at Newark and then at the Museum of Modern Art, before going on to head the Federal Arts Project Unit of the WPA.[11] Even as the Museum of Modern Art collected primarily European art and followed the European story of the modern through the 1920s, '30s, and '40s, the curators of the Museum supported a side interest in American folk art (as well as American Indian art). At the Downtown Gallery, the dealer Edith Halpert specialized both in American "plain painters" such as John Peto and William Harnett, and in folk art. Major collectors of folk art included Gertrude Whitney and Juliana Force, and Abby Aldrich Rockefeller.

Abstract Expressionist Milton Resnick tells a story of meeting Cahill with de Kooning and fellow painter Aristodemos Kaldis at the Cedar Tavern one night; at closing time, Cahill invited them back to his apartment for scrambled eggs. With his wife, MoMA curator Dorothy Miller asleep in the next room, Cahill told the three artists "I want to tell you right now that you're not going to get in [to MoMA]," which Resnick interpreted as meaning "you foreigners, you Jew"; the place was being held for an American.[12] Cahill (himself an immigrant who often lied about his origins, renaming himself and manufacturing a Minnesotan childhood to replace his actual birthplace, Iceland) was an advocate of folk art as well as the wpa and "art for the millions," and Miller would go on to include the "real American" Pollock, and later, Jasper Johns, in her shows at MoMA. While Cahill doubtless made a good career for himself promoting American art, he had studied at the New

School not only with John Dewey, from whom he took in the value of an art imbricated with everyday life experience, but also with Horace Kallen, who (as mentioned in Chapter 4) was early, if not the first, to write on pluralism as an essential American quality.

A few scholars have linked Johns's involvement with American folk art to MoMA Director Alfred Barr's interest in the subject, although it's equally possible that Miller and her experience were influential in this regard.[13] In the early 1960s, a collector at MoMA saw Johns's work as so clearly connected to American "plain painting" that she sent him a reproduction of a work by Peto. Johns then used Peto's *The Cup We All Race 4* (ca. 1900) as a starting point for his 1962 painting, *4 The News*, which he signed as "Peto Johns." Johns was probably drawn to Peto's direct realism, sophisticated play with the two-dimensional representation of three-dimensional objects (the cup), and interest in vernacular mark-making such as the graffito scratched into the surface of Peto's painted door. While Johns's specificity of reference was unusual, gravitation towards American vernacular material was not. Rauschenberg also made reference to untrained, homely art (which he would have seen not only via wealthy patrons, but as a child, growing up in South Texas), and Oldenburg made sculptures from found wood in Provincetown, using New England architectural bits such as newels, at about the same time he was working on *The Street*. Many other artists in the 1950s and early '60s made work referencing early America, including Larry Rivers's paintings of George Washington and Civil War veterans and Roy Lichtenstein's paintings of Washington and pioneers/explorers. Gene Swenson's 1962 essay on Pop, the "New American Sign Painters" points to the highway, the American roadtrip, and mobility as motivating the Pop interest in signage, a clear theme not only in the well-known work of Robert Indiana, but particularly in that of Los Angeles artists like Ed Ruscha and Phillip Hefferton. The theme of signage also connected the artists of the 1950s with the tradition of the eighteenth- and nineteenth-century American artist's roots in commercial sign painting, as well as with Walker Evans's interest in signage as folk art. Pop was just one chapter in a broad tradition in American art since the seventeenth century,

which valued signage for its directness, utility, and often inadvertent beauty. But Hefferton played on the tradition of nineteenth-century American money painters such as Harnett, who depicted paper bills with stark realism.

The Shakers (a split-off from the Quakers) were an American religious sect who arrived from England in the late eighteenth century with a tradition of plain utilitarian objects that came to be valued by collectors and historians for their severe beauty as well as for their ideological uses. Oddly, art historians have not pursued the apparent influence of Shaker furniture and architecture on contemporary American art, particularly that known as Minimalism, preferring European historical precedents such as Russian Constructivism. J. T. Kirk, a historian of Shaker design rather than of modern art, posits a connection between Shaker objects and what he sees as a "reductive aesthetic" in American art (a more accurate characterization would be "direct," or "non-artsy"). He documents some of the motivations of the recurrent revivals of Shaker design in the twentieth century: "The greatest thrusts to mythologize the Shakers' past occurred when America was seeking to adjust its relationship to Europe . . . Historians since the 1910s have used the Shakers' artistic expressions as evidence that the Shakers, and by extension other Americans, anticipated the tight, functional, stripped forms of the German Bauhaus."[14] Shaker objects were central to the interest in American folk art in the 1930s, as part of an important exhibition at the Whitney in 1935, spurred by collector Juliana Force, as well as to the Index of American Design. Among the artists who collected folk art, Charles Sheeler in particular focused on Shaker objects, loaning them to the Index of American Design as well as filling his homes with them and depicting them in paintings and photographs.[15] (It was as part of the same wave of enthusiasm for Americana that Aaron Copland, intimate associate of New York modernists like Lincoln Kirstein, incorporated a Shaker hymn, "Simple Gifts," into his 1944 ballet score, *Appalachian Spring* of 1944, for which Isamu Noguchi designed the set.)

In the 1950s and early '60s, a spurt of articles on Shaker objects were published in popular magazines such as *Look* and *Life*,

as well as design, art, and home decor magazines.[16] Donald Judd, praising the work of engineers in making bridges and other utilitarian structures, bemoaned the fact that most architecture lacked the "the plain beauty of well-made things," using words very often associated with Shaker objects.[17] This is not to draw a direct connection, of course, but Judd associated these values of directness and an aesthetic born of utility explicitly with America and not Europe, and "plain" and "simple" are words that came up repeatedly for him, as for Frank Stella. James Turrell was raised by Quakers, and while he has rejected critical attempts to connect his use of light to the "inner light" of Quaker spirituality, he has acknowledged a general aesthetic sympathy between his art and the "economy of means and also quite a non-decorative bent [of] that form of Puritanism."[18] Fellow artist and sometime Minimalist Robert Morris is unusual in ascribing Minimalism's plainness and covert transcendence to an American Puritan heritage, which he traces from Jonathan Edwards down through James and Dewey.[19]

Jackie Winsor's rough wood and rope sculptures of the early 1970s were often associated with process art and the putatively natural, repetitive nature of "women's art" (braiding, wrapping, etc.); her work was included in the last room, titled, "Contemporary Explorations," of MoMA's controversial 1984 *Primitivism* exhibition. The artist's personal connection with *Nail Piece*, in which she repeated her childhood act of pounding hundreds of nails into wood, has been read as feminist (and psychologically regressive); not discussed is Winsor's description of the context, working on a house planned by her father and built by her mother as a familial do-it-yourself project.[20] The replay of pioneer homesteading is acknowledged in other cases: "Jackie Winsor marshals her strands of rope and metal, her 1 × 1 inch sticks and layers of laths and pounds of nails as laboriously as Cezanne organized his countless petites sensations, but she does it like a Yankee pioneer."[21] Significantly, this description ties her work to that of Judd and Turrell in some respects, though art classified under the label "process" was often opposed to that associated with "minimalism," with hand opposed to machine and expression to impersonality. While not without truth, this contrast is also misleading, as it was not critical

for all artists. Judd objected to the linking of his work chiefly with industrial finish, and Winsor worked with sheetrock and other mass-produced materials as well as hemp. As with Charles Sheeler, the crucial distinction was not between the handmade and the industrial, but between the preferred utility and directness and pretentious aesthetic and conceptual flourishes.

More Cavemen, More Indians

In 1970, the year of the first Earth Day, the Nearings' book was reprinted with a foreword by Paul Goodman, who had become a kind of father figure to counterculture youth; at that moment it was more influential than in the 1950s. Enough people went "back to the land" in the 1960s and '70s that they collectively constituted a statistically significant demographic event.[22] The Nearings' beliefs were a variation on the Jeffersonian, Thoreau-ian insistence on the fundamentally agrarian nature of America as opposed to European industrial capitalism. Some went still further: the concept of deep ecology put human concerns and life second to the health of the planet. The organization Earth First!, which was founded in 1980 but had its beginnings in the 1970s, was inspired in part by deep ecology. It was also influenced by Edward Abbey's writing, especially *The Monkey Wrench Gang* (1975), in which young people traveled to the Southwestern U.S. for a direct action monkey-wrenching campaign to preserve primordial America (the book was dedicated to "Ned Ludd"). A more balanced model of the human relationship to the earth than the modern industrial one was located—once again—in American Indians and prehistoric man as well. A University of Chicago anthropology symposium of 1966 on "Man the Hunter" was both typical and influential.[23] Along with scientific investigation, fantasies about prehistory were widespread in the culture and in art. A particularly early example is to be seen in painter and performance artist Carolee Schneemann's *Eye/Body* of 1963, which, like her other performances, stressed not only the performative aspect of gestural painting, not unrelated to work by the Abstract Expressionists, but

its ritual connotations. Her work hinted at a coming disaster: having moved too far from a primal and more natural state, modern society was heading back to a pre-technological era.

In 1967, the same year Timothy Leary told a crowd at a be-in to "Tune in, turn on, drop out," he published an essay titled "Start Your Own Religion." Leary lent an apocalyptic urgency to the call for young Americans to return to the land: "You will find it absolutely necessary to leave the city. Urban living is spiritually suicidal. The cities of America are about to crumble as did Rome and Babylon. Go to the land. Go to the sea."[24] Babylon was frequently invoked by gurus and communal organizations (such as the Rainbow Gathering) warning of the dangers of modern Western culture. Leary's biblical undertone is not surprising, given the long history of the crisis warning in American culture, but it was not Protestant evangelism that drove him. Rather, he looked back to the beginnings of evolution, or at least archaic civilization:

> A group liberation cult is required. You must form that most ancient and sacred of human structures—the clan. A clan or cult is a small group of human beings organized around a religious goal. Remember, you are basically a primate. You are designed by the 2-billion-year blueprint to live in a small band . . . Your clan must be centered on a shrine and a totem spiritual energy source.[25]

Leary again: "Your new religion can be formed only by you. Do not wait for a messiah. Do it yourself."[26] Do it yourself—an amazingly American phrase, and one surprisingly pragmatic for the transcendental guru (one that echoed Newman's ironic question about Hiroshima, "Wasn't it an American boy who did it?").

Similarly, Stewart Brand would open the 1968 *Whole Earth Catalog* (a collection of "tools for self-reliance" originally intended to allow communes to construct their own buildings) with, "We are as gods," a curious and characteristic blend of scrappy, can-do spirit and self-aggrandizement. "We are as gods," was an obvious, although little commented-on, acknowledgment of the invention of the atomic bomb, and the Promethean boldness of its inventors.

Carolee Schneemann, *Eye Body—36 Transformative Actions*, 1963, action for camera.

Alan Shields, *Whirling Dervish*, 1968–70, acrylic and thread on canvas over wood.

The language of Protestant exhortation remained, with the replacement of God by "we." The future also came to the 1960s in the form of utopian communities and plans for forms of architecture that would facilitate the new social forms, often following the ideas of Buckminster Fuller but also invoking tepees and other "primitive" structures. Among artists, Alan Shields used strung beads in open-work, unstretched canvases, and also draped dyed canvases into hogan or tent forms. He imagined his paintings as built for geodesic dome houses, structures without walls. Shields saw himself as a nomad, with collapsible paintings, even paintings on wheels, such as *Whirling Dervish*, referencing Fuller's ideals and Indian traditions of the movement and freedom of flexible, impermanent architectural forms and even mobile homes.[27]

Such invocations of the prehistoric were also tied to living Indian culture. While the Chicago symposium covered the study of prehistorical peoples around the world, certainly the contemporary climate in the United States stimulated interest in the past; as one participant in "Man the Hunter" said, "The case of the North American Indians is especially significant. They seem to be waiting for us to go away."[28] (Even this innocent quote implies not only a very long, long view of history, stretching across eras, but a kind of

apocalypse in reverse, in which industrial modern life would be destroyed to restore the Indian way of life.) Such thoughts were prefigured in William Carlos Williams's *In the American Grain*: "He turned back to the Indians, it is the saving gesture—but a gesture of despair . . . However hopeless it may seem, we have no other choice: we must go back to the beginning; it must all be done over; everything that is must be destroyed."[29]

Younger artists were more conscious of the impossibility of the gesture of connection. Painter David Reed made trips to the Southwest deserts in the mid-1960s to escape the city and expand his consciousness, as well as to paint the expansive landscape. Thinking that he was living in nature, like the Indian, he even fantasized a semi-mystical experience of familiarity when visiting a cave. Later, he realized that he was in the same location where the John Wayne film *The Searchers* was filmed. His experience of naturalness was already mediated by film (not to mention the content of that film, the hatred of Indians).[30]

The Abstract Expressionists had tied America to the Indian as the alternative to Western civilization, which they identified with Europe. America was vulgar and commercial, but at least it was not civilized. This identification of America with the Indian ended in the 1960s, when it had become apparent that the values of the United States were dominating the "civilized" world. Indians were now distinct from American identity, aligned instead with the Third World peoples whom the United States was fighting in Central America and Southeast Asia. In the 1970s, historians such as Richard Slotkin tied the genocide of the Indian population in North America to the military invasions of the late twentieth century. Nonetheless, reading seventeenth- and eighteenth-century narratives of settlers taken captive by Indians, Slotkin and others addressed the pleasure Europeans found in new lives among their captors.[31] These writers also noted the appeal the Indian way of life had had for colonial writers such as Thomas Jefferson, who focused on sexual freedom and the loosening of political hierarchy and social control.

One of the first major San Francisco happenings, in 1967, was promoted as a "gathering of the tribes." Organized by Beat artist

Michael Bowen, the festival featured bands including the Grateful
Dead, and posters depicting an Indian on horseback wielding
an electric guitar. In the later 1960s and '70s, again despite the
ostensibly progressive, future-orientation of politics, much
hippie imagery and self-fashioning incorporated various forms of
primitivism. While the so-called counterculture emphasized drug
use and sexual disinhibition, more mainstream versions looked
to whole foods, natural clothing, natural or no makeup, and
recycling. Founding communes in the country, living in canyons
where you could trap your own food—all this drew on the
American imagining of a pre-modern way of life as young people
moved away from politics and organizations like SDS. Hand-dyed
clothing, beads, and long hair worn by both men and women
invoked a range of Third World cultures, embodying ancient and
indigenous pre-modernism and, more immediately, a rejection of
professional work and uniform culture. Many of the cultural
trappings—moccasins, beads, face paint, tents—invoked the
American Indian in particular, just as psychedelic drugs were
related to Native Americans' use of peyote and magic mushrooms.

As in the late 1930s and early '40s, there was a round of
museum exhibitions of Indian art, including one at the Whitney,
200 Years of American Indian Art, in 1971; the following year,
American Indian Art: Form and Tradition at the Walker, whose
catalog referred to the Indian as "the original American." Artists
explored natural forms (twigs, hides), the decorative artifacts of
Indians (beads, feathers, even tents and hogans), and recycled
materials (especially worn fabric), evoking the past rather than
expressing an orientation towards the new. William T. Wiley, Frank
Viner, Rafael Ferrer, and others featured rough materials such as
rawhide and wood (this art was sometimes referred to disparagingly
as "twig art"), as a counter to the shiny mass-produced quality
affected by Pop, Colorfield painting, and Minimalism. Ferrer,
who is Puerto Rican, explicitly connected his forms, which made
explicit reference to tents and kayaks, to a turning away from
American efforts at fulfilling its Manifest Destiny: "I saw the
North American Giant as tired, bleeding from excesses which
were never meant to produce pleasures except perhaps those of a

puritanical order, foreign and strange."[32] Underlying what has been referred to as "Process" art, or by some other unsatisfactory marker, is often some variant of primitivism, which incorporated more of the artist's handling, but also materials that are essentially pre-modern and therefore "natural," and often given political, social meanings, as in the rejection of "formalism" (seen as rationalism) for its purported association with the war in Vietnam.[33] In Ferrer's hands, aesthetic politics became extremely complex; working with artifacts like the kayak, he incorporated steel to imply the corruption of non-Western peoples by industrial capitalism. Most artists, however, sought an explicit alternative to the West in indigenous, ancient, and non-Western sources. (Some of this work, along with Shields's open grid painting, *Poems Needed*, 1971, and a Ree Morton installation, was gathered together in a 1975 exhibition at Vassar College called *Primitive Presence in the '70s.*)

Paul Thek deliberately contrasted what he saw as the then-dominant technological/industrial orientation of Minimalism with his own interest in warm materiality in the *Technological Reliquaries*, hairy, waxy flesh sculptures sealed inside Plexiglas boxes that he first showed in 1964. Thek was one of the artists who went against what they saw, rightly or wrongly, as the dominant grain of industrially-oriented art, towards something more psychologically complex, less rational. In wildly imaginative installations as well as wide-ranging notebooks, he took his starting point from fantasy and counterculture references. He worked collaboratively, influenced by theater and rock bands. As friend and collaborator Ann Wilson said, "The hallucinatory character of the mass acid trip mentality influenced Paul's *Tomb*. Psychedelic drugs were an art supply for us at the time."[34] For this work (originally subtitled *Death of A Hippie*), made in 1967, Thek built an eight-foot pink pyramid/tomb containing a figure cast from his own body, adorned with a blond wig and a pink suit. The relics around him invoked both ancient ceremony and contemporary hippie culture, marking the passing of the latter as well as the former. *The Tomb* represented fantasies of prehistoric man basic to hippie self-fashioning, a mode of selfhood that modern culture rejected, even killed. Thek was not alone in perceiving this death: that same year, a ceremony took

Paul Thek, *The Tomb*, 1967, wax wood and mixed media, installation view, Stable Gallery, New York.

place in San Francisco with a coffin carried in procession, announced by invitations stating "Funeral notice. Hippie, devoted son of Mass Media. Friends are invited to attend services beginning at sunrise, October 6, 1967, at Buena Vista Park."[35]

Space Age / Stone Age

Thek's best-known artwork is probably a modest painting of the earth seen from space, done on newspaper in 1974. Transcendental or mystical in nature, like *The Tomb*, it is a more hopeful work. Thek's painting looks very much like the famous image on the cover of *The Whole Earth Catalog*, an image whose story began even before the first photograph of the Earth seen from outer space was taken. In 1966, Brand had initiated a public campaign to have NASA release the then-rumored satellite image of the sphere of the Earth as seen from space. He thought the image of

our planet might be a symbol powerful enough to evoke adaptive strategies from people. In *The Electric Acid Kool Aid Test*, Tom Wolfe described Brand's (LSD-fueled) epiphany of the mid-1960s: "he was struck with one of those questions that inflame men's brains: *Why Haven't We Seen a Photograph of the Whole Earth Yet?*— and he drove across America from Berkeley, California to 116th Street, New York City, selling buttons with that legend on them."[36] A MoMA catalog of 1951, *Abstract Painting and Sculpture,* begins with an essay by curator Andrew Ritchie that discussed Mark Tobey's interests in the context of a supposed scientific impetus behind modern art. It is illustrated with aerial views of the world, views of the heavens seen from Earth, and microscopic views of matter, on the cellular level. The photographs all echo the all-over format of Tobey's paintings (as well as those by Pollock and others in the show). They also bear a remarkable resemblance to images in the *Whole Earth Catalog* of Spring 1969, in which one section features NASA pictures of the earth as seen from space, and photographs of the Earth's surface, along with extreme close-ups of the human body.[37]

When John F. Kennedy accepted the Democratic nomination for president in 1960 in Los Angeles, he proclaimed, in that end point of the former frontier, a "New Frontier," one of "unknown opportunities and perils—a frontier of unfulfilled hopes and threats."[38] The most obvious element of this nebulous concept was science, and particularly space exploration. The Cold War stimulated race to the moon and the ability to put a rocket into outer space brought two new "first man" episodes: the first man in space and the first man on the moon. On July 20, 1969, Neil Armstrong commanded the Apollo 11 moon-landing mission, in which he and Buzz Aldrin walked on the lunar surface to make the famous "giant leap for mankind." In human history, there are very few firsts—we've done so much—of this obvious momentousness, so it's not surprising that this futurist milestone would be so frequently imagined as a fetal one, of birth and beginnings. As television news anchor Eric Sevareid said in narrating Armstrong's moonwalk, "We've seen some kind of birth here."[39] Science fiction and pop culture sometimes traced the beginning even further

back, in a mishmash of phylogeny and ontology, to babies, and earlier evolutionary beginnings embodied by cavemen and even pre-human ancestors, as in the popular *Planet of the Apes* series of films. Amusingly, Armstrong's biographer, who refers to him as the "First Man," writes, "Fittingly, for the family history of the First Man, the ancestry goes back literally to Adam"—this being the Christian name of Armstrong's ancestor who emigrated to America in the eighteenth century.[40] As NASA artist Paul Calle said, "I like to use the analogy of oneness that I see between Neil Armstrong's boot sinking into the dust of the moon and the moccasined foot of a man like John Colter sinking into the snow as he entered Yellowstone River Valley for the first time."[41]

Robert Rauschenberg was invited to Cape Canaveral by NASA to witness the launch of Apollo 11 and to make a work of art in response. His series of lithographs, *Stoned Moon* (1969–70), was made quickly in the following month. Rauschenberg juxtaposed NASA photographs of the rocket with creatures and scenery from Florida's natural world; the "stoned" is a pun linking lithography (and its prehistoric connotations, as in his famous complaint about the fact that artists were still drawing on rocks in the late twentieth century), to the psychedelic nature of the space experience.[42]

The affinity between the ancient past and the distant future, and even the difficulty in distinguishing them, are recurrent themes. Art and writing about art sometimes swings between these two poles, as in the readings of Minimalism as regressive / reductive / fundamental, or as industrial / inhuman / untouched, and therefore futuristic. But much of the time artists—like science fiction writers—consciously put the two together. In their essay "The Domain of the Great Bear," set in the Hayden Planetarium at the Museum of Natural History, Robert Smithson and Mel Bochner encapsulate the two extremes while musing about outer space and about the planetarium as an ancient whirlpool "at the end of the world" (indicating early on some of the interests that would drive Smithson's earth projects in the following years). The Planetarium represented a timeless view of the heavens, stretching from before to after man's time on earth. As Smithson described the past and future collision: "Space Age and Stone Age attitudes

overlap to form the zero-zone, wherein the spaceman meets the brontosaurus in a Jurassic swamp on Mars."[43] Nancy Graves, a friend of Smithson's, having begun to work with the metaphoric and material subject of the camel in the mid-1960s, moved quickly into prehistory, shifting from sculptures of camels to cast and sculpted skeletons and bones that she often displayed as if they had been found at an archaeological site. Graves's father had worked at the Berkshire Museum, which included natural history exhibits, and she even dedicated one work of 1971 to the head of casting at the Department of Vertebrate Paleontology at New York's Museum of Natural History, Martin Cassidy.[44] (Susan Rothenberg, her former studio assistant, would go on to paint schematic, gestural images of horses that evoke the cave paintings at Altamira and Lascaux.) Overlapping these large sculptural and installation projects was two-dimensional work about outer space. Graves made lithographs of the Apollo landing sites, as well as drawings and large paintings from photos by NASA's Mariner 9 satellite, and in 1973, a large, four-panel work titled *Mars*.

Connections between the bomb, the end of the world, the beginning of a new world, and space travel were made by other artists as well. Vija Celmins, in Los Angeles, made beautiful pencil drawings titled *Hiroshima* and *Bikini* in 1968; the former depicts an overview of the city after the bomb, the latter an atomic cloud. Made after photographs, the drawings connect to her own terrifying experiences as a child in Europe during the war. Beginning in 1968, Celmins also started a series of all-over drawings of the moon surface, using newspaper photographs and Russian and American satellite images.

From these subjects Celmins turned to images of the desert, first Death Valley in California, and then deserts in New Mexico and Arizona. The empty land allowed for the same all-over treatment as the moon's surface, with the obviation of figure and ground so prized in Pollock's painting (where it was similarly seen as an expression of Western expanse) a generation before Celmins. Here, the empty land signifies both its once-virgin nature and a post-apocalyptic state. That is, as in the work of Smithson and Graves, the desert looks both ancient, a place not yet inhabited

by man, and yet futuristic, in suggesting the aftermath of the apocalypse.

In 1950, perhaps the most popular historical reading of the West was Henry Nash Smith's *Virgin Land: The American West as Symbol and Myth*. During the following decades, the idea that the American frontier was Edenic and unpopulated was thoroughly attacked, and as part of the separation of "America" from the Indian identity, virgin land was replaced by "widowed land."[45] At the time of the American war on Indochina, amidst new scholarship and the activism of the American Indian Movement, it became clear that the American sensation of being alone, being first, was based on the horrific devastation of the Indian population, a genocidal wiping of the slate. This apocalyptically violent event reverberated with the Puritan mission in its emphasis on crisis, the risk that America would be all or nothing, as Emerson said, as well as with the subsequent devastations of World War II and the threat of planetary annihilation. Space was not only, as the catchphrase of the time had it, a new frontier, but had the slightly ominous cast of being the final frontier, as in the famous voiceover for the television series *Star Trek*.

The End is Near

In the wake of the failures of the social movements of the 1960s and '70s, as well as the global economic downturn of the mid-'70s, the activities of metaphoric first men took on a negative cast. In the early 1970s, as the rest of the country was experiencing a severe economic recession, New York City in particular, cut off from federal funding, seemed on the brink of total ruin. A "plague" of graffiti on subway cars and public buildings became a symbol of the city's degradation, along with its rising crime rates; complaints about graffiti were covertly (or overtly) racist statements of fear and anger about the supposed threat of young black and Latino men. In the nineteenth century and early twentieth, graffiti were prized as an authentic, primitive—that is to say, untrained— American expression, depicted by John Peto and Walker Evans as

Keith Haring, *Untitled*, 1982, vinyl ink on vinyl tarpaulin.

part of their compendia of signage and marking. In New York City in the last quarter of the twentieth century, primitivism became a cause for panic, reviving hysteria about the threat posed by savage—not noble—Indians or rebellious slaves. In the conflicted American tradition, graffiti artists, decried by Mayor Lindsay, were celebrated in traditional, primitivizing (and often racist) terms by gallerists and European documentary filmmakers and photographers. Norman Mailer, in an essay for a 1974 book on graffiti, made the obligatory references to Altamira and Lascaux, but also tied the tagging epidemic, beyond an apocalyptic New York City in a recession, to what seemed to him to be the end "of a once-leviathan bourgeois culture," the dissolution of art as a middle-class mystical passion. "Is civilization coming to an end?," he asked. "Is the day of the cave man returning? And the cave drawing? . . . We are at the possible end of civilization, and our instinct, battered, all polluted, dreams of some cleansing we have not found." But Mailer believed that graffiti also pointed somewhere else: "a new civilization may be stirring in its roots." While the ghetto environment was "near to the plague," "the

beginning of another millennium of vision may also be" found in its expression.[46]

Mailer's portentous philosophizing bears little relationship to the way the graffiti writers and artists thought of themselves. Well-known figures in graffiti of the 1970s, at least in their statements and interviews, did not see themselves as cavemen or primitives; rather they competed for daring in placement and sophistication of execution. In contrast, trained artist Keith Haring, drawing on (some said stealing) the energy of graffiti, deliberately played on the kind of references Mailer made. Haring made his early drawings in white chalk on the blackout paper used to back advertisements in public areas, primarily in the subway. His best-known image was the "radiant baby," a crawling cartoon figure whose implied radioactivity carried connotations of absolute beginnings and messianic transcendence; he paired it with 1950s-style flying saucer spaceships, robots, and nuclear reactors. Haring was originally from Kutztown, near Three Mile Island, the nuclear reactor that melted down in 1979; one curator referred to his mode of work as "techno-primitivism."[47] Others spoke of cave cartoons or modern-day cave drawings, much as actual graffiti were commonly associated with cave painting in popular writing, including fiction, from the 1980s forward.

Haring was only the most visible representative of a larger social scene and mood. In 1983, painter Peter Halley curated an exhibition called *Science Fiction* at John Weber's gallery. Halley painted the walls black, choosing a surface like Haring's, and one that also invoked the cave, although he saw it as stressing the pessimism of art's return to the gallery after a decade or two of such expansive, ambitious projects as Earth art and performance. "[Current science fiction] portrays not a technocratic, utopian future," he wrote, "but a future in which nuclear apocalypse is almost a given."[48] The show was filled with flashing lights, like a kitschy sci-fi film or a discotheque; one artist, Taro Suzuki, exhibited a figurative sculpture made from geometric mirror fragments called *Disco Mummy*. In contrast, Halley's catalog included a still from the 1981 film *Road Warrior*, which depicted the final roadtrip amidst a savage, caveman-style post apocalypse.

Halley noted the prevalence of barbarism visualized as either the "primitive tribe or the law of the streets" in current science fiction. As he had written in a slightly earlier essay, "We have cause to believe we can eradicate our own species from the planet, that we can destructively transcend our own existence: we seem to have ourselves acquired a power that has in the tradition been attributed to super-natural beings."[49] Like Brand, he pointed out the powerful and apocalyptic psychological aspect of the bomb almost forty years after its use.

The 1984 MoMA exhibition *Primitivism in Twentieth Century Art* looked for formal relationships between modern and tribal art, treating contemporary art—as is MoMA's habit—as an extension of European modernism, largely ignoring the specifically American relation to the indigenous and prehistoric, as well as American variants of primitivism in folk and untrained art. The contemporary section of the exhibition seemed to replicate earlier exhibitions, such as *Primitive Presence* and Lucy Lippard's *Strata* of 1977, without analysis or much addition. With the increasing awareness of ethnic identities and artists, the complications of referencing the primitive moved from the background to the foreground in this period. Even the well-meaning invocations of indigenous or Third World forms in the 1970s tended to look absurd, or worse. In general, there was less fantasizing about cavemen or indigenous peoples on the part of European-Americans. In earlier generations, artists of color had often tried to distance themselves from obvious reference to African or Indian forms, for fear of being taken as literally naïve or "primitive" artists. In the 1980s, black and Indian artists began to toy with the stereotypes of primitivism, still critical of essentialist ties. Jean-Michel Basquiat both used the stereotypical imagery of the primitive—bare feet, a myth of wildness, scrawled graffiti in his paintings—and was its object.

Amidst a political and art world discourse focused on sexual and ethnic identity, Indian artists such as Edgar Heap of Birds, Jimmie Durham, and Kay Walking Stick used mainstream artistic strategies and forms to express their own marginality and ambivalence about those very forms. In a 1987 performance, *Artifact*, James Luna lay among the Kumeyaay exhibits at the Museum of

Man in San Diego in a vitrine-like case. Wearing a loincloth, with his eyes closed, the Indian artist played dead. Labels gave his name and commented on the scars on his body, attributing them to "excessive drinking"; instead of pottery pieces or spear points, the artifacts around him included his college diploma, a photo of Jimi Hendrix and his divorce papers, as well as his Motown tape collection. His placement in the Museum recalls that of Ishi, the last Yahi Indian of California, who was captured in 1911 and spent the remainder of his life in a San Francisco anthropological museum. Like Ishi in his time, Luna is alive in the present, despite being confined to the mausoleum of the museum; his contemporary, capitalist-era accumulation of goods insists on his present-ness within the past, a refusal of the authenticity prized by MoMA and tourists alike. The backdrop to the new attention to Indian artists in the 1980s was ironically a vogue for the Southwest, for "Santa Fe style" in home decor and the invented "Southwest cuisine," even as regionalism along with multiculturalism were officially packaged and enshrined in books ranging from Lucy Lippard's

James Luna, *Artifact Piece*, 1985–1987, performance at the Museum of Man, Balboa Park, San Diego, 1985.

Mixed Blessings: New Art in a Multicultural America to *The Coyote Café Cookbook.*[50]

In another performance, *End of the Frail* (1991), Luna assumed the pose of the exhausted, extinct "last Indian" in James Earle Fraser's famous 1894 sculpture, *End of the Trail*, now slumped on a sawhorse clutching a bottle of booze rather than a spear. Along with anger at the confinement and display of human beings, the ambivalence of the first man's end drives both performances.

Last First Man

By the mid-1990s, both reference to and critiques of first men had largely faded from art. In part, this may have been a result of the shifting of racial attention to the study of "whiteness" (as discussed in Chapter 2). But even more, this seems to be an effect of the turn of business and consumption, along with political discourse, towards globalism, at its absolute high point as a novelty at this moment. In special issues of art magazines and new biennials around the world, art lovers were directed sequentially to Latin America, Japan, China, and Africa for sophisticated contemporary art, rather than primitive inspiration and artifacts.

Surprisingly, just a few years later, in the late 1990s and the early part of the twenty-first century, many American artists turned back to the tropes of first and last men. Not as imagined in the romance of indigenous primitivism—that may be permanently foreclosed by the audible voices of Indian artists themselves— but in a kind of review of American mythologies of first and last throughout history. A striking variation on primitivism—or at least early-Americanism—not requiring Indian ancestry combines the violence of the cowboy/settler with the idealism and severity of the Shakers or Thoreau. The asocial individual is central to American history, in tacit distinction from European high culture and organized sociality. In 1975, when he was just twenty years old, Fred Tomaselli hitchhiked from his native Los Angeles to Vermont, where he found an older group of Marxists in retreat from the American 1950s, as well as a culture of younger hippie

Fred Tomaselli, *Desert Bloom*, 2000, photo collage, acrylic, resin on wood panel.

drop-outs. Hanging out at the Packers Corners commune he found community and nature, the seeming opposite of the artifice of suburban California; instead of the shiny culture of amnesia there was a whole history that included Thoreau, John Muir, and a political tradition carried on by the older denizens that combined communal living, self-reliance, and Marxism. Quickly, however, Tomaselli realized that the scene was too mellow for his metabolism, as well as for the historical moment.

After hitchhiking to Yosemite, where he spent almost a year, he returned to Southern California, to college, and to punk music. But he retained a memory and affection for that culture, and when punk too began to corrode, his musical affiliations metamorphosed into music that married that "art-damaged" strain of punk with the psychedelia and folk of the Paisley Underground in a pop-

cultural version of the dual American philosophical tradition that joined materialism or pragmatism (as embodied in the work of James, Dewey, Hartnett, and Judd) with metaphysics or transcendentalism (to which we might attach Ryder, Richard Pousette-Dart, and Bruce Conner along with Emerson, Thoreau, and Josiah Royce). Tomaselli began painting exquisitely detailed works combining reference to organic nature with traces of the drug and music culture of his early social environment. The locus of his activity is the peculiarly American, suburban home of DIY experimentation, is the home as well of amateur music (the garage band). For Tomaselli, the garage has been both a psychological refuge and the embodiment of his class identity (he worked his way through school as a car mechanic). As he says himself, "I'm a garage guy."[51]

The garage signifies self-reliance, cultural and social isolation (without actually being *too* far away, much like Thoreau's retreat). In *Desert Bloom* (2000), Tomaselli tracks this mode of home-grown primitivism through history and across the ideological spectrum, dotting an arid landscape with landmarks like Walden, the shack where Ted Kaczynski (the Unabomber) lived, David Koresh's Christian sectarian compound at Waco, Texas, Fuller's geodesic domes, a Quaker meeting house, and Charles Manson's headquarters (both Barker Ranch, near Death Valley, and Spawn Ranch, near Cal Arts), among others. The last of these, aside from referencing Tomaselli's roots—Manson looms large in L.A. art—reveals the dark side of Emersonian self-reliance, of the American dream of individualism and self-creation on the blank slate of the frontier. Alongside these ideals, or perhaps beneath them, lies a deeply anti-social millennialism, the regeneration through violence required to wipe the slate clean, to create a new world perfect in nature, uncorrupted by civilization. Kaczynski, following Thoreau, was more extreme than his predecessor in refusing technology, after the advent of the atomic bomb and the computer. Living in a cabin in the woods, he was not a pioneer exploring the boundaries of the present terrain, but in retreat from the future and the frontier.

Dana Schutz's paintings are full of beginnings and endings, and it isn't always easy to tell them apart. In the 2002–03 series, *Frank from Observation*, which first won her critical attention,

Schutz depicted a man alone. Frank, a slightly sweet, hippie burnout type, poses languorously in a lonely beachscape, is set adrift on an ice floe, looks out on the empty world at night. "Frank was somebody that I invented. He was the last man on earth and I proposed to paint him from observation. He was the last subject and the last audience and I was the last painter."[52] More bewildered than either liberated or terrified, he seems vaguely aware that, despite his aloneness, his last-man status, someone is watching. From this vantage point Schutz herself obviously becomes the last painter on earth. What is the implied relationship between artist and subject? The bare facts of this set-up are complicated: "man" of course is the sexist, outdated synonym for "human," so if Frank is the last human, what does that make the last artist? A distant, more-than or less-than human figure? Is she all-seeing? Cold and scientific? Or if Frank is literally the last man, and Schutz is the last woman, are they Adam and Eve? Are we once again in a New Eden?

In all the different settings of the series, Frank recalls a desert island castaway, a figure central to the Western social imagination, especially recently. *Robinson Crusoe* and *Gilligan's Island* have been updated by a variety of movies and television shows, including myriad *Survivor* reality shows and *Lost*. It seems that the pastoral, escapist, back-to-nature sensibility kicks in when politics go bad, when the world looks particularly hopeless and the end seems plausibly within view. The castaway scenario always issues from an all-too-civilized, self-destroying society. Whether it involves stranding a handful of people on a desert island, or leaving a few final occupants after a globally scaled apocalypse, the end nevertheless evokes the nascent society of the past, the au naturel beginnings, before the rules were set, before things were named. Of course, these survivors are not really Neanderthals, but have all the memories and knowledge of society as it stands or stood. On a desert island or roaming the empty canyons of Wall Street, the survivors are left reinventing the wheel, making radios out of coconuts, acting like Adam and Eve, or even like monkeys. The liberating, positive feature of the castaway is that he has permission to recreate the world from scratch, to rediscover himself and society,

as if for the first time. Much of Schutz's work since the Frank series has developed a vein of American history painting, depicting the tangled Cabinet of the second Bush administration, but also the signing of the Declaration of Independence. In 2007, she showed a group called *Stand by Earth Man*, inspired by the words of Cleveland musician David Thomas: "We live in the beginning of a voodoo age of magic superstition and ignorance. We are the last generation that will ever know what it was like, to live in an enlightened world . . ." The paintings were visions of a mysterious, post-rational future of time travel, plague hospital, old cars and telephones with actual wires, as well as an abstraction titled, simply, *Cleveland*.

In *Black Out* (2001), Mike Kelley combined space travel with a vision of a crumbling Detroit, the home of the once-triumphant automobile industry (as well as the hometown of Kelley himself), and now a city whose ruin has recently replaced New Jersey's as the heart of an already-finished America as seen from a post-apocalyptic future. Kelley's sprawling installation, first done in Detroit itself, managed to conflate astronaut John Glenn,

Dana Schutz, *Frank as a Proboscis Monkey*, 2002, oil on canvas.

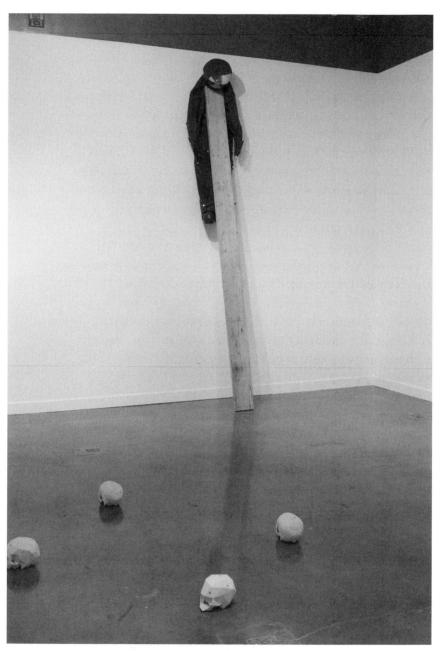

Matthew Day Jackson, *Lonesome Soldier*, 2008, Vietnam-era military blankets, rubber, wood, aluminum, plastic.

commemorated in a monumental mosaic statue made from shards of cast-off china, metal, and glass collected from the Detroit River islands, with the Indian maiden on the Land O'Lakes butter package (an early sexual fantasy object of the artist), and a chainsaw sculpture of the mythical woodland monster, Bigfoot.[53] Along with the statue, he showed a variety of photographs, including some taken on a tour of the islands and others depicting "local culture" from the archive of the local newspaper dating from his youth (when his high school library was the site of a John Glenn statue), together with a video loop from the 1959 B-movie *The First Man into Space*, in which the protagonist returns from outer space as a crusty, tortured bloodsucker (another doomed, primitive first man). Memory, history, and even the future, are literally garbage. The tightly interwoven group of works, swinging between future and already-past, looks at the contraction of history in relation to social myth and personal biography.

The confluence of virtually all of these subjects—cars, astronauts, Vietnam, the atomic bomb, Fuller's geodesic dome, the frontier, the desert, garbage, and prehistoric rock formations—appears in the work of Matthew Day Jackson. Timed for MIT's celebration of the fortieth anniversary of the Apollo 11 mission, *The Immeasurable Distance* (2009) included video, sculpture, and installation. Jackson's *Study Collection* is an enormous stainless steel shelf-unit (inspired by the artist's visits to the technological artifacts in the MIT Museum's basement storeroom). It includes models of all of the major missile systems from the German V1 and V2 through the Thor, Titan, and Cruise missiles, along with the Fat Man and Little Boy atomic bombs dropped on Japan, and thought-artifacts created in the artist's studio. *Study Collection* also includes another series of models that show the skull of Phineas Gage, an unfortunate railway-worker whose actual skull is in Harvard's Warren Medical Museum because he survived its penetration with a spike. A statue, *Lonesome Soldier*, pinned an astronaut's suit made from Vietnam-era military blankets against the wall, high above the gallery, as if looking downward, and also helpless. The aerial view was also invoked by two paintings both titled *August 6th, 1945* (2008–09)—named for the day the first atomic bomb was used

Mark Bradford, *Help Us,* 2008, rooftop installation at Carnegie International "Life on Mars" exhibition, Carnegie Museum of Art, Pittsburgh.

to end 140,000 lives. The two images present aerial views of two cities on rivers, but one is Hiroshima, Japan, and one is Washington, DC. This god-like view links the two cities in the history and legacy of the development of nuclear weapons, as well as outer space and Vietnam as frontiers.

New Orleans, like Cleveland and Detroit, has recently become a real rather than imagined site of disaster, of a kind of preview of apocalypse here in America. Hurricane Katrina's effect on New Orleans was ubiquitously compared to that of the bomb on Hiroshima by the media, though some noted that while the earlier disaster was planned and inflicted by humans, the latter was a natural occurrence, even if spurred by global warming. When President Bush went, finally, to visit New Orleans after Hurricane Katrina, Karl Rove allowed the press onto AirForce One with the President, unusual access for a closed regime. It was a bad decision: looking out the window, down onto and far removed from the disaster, Bush looked not empathetic, but detached, distant. He could not have seen the individual people on the ground, their

struggle to survive, to care for their loved ones, to save their homes. Imagining the view back from below, Mark Bradford's 2008 project for the Carnegie International spelled the words "HELP US" on the museum's roof, recalling the citizens of New Orleans who had used paint or tape on rooftops to write such messages as "THE WATER IS RISING PLEASE HELP" or "WE ARE AMERICANS PLEASE HELP." To whom are the words, visible only from the air, addressed: Rescue workers? President Bush? Aliens? The people of the future? Bradford used stone, rather than paint or tape, implying a problem at once archaic and enduring into the future, to be found by archaeologists. He also traveled to New Orleans in 2008, where, in the Lower 9th Ward, a vast landscape of wiped-out houses, he built *Mithra*, an ark, from reclaimed wood and signage (brought down from his Leimert Park neighborhood in South Central Los Angeles, a place with its own history of disaster). The ark obviously anchors the Biblical narrative of new beginnings predicated on disaster; the title refers to a still more ancient mythology of rebirth. The upheaval Bradford hopes for is still to come: "I have always liked potentiality better than actuality. We all wait for the storm."[54]

The storm that Bradford seeks seems to be on its way. Not only, literally, in extreme climate change, but also, finally, maybe really, in the end of America that so many see prefigured in the current economic and political situation. The short American century, which began with the economic ascension of the country in the 1920s, reached its highpoint with the end of World War II; at the same time, many claimed that moment of domination was also the end of America as historically constituted, as it marked the full entanglement of the nation in global affairs. One end after another has followed: recessions, military defeats in Vietnam and the Middle East, the attack on American ground of September 11, 2001, the economic crash of 2008. From even the slight distance of a few years, they seem of a piece, part of the same end, as well as a ritualistic repetition of America's historical pattern of crisis, always already a ruin. Is this latest crisis just a repetition, or part of a long good-bye?

References

Preface

1 Ralph Waldo Emerson, Journal GL [1861–2], reprinted in *The Journals and Miscellaneous Notebooks of Ralph Waldo Emerson*, vol. XV, *1860–1866*, ed. Ralph H. Orth (Cambridge, MA, 1982), p. 166.
2 Lee Lozano, notebooks, April 24, 1969, quoted in Lucy Lippard, *Six Years: The Dematerialization of the Art Object from 1966 to 1972* (Berkeley, CA, 1997), p. 101.
3 See, for example, David Noble, *Death of a Nation: American Culture and the End of Exceptionalism* (Minneapolis, MN, 2002). There is an enormous literature on American exceptionalism, now coming in yet another new wave.
4 The necessary correction to the bias for using European modernism as a lens for postwar America has been undertaken by historians of American art. All too often, however, they take the position of defending the art seen as provincial and American, excluded from the story. This advocacy not only leads to equally warped history (and occasionally the seemingly bitter denigration of Abstract Expressionism), but the advocacy of America, rather than a critical understanding. For the purposes of this book, it is more important to note that the content of American studies and American history in the immediate postwar period was elegiac, rather than triumphalist.
5 Eric Hobsbawm, *The Age of Extremes: The Short Twentieth Century, 1914–1991* (London, 1994).

1 Beginning and End

1 Robert Enright, "Death Defier: The Art of Dana Schutz" (interview), *Border Crossings*, 92 (2004), p. 50.
2 Originally a talk in 1950, published in 1951. Perry Miller, "The End of the World," *William and Mary Quarterly*, 8, no. 2 (April 1951), pp. 172–91.
3 Ibid., pp. 186, 190.
4 Freeman Dyson, *Disturbing the Universe* (New York, 1981), p. 61.
5 Harold Rosenberg, "École de New York," as cited in Relyea, "Modernist Jeremiad," p. 69.
6 See Paul Boyer, *By the Bomb's Early Light: American Thought and Culture at the Dawn of the Atomic Age* (New York, 1985), pp. 237–40, on the Bomb

and a revival of eschatological thinking, in particular the rhetoric and ascension of Billy Graham. See Sacvan Bercovitch, *The American Jeremiad* (Madison, WI, 1978), on the tradition of the rhetoric of crisis in the American Protestant tradition. Thanks very much to Lane Relyea for pointing me towards Bercovitch, and sending me his own Master's thesis, which used Bercovitch to analyze American art criticism. Lane Relyea, "Modernist Jeremiad: Abstract Art and the American Dream circa 1967" (MA thesis, Department of Art and Art History, University of Texas at Austin, December 1997).

7 Barnett Newman, "Response to the Reverend Thomas F. Mathews" [1967], in *Barnett Newman: Selected Writings and Interviews*, ed. John P. O'Neill (New York, 1990), p. 287.

8 Barnett Newman, "The New Sense of Fate" [1948], in *Barnett Newman: Selected Writings and Interviews*, p. 169.

9 Sam Hunter, "The United States," in *Art Since 1945* (New York, 1958).

10 See, for example, John Anthony Thwaites, "Report on Documenta II," *Arts*, 34, no. 2 (November 1959), pp. 44–9; Lawrence Alloway, "Before and After 1945: Reflections on Documenta II," *Art International* (1959), pp. 29–36, and in the same issue, Friedrich Bayl, "Die II Documenta," pp. 37–42 and Pierre Restany, "Documenta II," pp. 43–60.

11 For *Art Since 1945*, see, for example, Thomas B. Hess, "How to Ignore Modern Art," *Encounter*, 12, no. 4 (April 1959), pp. 52–4; May Natalie Tabak, "Art Since 1945," *It is*, 3 (Winter–Spring 1959), pp. 38–9; E. A. Navaretta, "The Epos of the Eye," *ArtNews*, 57, no. 10 (February 1959), pp. 44, 63–5.

12 There seems to be some slight tendency for surveys beginning in 1940 to emphasize continuity between the first and second halves of the century, between European modernism and American contemporary art. This tendency is most pronounced in a recent survey, *Art Since 1900*, which surveys the twentieth century as a piece, both as a device to coordinate it with the college-level modern art courses for which it is intended, and more pointedly, to support the authors' own interest in connecting the European avant-gardes (particularly Surrealism) to the more recent American artists they support.

13 Clement Greenberg, "The Crisis of the Easel Picture" [1948], in *The Collected Essays and Criticism*, vol. 2: *Arrogant Purpose, 1945–1949*, ed. John O'Brian (Chicago, IL, 1986), pp. 221–5.

14 Harold Rosenberg, "The American Action Painters," *ArtNews*, 51, no. 8 (December 1952), pp. 22–3, 48–50.

15 The "Sessions at Studio 35," as they were called, were published: Bernard Karpel, Robert Motherwell, and Ad Reinhardt, eds., *Modern Artists in America*, no. 1 (New York, 1951), p. 11.

16 Ibid.

17 Ibid., pp. 11–12.

18 David Smith, "David Smith, Sculptor," *Everyday Art Quarterly*, 23 (1952), p. 20.

19 William Baziotes, Letter to Dorothy Miller, excerpted in *15 Americans*, ed. Dorothy Miller (New York: MoMA, 1952), 12.

20 Thomas B. Hess, "De Kooning Paints a Picture," *Art News*, 52 (March 1953), pp. 30–32, 64–7.

21 Ibid., p. 30.

22 Samuel Wagstaff, Jr., "Talking with Tony Smith," *Artforum*, 5, no. 5 (December 1966), 19.

23 Ibid., 19.

24 Berton Roueché, "Unframed Space," *New Yorker*, 26, no. 24 (August 5, 1950), p. 16.

25 Michael Fried, "Art and Objecthood," *Artforum*, 5, no. 10 (June 1967), pp. 12–23. This exchange has been discussed extensively in the secondary art-historical literature, particularly by those of my generation. I am hesitant to recount the story yet again. But while many of the accounts are creative and engaging, most ignore the historical American sources for the philosophical content. On the question of the negative connotations of duration, we might look generally to the American tradition of privileging space over time. More specifically, although probably not exclusively, we might look to F. O. Matthiessen, whose *The American Renaissance* of 1941 was key to the American studies tradition to which Miller and other influential figures belonged. He cites Emerson's belief that "when we come to the quality of the moment we drop duration altogether" and Thoreau's search for a life in which "the moment becomes infinitely larger than itself" (cited in David Noble, *Death of a Nation: American Culture and the End of Exceptionalism*, Minneapolis, MN, 2002, p. 99).

26 What Smith and Smithson saw was also a commonplace of postwar America; as Donald Judd wrote in a 1964 review of MoMA's *Twentieth-Century Engineering*: "Dams, roads, bridges, tunnels, storage buildings and various other useful structures comprise the bulk of the best visible things made in this century . . . Until lately art has been one thing and everything else has been something else. These structures are art and so is everything made." Donald Judd, "Month in Review," *Arts Magazine* (October 1964), reprinted in Judd, *Complete Writings, 1959–1975* (Halifax, Nova Scotia, 1975), pp. 137–8. I would put this in the American tradition of "everyday art" and a preference for directly made objects.

27 Krauss and Fried *et al.* lionized Greenberg, in their own recounting, as a counter to the unscientific writing of Rosenberg, Thomas Hess, Dore Ashton, and others. The bitterness of the divide at the time was captured in Greenberg's "How Art Writing Earns its Bad Name," *Encounter* (December 1962), pp. 67–71.

28 Krauss, in Amy Newman, *Challenging Art: Artforum 1962–1974* (New York: 2003), pp. 292–3.

29 Rosalind Krauss, "A View of Modernism," *Artforum*, 11, no. 1 (September 1972), pp. 48-51.

30 See, for example, for "post-formalism," Jack Burnham, "Systems Esthetics," *Artforum*, 7, no. 1 (September 1968), p. 32. Burnham is iterating an early version of the postmodern shift from objects to images or activities; Robert Pincus-Witten used "post-Minimalism" in a variety of monographic and general essays in *Artforum*, beginning in 1969, and eventually titled a

collection of his writings "Post-Minimalism." He defines the phenomenon as a movement with a canon of originators in "Eva Hesse: Post-Minimalism into Sublime," *Artforum*, 10, no. 3 (November 1971), pp. 32–44.

31 Burnham, "Systems Esthetics," p. 31.

32 For a brilliant analysis of the relationship between the relationship of postmodernism as a category in the New York art world and the larger theoretical realm, see Chris McAuliffe, "Idées Reçues: The Role of Theory in the Formation of Postmodernism in the United States, 1965–1985" (unpublished doctoral dissertation, Harvard University, 1997).

33 Smithson, "Conversation in Salt Lake City," Interview with Gianni Pettena [1972], in Jack Flam, ed. *Robert Smithson, The Collected Writings* (Berkeley, CA, and Los Angeles, 1996), p. 298. For parallels and connections between Smithson and William Carlos Williams (his pediatrician), see Ann Reynolds, *Robert Smithson: Learning from New Jersey and Elsewhere* (Cambridge, MA, 2004).

34 The frontier thesis was formulated by Frederick Jackson Turner in "The Significance of the Frontier in American History," which he first delivered to a gathering of historians in 1893 at the World's Columbian Exposition, a huge fair to mark the four-hundredth anniversary of Columbus's voyage. Enormously influential for decades afterward, it has been the subject of much recent criticism and debate.

35 See David Noble, "The Birth and Death of American History," in *Death of a Nation*, pp. 1–37.

36 Dave Hickey, "Earthscapes, Landworks and Oz," *Art in America* (September–October 1971), reprinted in *Land and Environmental Art*, ed. Jeffrey Kastner (London, 1998), p. 198.

37 Turrell in Craig Adcock, *James Turrell: The Art of Light and Space* (Berkeley, CA, 1990), p. xx.

38 In his take on the suburb or edge city, Sternfeld was related to other photographers who have been grouped as New Topographics artists. Where he differed from Robert Adams and the others was his deep interest in American history and travel narratives, and their roots in biblical mythology.

39 Dorothea Lange and Paul S. Taylor, *An American Exodus: A Record of Human Erosion* (New York, 1939).

40 Edward Weston, "My Photographs of California," *Magazine of Art*, 32, no. 1 (January 1939), p. 32.

41 Eudora Welty, "Introduction," in William Eggleston, *The Democratic Forest* (London, 1989).

42 Michele Cone, "Cady Noland" (interview), *Journal of Contemporary Art*, 3 no. 2 (Fall–Winter 1990), pp. 20–25.

43 Alain Ehrenberg, *The Weariness of the Self: Diagnosing the History of Depression in the Contemporary Age* (Montreal, 2009), pp. xvii–xxi.

44 Cone, "Cady Noland."

45 Andrew Holleran, *Ground Zero* (New York, 1988).

46 Ibid., p. 12.

47 Nicholas D. Kristof, "An American Hiroshima," *New York Times* (August 11, 2004), A19. The crank nature of this rhetoric culminated in David J.

Dionisi, *American Hiroshima: The Reasons Why and a Call to Strengthen America's Democracy* (Bloomington, IN, 2005).

48 Cited in Boyer, *By the Bomb's Early Light*, p. 14.

49 Ron Rosenbaum, "Talkin' World War III," *Slate* (November 29, 2007); http://www.slate.com/id/2178792/, accessed April 20, 2010.

2 Black and White

1 A 1959 notebook page has a study for an announcement for a proposed gallery, a black silhouette of a ray gun, with the slogan of "Annihilate–Illuminate." Coosje Van Bruggen, *Claes Oldenburg: Mouse Museum/Ray Gun Wing* (Cologne: Museum Ludwig, 1979), p. 8, illustration b. According to the author, this is "Oldenburg's version of a paradoxical saying current in pop mysticism at the time."

2 Clement Greenberg, "The Present Prospects of American Painting and Sculpture" [1947], in *Collected Essays and Criticism,* vol. 1, p. 166.

3 Clement Greenberg, "Review of Exhibitions of Marc Chagall, Lionel Feininger, and Jackson Pollock" [1943], *Collected Essays and Criticism*, vol. 1, p. 165; "American Version of chiaroscuro" in "Review of Two Exhibitions of Thomas Eakins" [1944], in *Collected Essays and Criticism*, vol. 1, p. 220. There was another Jewish academic of his generation, a few years younger, who worked on race in what would come to be called American studies. Sidney Kaplan, who went to CUNY and seemed connected to socialist circles, is quoted in the preface of an edited volume as having used the phrase "American chiaroscuro," although there is no citation. Allan D. Austin, "Editor's Introduction," in Sidney Kaplan, *American Studies in Black and White: Selected Essays, 1949–1989* (Amherst, MA, 1996), p. xi. Perry Miller also described a "chiaroscuro effect" in American literature. In his 1956 study, *The Raven and The Whale* (obviously an allusion to the black and white of Poe and Melville), Miller discusses the early nineteenth-century writer Henry Cary, who wrote as "John Waters," and his use of "chiaroscuro." Miller says that the term was a cliché of nineteenth-century literary culture, and that it had many meanings. In New York at the time, it referred to the subtle shadings of Waters; it was also obviously used to mean the opposite, a harsh contrast of black and white, as Greenberg then used it. Perry Miller, *The Raven and The Whale* (New York, 1956), pp. 41–2. He dedicated the book to J. Robert Oppenheimer.

4 C.L.R. James, *Mariners, Renegades and Castaways: The Story of Herman Melville and the World We Live In* (1953; repr. Hanover, NH, 2001); James wrote the book while in prison at Ellis Island, putatively for immigration violations, but obviously in connection to his radical politics in a Cold War context.

5 Thomas Hess, *Abstract Painting: Background and American Phase* (New York, 1951), p. 92. The extremes of North and South—also a tacit implication of black and white—and their uneasy link through the device of the Mississippi, and later the telegraph, is an undercurrent in the history of the nineteenth century and into the twentieth.

6 See Paul Gilmore, "The Telegraph in Black and White," *ELH*, 69 (2002), pp. 805–33.

7 For a discussion of the Kent editions, see the extremely informative book by Elizabeth A. Schultz, *Unpainted to the Last: Moby-Dick and Twentieth Century American Art* (Lawrence, KS, 1995).

8 For a full discussion of all of this, see Schultz's chapter "Abstract Expressionist Paintings and Sculptures of Moby-Dick," in *Unpainted*, pp. 129–60. The book is very well researched, although the author seems occasionally not quite conscious of the artistic differences between figures like Robert Motherwell and Kelly.

9 Harold Rosenberg, "The American Action Painters," p. 48.

10 Charles Olson, *Call Me Ishmael* (San Francisco, 1947); reprinted in *Collected Prose: Charles Olson*, ed. Donald Allen and Benjamin Friedlander (Berkeley, CA, 1997), p. 17.

11 Charles Olson, "Cy Twombly" [1952 exhibition catalog preface], reprinted in *Collected Prose: Charles Olson*, p. 175.

12 Ibid.

13 Ibid., pp. 175–6. It is quite possible that he was also describing a problem or interest of slightly older artists he knew, particularly Pollock, who titled a work with black figures amidst a poured and dripped ground *Shadows No. 2*, 1948. And one section of Morton Feldman's music for Namuth's film (commissioned by Pollock, who was friendly with the composer), was titled "Jackson Pollock: Shadow."

14 Judith E. Bernstock, *Joan Mitchell* (New York, 1988), p. 39.

15 D. H. Lawrence, *Studies in Classic American Literature* [1923] (New York, 1977), p. 169.

16 Richard Wright, *Native Son* (New York, 1940), p. 129. Elizabeth Schultz has convincingly argued that Wright's *Native Son* plays on *Moby-Dick* (one of his very favorite books; he owned the Rockwell Kent edition as well as Lewis Mumford's 1929 book on Melville). Elizabeth Schultz, "The Power of Blackness: Richard Wright Re-Writes Moby-Dick," *African American Review*, 33, no. 4 (Winter 1999), pp. 639–54.

17 See Toni Morrison, *Playing in the Dark*, for an analysis of Poe's importance in establishing the Africanist presence as an Other against which whiteness was defined, and for the centrality of black and white imagery to his work. The American literary fascination with snow was also related to the early seventeenth-century experience of the cold of New England. The world was going through a "Little Ice Age," but the harshness of the cold, and the extreme variability of the weather seems to have been particularly strong and shocking in the Northeastern area of the continent. The settlers, of course, were not used to hurricanes and blizzards as natural events. Kevin Rozario, *The Culture of Calamity: Disaster and the Making of Modern America* (Chicago, IL, 2007), p. 35, n. 10.

18 Stevens's image here calls up Emerson's transparent eyeball.

19 Richard Shiff, "Whiteout: The Not-Influence Newman Effect," in *Barnett Newman*, ed. Ann Temkin (Philadelphia: Philadelphia Museum of Art, 2002), p. 104. Temkin also connects Newman's sense of white to Melville's

as a positive entity rather than the void or emptiness that she takes white to signify in Cage and Rauschenberg. Ann Temkin, "Barnett Newman on Exhibition," *Barnett Newman*, ed. Temkin, p. 44.

20 Here too, race is tacit, as Henderson has with him an orphan, a child of color, in specific contrast to the empty white around him. Bellow, *Henderson the Rain King* (New York, 1996), p. 341.

21 After World War II in Japan, *Invisible Man* movies served as allegorical explorations of the atomic bomb, much like Godzilla, using tropes of blindness and visibility. See Akira Mizuta Lippit, *Atomic Light (Shadow Optics)* (Minneapolis, MN, and London, 2005), pp. 82–3.

22 Ralph Ellison, *The Invisible Man* [1955] (New York, 1995), p. 6.

23 John Cage, statement published in Emily Genauer's column in the *New York Herald Tribune* (December 27, 1953), sect. 4, 6. Both, according to Tomkins, had once considered becoming ministers.

24 The announcement for Parsons's show of 1951 has a mostly empty white field with an arrow pointing from the left side of the announcement toward a dot on the right side—like the dot and double arrow in a lost vertical painting that may have been in the show, as well as a bit like the red star in the lower right-hand corner of *White Painting with Numbers*, 1950, the red circle at center of one flower amidst two rows of otherwise black and white flowers of *Eden*, 1950, and a red circle in the lower right of *Untitled*, 1950. The graphic seems to function as an emphatic "you are here" punch in the images. It also suggests that there is no natural orientation, a way of expressing the American wish for no hierarchy, related to Newman's human presence in a sublime without social markers, but again, with a lighter, even absurdist (if no less profound) spirit.

25 Cage, statement, sect. 4, 6.

26 It's not clear what de Kooning's thoughts on race were, although he was not, for a man of his generation, particularly racist; he may have been interested in the protagonist's ambivalent status as both black and white, as well as the symbolism of Joe Christmas as Christ, an outcast who died at 33, crucified at the book's end, a subject of lifelong interest to the artist. "Well, he read *Light in August*. He adored Faulkner and he loved Faulkner's endless sentences. He just was lost in admiration over how much would happen in one sentence. He talked of a sentence where a man was failing and then there was a great deal of memory involved before Faulkner got to the end of the sentence, and Bill just loves that. His way of reading is to become totally immersed in an author, and back then, in the late '40s and the early '50s, he was very much involved with Faulkner." Phyllis Tuchman, interview with Elaine de Kooning (August 27, 1981) for the Archives of American Art, Smithsonian Institution. For a general account of de Kooning and Faulkner, see Charles Stuckey's very interesting "Bill de Kooning and Joe Christmas," *Art in America*, vol. 68, no. 3 (March 1980), pp. 66–79.

27 Willem de Kooning, "What Abstract Art Means to Me," *Bulletin of the Museum of Modern Art*, 18, no. 3 (Spring 1951), p. 7.

28 John Hersey, *Hiroshima* [1946] (New York, 1959), p. 67.

29 Lippit, *Atomic Light*, p. 94, citing Paul Virilio at length. Lippit makes this

excellent point, and also quotes de Kooning, but his focus is on atomic representation in Japanese, and to a lesser extent, American cinema throughout the twentieth century.

30 Newman, "A Conversation: Barnett Newman and Thomas B. Hess," *Barnett Newman: Selected Writings and Interviews*, pp. 276–7, 282. Both Richard Shiff and Mark Godfrey cite an unbroadcast remark in an interview with Alan Solomon in which Newman states that the sufferings of Hiroshima or Vietnam today are much worse than those suffered by Christ at the crucifixion.

31 In a 1966 talk with Hess at Guggenheim, quoted by Hess, in "Barnett Newman: The Stations of the Cross–Lema Sabacchthani," in *American Art at Mid-Century: The Subjects of the Artist* (Washington, DC: National Gallery of Art), p. 206.

32 Newman in *ArtNews* (April 1966), reprinted as Appendix B to Hess's essay in *American Art at Mid-Century*, p. 212.

33 "Joan Weissman, who was living with Lewis when he painted *Every Atom Glows*, recalled that the work addressed the Bomb and the Cold War, but also Lewis' ambivalent feelings toward Albert Einstein." Ann Gibson, "Black is a Color: Norman Lewis and Modernism in New York," in *Norman Lewis: Black Paintings, 1956–1977* (New York: Studio Museum in Harlem, 1998), p. 20.

34 Hughes wrote a column for the *Chicago Defender* as the character Simple. Cited in Paul Boyer, *By the Bomb's Early Light: American Thought and Culture at the Dawn of the Atomic Age* (New York, 1985), p. 199, n. 12.

35 In a more recent case of urban disaster as social planning opportunity, Spike Lee, focusing on the government's systematic neglect (before and after Katrina) of black neighborhoods in New Orleans: "It looked like what I assume Hiroshima looked like after World War II. I just couldn't believe this was happening right now in America."

36 William Seitz, *The Art of Assemblage* (New York: Museum of Modern Art, 1961), p. 89.

37 See Brenda Richardson's meticulous catalog, *Frank Stella: The Black Paintings* (Baltimore: Baltimore Museum of Art, 1976).

38 Cited in Barbara Rose, *Claes Oldenburg* (New York: Museum of Modern Art, 1970), p. 24.

39 Oldenburg, "Notes" [1968, reflecting on 1960], reprinted in Rose, *Claes Oldenburg*, p. 195.

40 Denby goes on, "Luck has uncovered this bloom as a by-produce/Having flowered too out behind the frightful stars of night." Rauschenberg's detritus-covered *Night Blooming* series, urban, even in its dirt and gravel, reminds one of Denby's sonnet. These artists were all nocturnal, if only to flaunt their non-normative work hours, in particular de Kooning, Kline, and Lewis. Denby, "The Silence at Night," in Edwin Denby, *Dance Writings and Poetry*, ed. Robert Cornfield (New Haven, CT, and London, 1998), p. 11.

41 Oldenburg, originally written in 1961, then edited and published in 1967, the version printed in Rose, *Claes Oldenburg*, p. 190.

42 In Joshua A. Shannon, "Claes Oldenburg's 'The Street' and Urban Renewal in Greenwich Village, 1960," *Art Bulletin*, 86, no. 1 (March 2004), p. 144.

43 There is a long history of artists picking up both industrial materials and detritus from Canal Street, one of New York's main commercial streets.

44 Oldenburg, 1961, cited in Van Bruggen, *Claes Oldenburg: Mouse Museum*, p. 15. In a 1961 performance, *Circus (Fotodeath/Ironworks)*, he split the stage in half, one side being black and white, the other color, representing the masculine and feminine respectively. He saw the split between *The Street* and *The Store* in the same terms. Oldenburg, "Notes," 1961, as cited by Ellen H. Johnson, *Claes Oldenburg* (Baltimore, MD, 1971), p. 16.

45 Rose, *Claes Oldenburg*, p. 37; Rose, as cited in Shannon, "Claes Oldenburg's 'The Street' and Urban Renewal in Greenwich Village, 1960," p. 147.

46 Rose, *Claes Oldenburg*, p. 37.

47 He also cited fires, perhaps influenced by the Red Grooms happening of 1959, *The Burning Building*, which he had seen. Also, for Oldenburg's first show at the Judson that season, he installed sculptures made mostly of newspaper mixed into wheat paste and laid over chicken wire forms. Often called "the white show" (including by Rose), Johnson states that the artist told her it "should be designated as black, white and grey; it was basically a study of light and shadows on the street" (Johnson, *Claes Oldenburg*, p. 13).

48 For an extended discussion of this work, although with limited attention to the questions of race and/or primitivism, see Shannon, "Claes Oldenburg's 'The Street.'"

49 Oldenburg, together with his interest in profiles, was much interested in stereotypes, particularly in the Happenings, such as *Injun* (a Twainism), for their parable-like character. But it is not clear that he is dealing with racial stereotypes.

50 For an extended and very interesting discussion of the exhibition, see James Meyer, *Minimalism: Art and Polemics in the Sixties* (New Haven, CT, and New York, 2001), pp. 77–80.

51 In a 1965 notebook, Jasper Johns advised himself to "avoid a polar situation." And indeed, his work is more gray than black and white. In 1967 Yvonne Rainer linked Alain Robbe-Grillet, as was common at the time, to Morris's Minimalist sculpture, citing its "flatness and grayness" as bespeaking "inertness and retreat. Its simplicity becomes 'noncommunicative,' or 'noncommittal.'" Quoted in Carrie Lambert-Beatty, "Other Solutions," *Art Journal*, 63, no. 3 (Autumn 2004), p. 52. For further discussion, see James Rondeau, "Jasper Johns: Gray," in *Jasper Johns: Gray*, ed. James Rondeau and Douglas Druick (Chicago: Art Institute of Chicago, 2008), pp. 22–79.

52 Bob Holman, "Richard Tuttle" (interview), *Bomb* 41 (Fall 1992), p. 34.

53 Dwight Macdonald, "A Theory of Mass Culture," *Diogenes*, 1, no. 3 (June 1953), pp. 1–17.

54 One of which, *Small Race Riot*, a grouping of four small canvases, was owned by Robert Mapplethorpe. Presumably it came to him through Wagstaff, his lover and a prodigious collector. It's an odd footnote to Mapplethorpe's own sexual objectification of black men in his photographs (and presumably his life), later the subject of a scathing art work by Glenn Ligon and Kobena Mercer, *The Black Book*. Also, as an aside, it's interesting that most of the race riots were titled after their color (e.g., *Mustard Race*

Riot); those that are black and white are called *Little Race Riot* or *Birmingham Race Riot* (a print), or simply *Race Riot*, which would seem to indicate Warhol's awareness of the racial implication of color, that "White Race Riot" or "Black Race Riot" might sound odd.

55 Bruce Glaser, "Oldenburg, Lichtenstein, Warhol: A Discussion," *Artforum*, 4, no. 6 (February 1966), p. 24.

56 Bearden, like Eggleston, from very different perspectives derided the corniness of *Life* magazine photojournalism. *William Eggleston: Democratic Camera. Photographs and Video, 1961–2008*, ed. Elisabeth Sussman and Thomas Weski (New Haven, CT, 2009), p. 261; Lee Stephens Glazer, "Signifying Identity: Art and Race in Romare Bearden's Projections," *Art Bulletin*, 76, no. 3 (September 1994), pp. 411–26.

57 Lisa E. Farrington, *Faith Ringgold* (Petaluma, CA, 2004), p. 33.

58 Ringgold and Lewis both cite Reinhardt, Lewis going so far as to say that perhaps he did something closer to Black expression than the work of some Black artists. It may be that he is cited for his political and social anti-racism as much as his formal interest in the color black.

59 Faith Ringgold, *We Flew over the Bridge*, pp. 162–3, cited in Patrick Hill, "The Castration of Memphis Coly: Race, Gender, and Nationalist Iconography in the Flag Art of Faith Ringgold," in *Dancing at the Louvre: Faith Ringgold's French Collection and Other Story Quilts* (Berkeley, CA, 1998).

60 Quoted in Lucy Lippard, "Beyond the Pale: Ringgold's Black Light Series," in *Faith Ringgold: Twenty Years of Painting, Sculpture, Performance (1963–1983)* (New York: Studio Museum in Harlem, 1984), p. 22.

61 David Joselit also makes the connection between Johns and Hammons and Walker in "Notes on Surface: Toward a Genealogy of Flatness," *Art History*, 23, no. 1 (March 2000), pp. 19–34. While all stress distortion of the figure in disjunction with the putative truthfulness of the silhouette's indexical nature, Johns emphasizes spreading as well as containment.

62 For a reading of Johns's early work, including *Skin* and *Shade* as about isolation and interiority connected to an American tradition including Poe, Melville, and Ryder, see Robert Morris, "Jasper Johns: The First Decade," in *Jasper Johns: An Allegory of Painting, 1955–1965*, ed. Jeffrey S. Weiss (New Haven, CT, 2007), pp. 208–35. For writing on self-transformation, see Richard Shiff, "Metanoid Johns, Johns Metanoid," in Rondeau and Druick, *Jasper Johns: Gray*, p. 127.

63 Johns's *Shade*, 1959, which Leo Steinberg owned and which for him represented an apocalyptic nightfall with bursts of light; Hammons's *Black Boy's Window*, 1968, in which a body print is screened onto a windowpane that had a shade to be opened or closed by the viewer. The reference to the second work is in Kellie Jones, "The Structure of Myth and the Potency of Magic," in *David Hammons: Rousing the Rubble* (Cambridge, MA and New York, 1991), p. 17.

64 According to a childhood friend, his favorite radio character. Victor Bockris, *The Life and Death of Andy Warhol* (New York, 1989), p. 57.

65 Kerry James Marshall, on the television program *Art21*. http://www.pbs.org/art21/artists/marshall/clip1.html.

66 Bearden, 1964, as cited in Glazer, "Signifying Identity," p. 414.
67 Ibid., p. 422.
68 *Art21* interview.
69 Thierry de Duve, "Ryman irreproductible," *Parachute*, 20 (Fall 1980),
 pp. 18–27; Suzanne Hudson, "Robert Ryman, Retrospective," *Art Journal*,
 64, no. 3 (Fall 2005), p. 63.
70 Artist Matthew Brannon cites Sherman's statement that she would have no
 history without watching movies on television. Brannon, "Like It or Not,"
 Artforum, 47, no. 6 (February 2009), p. 58.
71 Art historian Michael Leja has argued that Abstract Expressionism was
 deeply influenced by film noir, but he gets the feel of it wrong: those artists
 were not cynical so much as fearful and ecstatic in their will to live and act
 as they wanted. The later generation of artists that included Longo, Sherman,
 and Salle was much more closely linked to film noir, and draw on it much
 more directly. Michael Leja, *Reframing Abstract Expressionism: Subjectivity
 and Painting in the 1940s* (New Haven, CT, 1993).
72 Paul Taylor, "David Salle" [1987], reprinted in Taylor, *After Andy: Soho in
 the Eighties* (Melbourne, 1995), p. 38.
73 Lucy Lippard, "Retrochic, Looking Back in Anger," *Village Voice*, 24, no. 50
 (December 10, 1979), pp. 67–9.
74 Richard Price, "Save the Last Dance For Me," in *Richard Longo: Men in the
 Cities, 1979–1982* (New York, 1986), p. 87.
75 Richard Longo, "Interview with Richard Price," in *Richard Longo: Men in
 the Cities, 1979–1982* (New York, 1986), p. 91.
76 Carter Ratcliff, *Robert Longo* (New York, 1985), p. 18.
77 Charles Olson, in *Mythologos: The Collected Lectures and Interviews*, ed.
 George F. Butterick, vol. 1 (Bolinas, CA, 1978–79), p. 133.
78 Richard Dyer, *White* (London and New York, 1997).
79 See in particular, Theodore W. Allen, *The Invention of the White Race*, 2 vols.
 (London, 1994).
80 Katharine Kuh, "Franz Kline" [1963]. Reprinted in *Franz Kline 1910–1962*,
 ed. Carolyn Christov-Bakargiev (Milan: Skira Editore and Castello di Rivoli,
 2004), p. 134.
81 "Conversations with Contemporary Artists" (New York: Museum of
 Modern Art 1999); http://www.moma.org/onlineprojects/conversations/
 kw_f.html.
82 Jerry Saltz, *Recent Tendencies in Black and White* (New York, Sidney Janis
 Gallery, 1987), p. 6.
83 Basquiat used nine sheets of paper in a 3 x 3 grid. He wrote the book's
 chapter titles in black crayon in the top two rows; on the bottom row he
 listed synonyms for the whale, two key phrases from the novel (one of which
 is "Call me Ishmael"), and a few words from the book.
84 "The Poetry of Form" [1996], reprinted in *Mike Kelley: Minor Histories:
 Statements, Conversations, Proposals*, ed. John C. Welchman (Cambridge, MA,
 2004), p. 98.
85 Kara Walker, in interview for television program *Art21*: http://www.pbs.org/
 art21/artists/walk/clip1.html.

86 Ibid.
87 Ibid. Ralph Ellison titled his 1964 collected essays *Shadow and Act*, taking the title from T. S. Eliot's *The Hollow Men*, and clearly drew on some scenes of the shadow's suspension between absence and presence:

> Between the idea
> and the reality
> Between the motion and the act
> Falls the Shadow.

See John Samuel Wright, *Shadowing Ralph Ellison* (Jackson, MI, 2006), p. 15.
88 For a tie between Walker's work and Poe's use of the shadow as a figure for death, see Gwendolyn DuBois Shaw, *Seeing the Unspeakable: the Art of Kara Walker* (Durham, NC, 2004), p. 43.
89 http://www.pbs.org/art21/artists/walk/clip2.html.
90 "I also remember Steven's announcement in the late '90s that he would only make silver-colored aluminum paintings and black paintings—nothing else. And he did!" "Dark Star: Bob Nickas and Jutta Koether on Steven Parrino," *Artforum*, 43, no. 7 (March 2005), p. 59.
91 Quoted interview with Jack Goldstein in Steven Parrino, "The No Texts" in *The No Texts* (Jersey City: Abaton Book Company, 2003), p. 46.
92 "If works of art are to survive in the context of extremity and darkness, which social reality, and if they are to avoid being sold as mere comfort, they have to assimilate themselves to that reality. Radical art today is the same as dark art: its background color is black." Theodor Adorno, "Black as an ideal," in *Aesthetic Theory* [1970] (London, 1997), pp.39–40. T. J. Clark ascribes to modernism the belief in pure negativity, pure abstraction and reference only to art itself that ends up offering up exactly nothing in the black square or the very thin sheet of paint; I would argue that this distinguishes European modernism from the American contemporary as a mode of operation.
93 Steven Parrino, Interview with Marc-Olivier Wahler [April 1998], reprinted in *La Marque noire* (Paris, 2007), p. 28.
94 Michele Cone, "Cady Noland" (interview), *Journal of Contemporary Art*, 3 no. 2 (Fall–Winter 1990), pp. 20–25.
95 Amy Granat, statement quoted in press release, 2006.
96 Clement Greenberg, "Review of Exhibitions of the Jane Street Group and Rufino Tamayo" [1947], in *The Collected Essays and Criticism, Volume II: Arrogant Purpose, 1945–1949*, pp. 133–4.

3 Success and Failure

1 Dwight Macdonald, "Masscult and Midcult," in *Against the American Grain* (New York, 1962), p. 64.
2 "Love Minus Zero/No Limits," 1965.
3 Franz Kline, in "Abstract Art Around the World Today," forum presented by the American Abstract Artists at MoMA, 1954. Reprinted in *Franz Kline 1910–1962*, ed. Carolyn Christov-Bakargiev (Milan, 2004), p. 98.

4 Mark Rothko, "The Romantics Were Prompted," *Possibilities*, 1 (1947–48), p. 84.

5 As quoted in Howard Singerman, "Duchamp in the Stieglitz Circle: Sherrie Levine's American Modernism," Georgia O'Keeffe Museum, Santa Fe, New Mexico. Paper delivered January 28, 2007. Thanks to Howard Singerman for sending me the paper. The statement is cited at greater length in James E. B. Breslin, *Mark Rothko: A Biography* (Chicago, IL, 1993), pp. 293–4.

6 De Kooning, too, argued later against reducing even the fine artist to a single commercially identifiable style (and also tacitly against formalism): "There's no way of looking at a work of art by itself. It's not self-evident. It needs a history . . . It's part of a whole man's life . . . Certain artists you like very much on the basis that they did stick around and fulfilled themselves more or less. You have an idea what he was after and then you kind of understand the person." In Robert Snyder, *Masters and Masterworks*, film of July 1955 interview with de Kooning, Snyder, and Michael Sonnabend. Transcript by Marie-Anne Sichere, p. 4.

7 See Michelle Bogart's fantastic *Artists, Advertising, and the Borders of Art* (Chicago, IL, 1995) for a discussion of the complex historical relationship between the fields of advertising or commercial art and fine art.

8 Rosenberg, "The American Action Painters," p. 22. The wall he refers to is probably the wall that the painting would hang on in the studio, the gallery, or possibly even a collector's home, but the use of the word hints of the name written on the wall as graffiti, a phenomenon that interested photographer Aaron Siskind, friend to de Kooning and Kline.

9 Quoted by Scott A. Sandage, *Born Losers: A History of Failure in America* (Cambridge, MA, 2003), p. 13.

10 "Somebody" as a descriptor, one that carries with it the intimation of false or boastful representation, seems to come from the Bible: "For before these days rose up Theudas, boasting himself to be somebody; to whom a number of men, about four hundred, joined themselves: who was slain; and all, as many as obeyed him, were scattered, and brought to nought" (Acts 5:36, King James version). The term "Somebody" as an uppercase designation or category heading has been used often in the U.S. to refer to the striving for success that seems so central to American identity, and also by African Americans to refer to a wholly human, post-slavery condition—to be Somebody could also mean, "I am a man."

11 This has been argued by many scholars and critics, most notably Warren Susman, "Personality and the Making of Twentieth Century Culture," in *Culture as History* (New York, 1984). He cites the common advice of almost every early self-improvement manual: "Personality is the quality of being Somebody." Susman, "Personality," p. 277.

12 Eleanor Munro, "Reviews and Previews," *ArtNews*, 55, no. 4 (Summer 1956), p. 50.

13 Even before he found success, Still ordered his dealer Betty Parsons not to show his work to anyone who would not have insight into it, and above all not to show it to the "scribblers," his list of whom included the most powerful art critics of the day, as well as Alfred Barr.

14 Conversation with David Reed, April 2008.

15 Hilton Kramer, "Month in Review," *Arts*, 33, no. 10 (September 1959), p. 59.

16 As cited by Julia Robinson in *Claes Oldenburg: Early Work* (New York: Zwirner & Wirth exh. cat.).

17 Milton Resnick, interviewed by John Taylor [unpublished, 1972], cited in Ann Gibson, *Abstract Expressionism: Other Politics* (New Haven, CT, and London, 1997), p. 24.

18 This was an obviously ironic reply to Coplans's pressure on the artist for an emotional revelation about his breakthrough moment, in the language of Abstract Expressionist criticism, such as "crisis." John Coplans, "An Interview with Roy Lichtenstein," *Artforum*, 2, no. 4 (October 1963), p. 31.

19 Patrick Smith, *Andy Warhol's Art and Films* (Ann Arbor, MI, 1989), p. 89.

20 Andy Warhol and Pat Hackett, *POPism: The Warhol Sixties* (Orlando, FL, 1980), pp. 22–3.

21 Victor Bockris, *The Life and Death of Andy Warhol* (New York, 1989), p. 142.

22 Allan Kaprow, "The Artist as a Man of the World" [1964], in *The Blurring of Art and Life*, ed. Jeff Kelley (Los Angeles and Berkeley, CA, 1993), p. 50.

23 Bradford R. Collins, "Modern Romance: Lichtenstein's Comic Book Paintings," *American Art*, 17, no. 2 (Summer 2003), pp. 64–5. Collins convincingly argues, based on interviews with the artist and his circle, that many of Lichtenstein's works are allegories about his own wishes and career strivings. Thus *Masterpiece*, 1962, humorously addresses his hopes for a show at Castelli and the results it might engender.

24 Kynaston McShine, "Introduction," in *Andy Warhol: A Retrospective*, ed. Kynaston McShine (New York: The Museum of Modern Art, 1989) 13–23.

25 For an extended, if overly psychoanalystic discussion of Warhol and self-transformation, see Bradford R. Collins, "Dick Tracy and the Case of Warhol's Closet: A Psychoanalytic Detective Story," *American Art*, 15, no. 3 (Autumn 2001), pp. 54–79.

26 Interview with Lichtenstein by Bradford R. Collins, cited in Collins, "Modern Romance," p. 64, n. 11.

27 Coplans, "An Interview with Roy Lichtenstein," p. 31.

28 Ibid., p. 31. In his fascinating book, Michael Lobel makes an argument about Lichtenstein related to Caroline Jones's discussion of Frank Stella, observing that his work shares many qualities with contemporary trademarks, such as symmetry and economy of design. Michael Lobel, *Image Duplicator: Roy Lichtenstein and the Emergence of Pop Art* (New Haven, CT, 2002); see for example, pp. 48–9.

29 C. Wright Mills, "The Man in the Middle," *Industrial Design*, 5, no. 11 (November 1958), p. 70. He is talking about the shift from production to distribution, and the subordination of art (as well as science and the humanities in general) to business. Mills sounds like an Andy Warhol and Guy Debord fusion.

30 Cited in Sharon Zukin, *Loft Living: Culture and Capital in Urban Change* [1982] (New Brunswick, NJ, 1989), p. 97.

31 Andy Warhol, *The Philosophy of Andy Warhol from A to B* (New York, 1974), p. 178.

32 Howard Singerman, *Art Subjects: Making Artists in the American University* (Berkeley and Los Angeles, CA, 1999).
33 William Seitz, "The Rise and Dissolution of the Avant-Garde," *Vogue*, 142 (September 1963), pp. 182–3, 230–33.
34 Ibid., p. 231.
35 Ibid., p. 230.
36 Allan Kaprow, "Should the Artist Be a Man of the World?," *ArtNews*, 63, no. 6 (October 1964), pp. 34–7, 58–9. It's interesting to note that Barnett Newman seemingly endorsed the artist as a professional as meaning "serious" at a 1950 artists' roundtable, cited in Howard Singerman, *Art Subjects: Making Artists in the American University* (Berkeley, CA, 1999), p. 189. But in a 1966 interview with Alan Solomon, Newman, in contrast to Kaprow, disdained the idea of being an artist as a profession like that of a priest, lawyer, or even a poet. Instead, he says "Every man is an artist," and then of himself, conversely, "what I'd like to be is a man in the world." Not *of* the world, but *in* it. Interview transcript of Barnett Newman (March 20, 1966), p. 18, Alan Solomon Papers, AAA, reel 3923.
37 Kaprow, "Man of the World," p. 35.
38 Leo Steinberg, "Other Criteria," in *Other Criteria* (New York, 1972).
39 Robert Morris, "The Art of Existence: Three Extra-Visual Artists," *Artforum*, 9, no. 5 (January 1971), p. 28.
40 Carter Ratcliff, "Frank Stella: Portrait of the Artist as Image Administrator," *Art in America*, 73 (February 1985), pp. 94–107. Buchloh refers back to nineteenth-century Symbolist art and a general shift towards rationalism but seems unaware of the American history or sociology of the professional or the particulars of its local resonance among artists. Benjamin H. D. Buchloh, "Conceptual Art 1962–1969: From the Aesthetic of Administration to the Critique of Institutions," *October*, 55 (Winter 1990), p. 128.
41 "Painters Reply," *Artforum*, 14, no. 1 (September 1975), p. 26.
42 David Riesman, *The Lonely Crowd* (New Haven, CT, 1950).
43 Thomas B. Hess, editorial, "Artists and the Rat Race," *ArtNews*, 64, no. 9 (January 1965), p. 23.
44 Timothy Leary, "Start Your Own Religion" [1967] in *Tune In, Turn On, Drop Out* (Berkeley, CA, 1999), p. 3.
45 Ibid., p. 6.
46 Timothy Leary, *Flashbacks: An Autobiography* (Los Angeles, 1983), p. 253.
47 Bruce Conner, "Interview with Mia Culpa," in *Theories and Documents of Contemporary Art: A Sourcebook of Artists' Writings*, ed. Kristine Stiles and Peter Selz (Berkeley: University of California Press, 1966), p. 331.
48 Stan Brakhage, *Film at Wit's End* (New York, 1989), pp. 136–9.
49 Lee Lozano, notebook entry dates "SEPT 8, 71."
50 For a discussion of Lozano in the context of her peers, see Katy Siegel, "Another History is Possible," in *High Times, Hard Times: New York Painting, 1967–1975*, exh. cat. (New York, 2006).
51 Leary, "Religion," p. 16.
52 "Is It 'Mike' Enough? 21 Years Later, Mike Kelley Continues a Discussion with Michael Smith," in *Mike's World*, exh. cat. (Austin, TX: Blanton

Museum of Art, 2007), p. 26.

53 Ibid., p. 23, n. 17

54 Ibid., p. 23, n. 17.

55 Ibid., p. 23.

56 Ibid., p. 24.

57 In this, Koons was typical of East Village artist/music/personality denizens, many of whom seemed to enact a parody of American middle-class habits and mores, less a critique than a fond, funhouse version. For a discussion of Americana as an impulse of these artists, see Carlo McCormick, "The Periphery of Pluralism," in *The East Village Scene*, exh. cat., ed. Janet Kardon (Philadelphia: Institute of Contemporary Art, 1984) 20-55. Even the so-called "leftist" critique of the East Village, by Craig Owens, called it "puerilism"—the refusal to grow up, to be a man.

58 As cited by Katy Siegel in *Jeff Koons* (Berlin, 2009), p. 110.

59 Calvin Tomkins, "The Art World: Boom," in *The New Yorker*, vol. 56, no. 44 (December 22, 1980), p. 79.

60 Ibid., p. 78.

61 Ibid., p. 79.

62 And in fact a series of ads for the investment company Drexel Burnham Lambert the following year featured athletes such as Kareem Abdul Jabar and Wilt Chamberlain alongside Andy Warhol, urging even the middle-class reader that he was not "too small" to invest with the (Mike Milken-led junk bond) company.

63 As cited by Katy Siegel in *Jeff Koons*, p. 189.

64 James Hall, "They Call it Puppy Love," *The Guardian* (October 29, 1992), Features, p. 4.

65 Michael Kimmleman, "Jeff Koons," *New York Times* (November 29, 1991), C28.

66 Richard Prince, "Anyone Who Is Anyone," *Parkett*, 6 (1985), p. 68. It's a little odd, but when I think of the man with a martini in his hand, the commercial artist, I think of Darrin, the ad executive husband on *Bewitched*. Not only was he inept and bumbling at home, but because of a back injury on the part of Dick York, the first actor to play him, he spent several seasons mainly lying on the couch.

67 Ibid., 69.

68 Glenn O'Brien, "Mike Kelley" [interview], *Interview*, vol. 38, no. 10 (December 2008/January 2009), p. 202.

69 Keith Thompson, "What Do Men Really Want? A New Age Interview with Robert Bly," *New Age* (May 1982), p. 31.

70 Ibid.

71 Ibid.

72 See, for example, J. Robert Moskin, "The American Male: Why Do Women Dominate Him?" *Look*, vol. 22, no. 3 (February 4, 1958), pp. 76–80.

73 Judith Newton, *From Panthers to Promise Keepers: Rethinking the Men's Movement* (Oxford, 2005), pp. 140–41.

74 See Mike Kelley, "Three Projects: Half a Man, From My Institution to Yours, Pay for Your Pleasure," in *Mike Kelley: Minor Histories*, ed. John Welchman (Cambridge, MA, 2004), pp. 12–20.

75 This was an interest of the Pop artists as well. After his initial painting of Mickey Mouse and Donald Duck, Lichtenstein explicitly sought imagery from unknown, anonymous pulp comics of romance and war genres. And Warhol was particularly fascinated by the crediting and non-crediting of commercial artists and designers, often noting in interviews that now comic book color artists, for example, were beginning to be credited.

76 Ralph Rugoff, "Jim Shaw: Recycling the Subcultural Straitjacket" [interview], *Flash Art*, 63 (March/April 1992), p. 91. Shaw has said at various times that Billy's story was very close to his own, without the Christian conversion element.

77 Thompson, "What Do Men Really Want?," p. 32.

78 Interview with the author, September 11, 2009, New York City.

79 Newton, *From Panthers to Promise Keepers*, p. 173.

80 In a work of 1990, *Candyass Kitchen*.

4 The One and the Many

1 Quoted in Barbara Rose, "Introduction," *Readings in American Art, 1900–1959* (New York, 1975), p. 6. Marsden Hartley's painting *Warriors*, 1913 is the background of the Stieglitz photograph of Duchamp's *Fountain*, exhibited at Stieglitz's 291 gallery after being removed from the Armory. See Debra Bricker Balken's *Debating American Modernism: Stieglitz, Duchamp, and the New York Avant-Garde* (New York, 2003) for a discussion of the relationship between Duchamp and the early twentieth-century Stieglitz circle.

2 See Chapter 1, "Self, Culture, and Self-Culture in America," Joan Shelley Rubin, *The Making of Middlebrow Culture* (London and Chapel Hill, NC, 1992), pp. 1–33.

3 Henri, letter of 1916, in Robert Henri, *The Art Spirit* [1923] (New York, 1984), p. 131.

4 Holger Cahill, "Foreword: American Resources in the Arts," in *Art for the Millions: Essays from the 1930s by Artists and Administrators of the WPA Federal Arts Project*, ed. Francis V. O'Connor (Greenwich, CT, 1973), p. 35.

5 Russell Davenport, "A *Life* Roundtable on Modern Art," *Life*, 25 (October 11, 1948), pp. 56–9, 75–9.

6 Clement Greenberg, "Present Prospects," *The Collected Essays and Criticism*, vol. 1: *Arrogant Purpose, 1945–1949*, ed. John O'Brian (Chicago, IL, 1986), p. 162.

7 Ibid., p. 170.

8 Greenberg, "Where Is the Avant-Garde?," *Collected Essays and Criticism*, vol. 4, p. 264.

9 Alan Wallach, "The American Cast Museum: An Episode in the History of the Institutional Definition of Art," in Wallach, *Exhibiting Contradictions: Essays on the Art Museum in the United States* (Boston, MA, 1998), pp. 38–56.

10 Joshua C. Taylor, "The Art Museum in the United States," in Sherman E. Lee, ed. *On Understanding Art Museums* (Englewood Cliffs, NJ, 1975), p. 48. The account emphasizes that even smaller museums that had been run by a

director and volunteers or support staff begin to have curators, departments; in other words, they professionalized.

11 D. S. Defenbacher, "Editorial Note," *Everyday Art Quarterly*, no. 13 (Winter 1949–50), p. 14.

12 Joan Shelley Rubin, *The Making of Middlebrow Culture* (London and Chapel Hill, NC, 1992), p. 30.

13 Deirdre Robson, "The Avant-Garde and the On-Guard: Some Influences on the Potential Market for the First Generation Abstract Expressionists in the 1940s and Early 1950s," *Art Journal*, 47, no. 3 (Autumn 1988), pp. 215–21.

14 Cited in "The Arts and Mass Media" [1961], in Lawrence Alloway, *Imagining the Present*, ed. Richard Kalina (London, 2006), p. 58.

15 Lucy Lippard, "Freelancing the Dragon," *Art-Rite*, no. 5 (Spring 1974), p. 18.

16 Robert Morris, "Some Splashes in the Ebb Tide," *Artforum*, 11, no. 6 (February 1973), pp. 42–9; Bochner in Newman, *Artforum*, p. 397.

17 Hal Foster, "Against Pluralism" [1982], reprinted in Foster, *Recodings: Art, Spectacle, Cultural Politics* (Seattle, WA, 1985), p. 15.

18 Danto, who, along with Robert Rosenblum, was one of the few major critics to take pluralism seriously, gained a certain popularity writing about the end of art and the subsequent historical condition of a multiple postmodernism. Whatever one thinks about his version of history, someone like Danto wasn't creating a position or a line of "correct" art to promote. Foster, "Postmodernism: A Preface," in *The Anti-Aesthetic*, ed. Hal Foster (Seattle, WA, 1983), p. xi.

19 Peter Schjeldahl, "Gated," *The New Yorker* (February 28, 2005), pp. 30–31.

20 In John Miller, "Interview," *Index* (January 1997), p. 30.

21 Alfred Leslie, quoted in, "The Modern Gone By: Inspiration for a New Way of Art," *The New York Times* (November 18, 2004) Section E, p. 3.

22 James Auer, "Museum Identities Lost in Renaming," *Milwaukee Journal Sentinel* (August 25, 2005), p. 2E. See my "On Wisconsin," in *Around the Lakes* (Madison Museum of Contemporary Art, 2006).

23 Alexis de Tocqueville, *Democracy in America* [1835], vol. 2, trans. Henry Reeve (New York, 1904), p. 535.

24 Ibid.

25 James Parton, *Triumphs of Enterprise, Ingenuity, and Pubic Spirit* (New York, 1874), p. 396.

26 Official John Rogers website. Warhol recalls discussing this fact with Jamie Wyeth.

27 Note prefatory to the section on "American Paintings," in Henry Watson Kent and Florence N. Levy, *The Hudson-Fulton Celebration*, vol. II (New York, 1909), pp. 3–4.

28 Cahill, "American Resources in the Arts" [1939 speech] in *Art for the Millions*, ed. Francis V. O'Connor, p. 37.

29 Lincoln Kirstein, "Photographs of America: Walker Evans," in *Walker Evans: American Photographs* [1938] (MoMA: New York, 1962), p. 195.

30 Quoted in Rose, "Introduction," *Readings in American Art*, p. 9.

31 Cahill, "Foreword: American Resources in the Arts," p. 39.

32 Elizabeth Halsey, "How to Live with Taste" [1953], quoted in Cécile

Whiting, *A Taste for Pop: Pop Art, Gender, and Consumer Culture* (Cambridge, 1997), p. 70.

33 John F. Kennedy and others, *Creative America* (New York, 1962).

34 See Lisa Wainwright, "Robert Rauschenberg's Fabrics: Constructing Domestic Space," in *Not At Home: The Suppression of Domesticity in Modern Art and Architecture,* ed. Christopher Reed (London, 1996).

35 Ellen Johnson, *Modern Art and the Object* (London, 1976), p. 167.

36 Sherrie Levine in Jeanne Siegel, "After Sherrie Levine" (interview), in *Art Talk: The Early 80s,* ed. Jeanne Siegel (New York, 1988), p. 245.

37 Valentin Tatransky, "Collage and the Problem of Representation: Sherrie Levine's New Work," *Real Life,* 1 (March 1979), p. 25.

38 McCollum, in D. A. Robbins, "An Interview with Allan McCollum," *Arts,* 60, no. 2 (October 1985), p. 43.

39 Cahill, "Foreword: American Resources in the Arts," p. 42.

40 Allan Kaprow, "The Artist as a Man of the World" [1964], in *The Blurring of Art and Life,* ed. Jeff Kelley (Los Angeles and Berkeley, CA, 1993), p. 58.

41 Donald Judd, "Nationwide Reports: Hartford" (review of *Black, White, and Grey* at the Wadsworth Atheneum) [1964], reprinted in Judd, *Complete Writings, 1959–1975* (Halifax, Nova Scotia, 1975), p. 118.

42 "Where to See Everyday Art," *Everyday Art Quarterly,* no. 13 (Winter 1949–50), p. 1.

43 Kaprow, "Man of the World," pp. 58–9.

44 Faith Wilding's "Monstrous Domesticity" in *M/E/A/N/I/N/G,* no. 18 (November l995). Wilding means her work to be a critique of men's "subversive" use of craft as playing off and reinforcing masculinity/gender, rather than undermining it. But I would argue that this is not true, that it is a way of describing several complicated things: that it has always been suspect to be an artist in America, a country without much use for art, and that it is feminizing for a man to be interested in art; that these things are also about complicated feelings for mothers, empathy as well as in some cases hostility or fear.

45 Alvin Loving, quoted in April Kingsley, "Alvin Loving: On a Spiralling Trajectory" [sic], in *Al Loving: Color Constructs* (Purchase, NY: Neuberger Museum of Art, 1998), p. 7.

46 For example, "New Sculpture: Robert Gober, Jeff Koons, Haim Steinbach," at The Renaissance Society at the University of Chicago, 1986.

47 D. S. Defenbacher, "Editorial Note," *Everyday Art Quarterly,* no. 13 (Winter 1949–50), pp. 13–14.

48 The installation, a curatorial project that included the work of other artists, housed Albert Bierstadt's nineteenth-century landscape painting *Lake Tahoe, California* (1867); Richard Prince's handwritten joke: "Fireman pulling drunk out of a burning bed: You darned fool, that'll teach you to smoke in bed. Drunk: I wasn't smoking in bed, it was on fire when I laid down"; and Meg Webster's *Moss Bed* (1986–8), a mattress of dirt and grass. Together the works spoke of a natural world already ruined and beyond redemption from the first moment of colonization. Jameson wrote for the exhibition catalog, and like Smith's story, the work has become a "proof" of postmodernism for

various authors speaking about allegory, spatiality, etc. In fact the installation is insistently meaningful (which is not to say didactic) and deeply connected to the long-running themes of revelation and ruin.

49 Carrie Tirado Bramen, *The Uses of Variety: Modern Americanism and the Quest for National Distinctiveness* (Cambridge, MA, 2000).
50 Horace Kallen, "Democracy Versus the Melting Pot," *The Nation*, 100 (February 18 and 25, 1915), pp. 190–94, 217–20.
51 Kallen, reprinted in *Culture and Democracy in the United States* [1924], (New Brunswick, NJ, 1998), pp. 116–17.
52 Robert Motherwell, in "Picasso Is Dead in France at 91," *New York Times* (April 9, 1973) 1, 47.
53 Russell Lynes, *The Tastemakers* (New York, 1953), p. 284.
54 Robert Ayers, "What's in your Studio, Rodney Graham?," [interview], Artinfo.com (October 9, 2007), www.artinfo.com/news/story/25773/whats-in-your-info-rodney-graham.
55 In "Tea No. 2: Rob Pruitt and Jonathan Horowitz," *Made in USA* (Autumn–Winter 1999–2000), p. 59.
56 Allan McCollum, "Allen Ruppersberg: What One Loves about Life Are the Things That Fade," in *Allen Ruppersberg: Books, Inc.* (Limoges: Fond Regional d'Art Contemporain du Limousin, 2001).
57 Interview on "Soundcheck" (November 1, 2006), WNYC radio.
58 Fred Turner, *From Counterculture to Cyberculture: Stewart Brand, the Whole Earth Network, and the Rise of Digital Utopianism* (Chicago, IL, 2006), p. 241.
59 "The Bomb and the Man," *Time*, XLVI, no. 27 (December 31, 1945), pp. 15–17. In naming Harry Truman Man of the Year for 1945, they played on Truman's figurative and literal small stature, his status as an "ordinary, uncurious man" as well as his shortness, in declaring the age of the great man over. *Time* noted that the bomb itself was the product of thousands of scientists as well as workers—very unusually calling the creative as well as the manual aspect of the bomb's making "the assembly line"—and was not even the product of the decision-making of a single politician.
60 Michael Hardt and Antonio Negri, *Multitude: War and Democracy in the Age of Empire* (New York, 2004), p. 340. It is amusing that this is the perfect synopsis of Surowiecki's book, written from a very different political vantagepoint.

5 First and Last

1 Cited by Robert Creeley, "Olson and Black Mountain College," in *Black Mountain College: Experiment in Art*, ed. Vincent Katz (Cambridge, MA, 2003), p. 302.
2 Jimmie Durham, "The Search for Virginity," in *The Myth of Primitivism*, ed. Susan Hiller (London and New York, 1991), p. 289.
3 This science fiction trope was ubiquitous in post-war America, mirrored by that of alien invasion, often expressing a fear of being overwhelmed by immigrants.
4 A report on the discussions published in Japanese that year is cited by Bert

Winther-Tamaki, "Isamu Noguchi: Places of Affiliation and Disaffiliation," in Winther-Tamaki, *Art in the Encounter of Nations: Japanese and American Artists in the Early Postwar Years* (Honolulu, HI, 2001), p. 122, n. 61.

5 Barnett Newman, "The First Man Was an Artist" [1947], in *Barnett Newman: Selected Writings and Interviews*, ed. John P. O'Neill (New York, 1990), pp. 156–60.

6 "Philip Guston's Object: A Dialogue with Harold Rosenberg," in *Philip Guston: Recent Paintings and Drawings* (New York, Jewish Museum, 1966), n.p.

7 For an important and insightful look at the relation between these two terms, see Jeffrey Weiss, "Science and Primitivism: A Fearful Symmetry in the New York School," *Arts*, 57, no. 3 (March 1983), pp. 81–7.

8 Charles Olson, "Cy Twombly" [1952 exhibition catalog preface], reprinted in *Collected Prose: Charles Olson*, ed. Donald Allen and Benjamin Friedlander (Berkeley, CA, 1997), p. 175.

9 Richard Warrington Baldwin Lewis, *The American Adam: Innocence, Tragedy, and Tradition in the Nineteenth Century* (Chicago, IL, 1955), pp. 90–109.

10 In Richard Slotkin, *Regeneration Through Violence: the Mythology of the American Frontier, 1600–1860* (Middletown, CT, 1973), p. 519.

11 For further discussion, see Raymond Henniker-Heaton and Beatrix T. Rumford, "Uncommon Art of the Common People: A Review of Trends in the Collecting and Exhibiting of American Folk Art," in *Perspectives on American Folk Art*, ed. Ian M. G. Quimby and Scott T. Swank (New York and London, 1980), p. 14.

12 Geoffrey Dorfman, "Resnick Interviews," in *Out of the Picture: Milton Resnick and the New York School*, ed. Geoffrey Dorfman (New York, 2003), p. 34.

13 There seems to be a general belief that Barr was the source of MoMA's interest in folk art, and an unawareness or underestimation of the role of Cahill and Miller.

14 J. T. Kirk, *The Shaker World: Art, Life, Belief* (New York, 1997), p. 230.

15 See Joan Shelley Rubin, "A Convergence of Vision: Constance Rourke, Charles Sheeler, and American Art," *American Quarterly*, 42, no. 2 (June 1990), pp. 191–222 and Wanda Corn, "Home, Sweet Home," in *The Great American Thing* (Berkeley and Los Angeles, CA, 1999), pp. 293–337.

16 See, for example, Edward Deming Andrews, "Shaker Influence— Traditionalists and Moderns Discover Virtues of Shaker Furniture— Honesty, Strength, Truth, and the 'Gift to be Simple,'" *Look Magazine* (1954); and Andrews, "Shaker Design," *Art in America*, 46, no. 1 (Spring 1958), pp. 45–9.

17 Donald Judd, review for *Arts Magazine*, in *Complete Writings, 1959–1975* (Halifax, Nova Scotia, 1975), p. 138.

18 Quoted in Adcock, *James Turrell*, p. 211.

19 Robert Morris, "Size Matters," *Critical Inquiry*, 26, no. 3 (Spring 2000), pp. 474–87.

20 Winsor is quoted (and interpreted) by Judith Barry and Sandy Flitterman-Lewis, "Textual Strategies: The Politics of Art-Making," reprinted in *Feminist*

Art Criticism, ed. Arlene Raven, Cassandra Langer, and Joanna Frueh (Ann Arbor, MI, 1988), p. 92. Gober, Celmins, and Winsor have in common that all of their fathers built the houses they grew up in (Robert Gober, "Interview with Vija Celmins," in *Vija Celmins* (London and New York, 2004), p. 25). The Celmins house was in Indiana, so she would have lived there from roughly ten on. Celmins and Gober both made early work in the form of wooden sculptures of houses.

21 Ellen Johnson, writing in the MoMA catalog for her 1979 retrospective (the first for a woman). This trope was repeated by other critics, see for example, the title of John Gruen's article, "Jackie Winsor: Eloquence of a Yankee Pioneer," *ArtNews*, 78, no. 3 (March 1979), pp. 57–60. Winsor was born in Canada, and lived on the coast of Newfoundland until moving to Massachusetts as a teenager. The relationship of Canada to the United States is complicated, obviously, and to what extent those national identities are conflicting or related differs depending on whether one is speaking of climate and geography, for example, or military status.

22 Calvin L. Beale, "A Further Look at Nonmetropolitan Population Growth since 1970," *American Journal of Agricultural Economics*, 58, no. 5 (December 1976), pp. 953–8.

23 *Man the Hunter*, ed. Richard B. Lee and Irven de Vore (New York, 1968).

24 Timothy Leary, "Start Your Own Religion" [1967] in *Tune In, Turn On, Drop Out* (Berkeley, CA, 1999), p. 12.

25 Ibid., p. 7.

26 Ibid., p. 12.

27 Many artists of the time saw themselves as nomads, in part because of the beginning of travel to more distant locations, and in part due to the peripatetic life of an artist finding precarious perches in New York real estate.

28 Sol Tax, "Discussions: Future Agenda," in *Man the Hunter*, ed. Lee and de Vore, pp. 345–6.

29 William Carlos Williams, *In the American Grain* [1925] (New York, 1956), pp. 213–15.

30 David Reed, interview by Stephen Ellis (October 29, 1989), in William S. Bartman, ed., *David Reed* (Los Angeles, 1990), pp. 14–15. Reed's early abstractions of the 1970s are similarly compact and conflicted. Painted in black and white, they refer simultaneously to Minimalism, the light of the Southwest (as discussed in Chapter 2), and to photography, as he again realized belatedly.

31 See Chapters 4 and 5 in Slotkin, pp. 94–145. Wilcomb E. Washburn and Bruce G. Trigger, "Native Peoples in Euro-American Historiography," in *The Cambridge History of the Native Peoples of the Americas*, vol. 1: *North America*, Part 1, ed. Wilcomb E. Washburn (Cambridge and New York, 1996), pp. 74–5, points to historian James Axtell's name for these people: "white Indians."

32 Quoted in Robert Hughes, "Ferrer: A Voyage with Salsa," *Time*, vol. 109, no. 9 (February 28, 1977), p. 67.

33 Carter Ratcliff, "On Contemporary Primitivism," *Artforum*, 14, no. 3 (November 1975), p. 57.

34 Ann Wilson, "Voices from an Era," in *Paul Thek: The Wonderful World That Almost Was* (Rotterdam, 1995), p. 62.

35 As quoted in George McKay, "The Social and (Counter-) Cultural 1960s in the USA, Transatlantically," in *Summer of Love: Psychedelic Art, Social Crisis and Counterculture in the 1960s*, ed. Christoph Grunenberg and Jonathan Harris (Liverpool, 2005), p. 43.

36 Tom Wolfe, *The Electric Acid Kool Aid Test* [1968] (New York, 2008), p. 252. The Blue Marble is a famous photograph of the Earth taken on 7 December 1972 by the crew of the Apollo 17 spacecraft at a distance of about 29,000 kilometres (about 18,000 miles).

37 *Whole Earth Catalog* (Spring 1969), pp. 7–9.

38 Quoted in Patricia Nelson Limerick, "The Adventures of the Frontier in the Twentieth Century," in *The Frontier in American Culture*, ed. James R. Grossman (Berkeley and Los Angeles, CA, 1994), pp. 80–81.

39 Quoted in James R. Hansen, *First Man: The Life of Neil A. Armstrong* (New York, 2006), p. 521.

40 Ibid., p. 15.

41 Cited in Anne Collins Goodyear, "NASA and the Political Economy of Art, 1962–1974," in *The Political Economy of Art: Making the Nation of Culture*, ed. Julie F. Codell (Cranbury, NJ, 2008), p. 196.

42 Ibid., p. 196.

43 Robert Smithson [ca. 1961–6], quoted in Robert A. Sobieszek, "Robert Smithson's Proposal for a Monument at Anarctica," in *Robert Smithson* (Los Angeles: Los Angeles Museum of Contemporary Art, 2004), p. 143.

44 Artist's note on *Bones and Their Containers (To Martin Cassidy)*, 1971 in *The Sculpture of Nancy Graves: A Catalogue Raisonné* (New York, 1987), no. 26, p. 60.

45 Francis Jennings, "Widowed Land," in Jennings, *The Invasion of America: Indians, Colonialism and the Cant of Conquest* (Chapel Hill, NC, 1975).

46 Norman Mailer, "The Faith of Graffiti," in Mervyn Kurlansky and Jon Naar, *The Faith of Graffiti* (New York, 1974), n.p.

47 Elisabeth Sussman, "Songs of Innocence at the Nuclear Pyre," in *Keith Haring* (New York: Whitney Museum, 1997), p. 20.

48 Peter Halley, "Introduction," *New Observations: Art and Culture* (New York, 1983), p. ii.

49 Halley, "Ross Bleckner: Painting at the End of History," *Arts Magazine* [New York], 56, no. 9 (May 1981), pp. 132–3.

50 For example, the decorating book of "warm adobe brick, simple hand-carved furnishings, rough-hewn beams, Indian pottery, Navajo rugs, and colorful folk sculpture" was published in 1986: Christine Mather and Sharon Woods, *Santa Fe Style* (New York, 1986).

51 Interview with the author, June 2008.

52 "Conversation between Raphaela Platow and Dana Schutz," in *Dana Schutz: Paintings 2002–2005* (Waltham, MA: Rose Art Museum, Brandeis University, 2006), p. 86.

53 See Mike Kelley, "Black Out," in *Mike Kelley: Minor Histories*, ed. John Welchman (Cambridge, MA, 2004), pp. 156–63.

54 Mark Bradford, interview with Kara Walker in the exhibition catalogue
 Bounce: Mark Bradford and Glenn Kaino, ed. Eungie Joo (Los Angeles:
 California Institute of the Arts, 2004), p. 55.

Select Bibliography

Alloway, Lawrence, *Imagining the Present*, ed. Richard Kalina (London, 2006)

Art Since 1945 (New York, 1958)

Bercovitch, Sacvan, *The American Jeremiad* (Madison, WI, 1978)

Boyer, Paul, *By the Bomb's Early Light: American Thought and Culture at the Dawn of the Atomic Age* (New York, 1985)

Gilmore, Paul, "The Telegraph in Black and White," *ELH*, 69 (2002), pp. 805–33

Greenberg, Clement, *The Collected Essays and Criticism, Volume II: Arrogant Purpose, 1945–1949*, ed. John O'Brian (Chicago, 1986)

Hobsbawm, Eric, *The Age of Extremes: The Short Twentieth Century, 1914–1991* (London, 1994)

Jennings, Francis, *The Invasion of America: Indians, Colonialism and the Cant of Conquest* (Chapel Hill, NC, 1975)

Jones, Caroline, *Machine in the Studio: Constructing the Postwar American Artist* (Chicago, 1996)

Kallen, Horace, "Democracy Versus the Melting Pot," *The Nation*, 100 (February 18 and 25, 1915), pp. 190–94, 217–20

Kaprow, Allan, "Should the Artist Become a Man of the World," *Art News*, 63, no. 6 (October 1964), pp. 34–7, 58–9

Katz, V., ed., *Black Mountain College: Experiment in Art* (Cambridge, MA, 2003)

Lawrence, D. H., *Studies in Classic American Literature* [1923] (New York, 1977)

Leary, Timothy, *Tune In, Turn On, Drop Out* (Berkeley, CA, 1999)

Lee, Richard B., and Irven de Vore, eds, *Man the Hunter* (New York, 1968)

Lynes, Russell, *The Tastemakers* (New York, 1953)

MacDonald, Dwight, "A Theory of Mass Culture," *Diogenes*, 1, no. 3 (June 1953), pp. 1–17

McAuliffe, Chris, "Idées Reçues: The Role of Theory in the Formation of Postmodernism in the United States, 1965–1985," unpublished doctoral dissertation, Harvard University, 1997

Miller, Perry, "The End of the World," *William and Mary Quarterly*, 8, no. 2 (April, 1951), pp. 172–91

Murakami, Takashi, *Little Boy: The Arts of Japan's Exploding Subculture* (New York and New Haven, CT, 2005)

Nearing, Helen and Scott, *The Good Life* (Harborside, ME, 1954)

Newton, Judith, *From Panthers to Promise Keepers: Rethinking the Men's Movement* (Oxford, 2005)

Noble, David, *Death of a Nation: American Culture and the End of Exceptionalism* (Minneapolis, 2002)

O'Connor, Francis V., ed. *Art for the Millions* (Greenwich, CT, 1973)

Olson, Charles, *Collected Prose*, ed. Donald Allen and Benjamin Friedlander (Berkeley, CA, 1997)

Orth, Ralph H., ed., *The Journals and Miscellaneous Notebooks of Ralph Waldo Emerson, Volume XV, 1860–1866* (Cambridge, MA, 1982)

Rosenberg, Harold, 'The American Action Painters," *ArtNews*, 51, no. 8 (December 1952), pp. 22–23, 48–50

Rozario, Kevin, *The Culture of Calamity: Disaster and the Making of Modern America* (Chicago, 2007)

Sandage, Scott A., *Born Losers: A History of Failure in America* (Cambridge, MA, 2003)

Singerman, Howard, *Art Subjects: Making Artists in the American University* (Berkeley and Los Angeles, 1999)

Slotkin, Richard, *Regeneration through Violence: The Mythology of the American Frontier, 1600–1860* (Middletown, CT, 1973)

Stewart, Kathleen, and Susan Harding, "Bad Endings: American Apocalypsis," *Annual Review of Anthropology*, 28 (1999), pp. 285–310

Thoreau, Henry David, *Walden* [1854] (Princeton, NJ, 1971)

Tocqueville, Alexis de, *Democracy in America* [1835], vol. II, trans. Henry Reeve (New York, 1904)

Turner, Fred, *From Counterculture to Cyberculture: Stewart Brand, the Whole Earth Network, and the Rise of Digital Utopianism* (Chicago, 2006)

Walker Evans: American Photographs [1938] (New York, 1962)

Welchman, John C., ed., *Mike Kelley: Minor Histories—Statements, Conversations, Proposals* (Cambridge, MA, 2004)

Winther-Tamaki, Bert, *Art in the Encounter of Nations: Japanese and American Artists in the Early Postwar Years* (Honolulu, 2001)

Zukin, Sharon, *Loft Living: Culture and Capital in Urban Change* [1982] (New Brunswick, NJ, 1989)

Acknowledgements

It is astonishing how much time and how many people it takes to write a book. First, thanks to Eleanor, Frank, the late Elsie Lou, and Sam Siegel.

Colleagues at the University of Memphis and Hunter College, as well as *Artforum*, *Art Journal*, and various other institutions over the years have made work engaging. I would particularly like to thank Greely Myatt, Melinda Parsons, Ed Bleiberg, Fred Albertson, Larry Edwards, Emily Braun, Valerie Steiker, Eric Banks, Jack Bankowsky, David Frankel, Don McMahon, and Lutz Eitel for their advice and their efforts to make me a teacher and a writer.

So many of my undergraduate and graduate students in both art history and studio art over the past fifteen years have been brilliant, creative people who care deeply about what they and others do; I regularly see people at their very, very best, and I am grateful. I particularly enjoyed the resourceful and imaginative students in a 2008 seminar on American art in the age of extremes. Unexpectedly, working with graduate students writing their master's theses on contemporary Korean and Japanese artists who reflect on their national histories and artistic techniques brought me to see the artists I study through a similar lens, in a new and productive light.

The artists I have worked with over the years have inspired me. For help with the ideas that went into this book, I would like to thank Matthew Barney, Mark Bradford, Harmony Hammond, Jeff Koons, Sharon Lockhart, Kerry James Marshall, Takashi Murakami, Dana Schutz, Alan Shields, Jessica Stockholder, and Fred Tomaselli. David Reed deserves his own thank you; he appears only briefly in this book, but he has been a source of exciting conversation as well as art, confirming and disturbing my own trains of thought in productive ways.

The other people who helped me to think about specific problems include Hannah Higgins, whose own work I very much admire, and who generously and perceptively read "Black and White" in draft form, and Jeff Wilson, who showed up at my house with a pile of books by authors ranging from D. H. Lawrence to Richard Slotkin, introducing me to a whole vein of historical imagination. Lane Relyea and Howard Singerman are both among my favorite scholars and my favorite people, and helped me with specific questions, raising broad conceptual issues, and most of all with the example of their own brilliant writing. They are cited in the book itself, but I owe them more than the endnotes' accounting. In particular, after reading the first chapter of the book, Lane pointed me towards

Since '45: America and the Making of Contemporary Art

the American Studies treatment of Puritan culture, which significantly inflected the book's present state.

Lauren O'Neill-Butler began working with me, as a graduate student and a research assistant, when I started this book in earnest, and I am grateful for her patience and intellectual openness as I felt for its contours. Katherine Behar took over for the last year of the book, and she was simply heroic in relentless library work, picture research, and the incisive thinking she contributed to the project. Her organizational skills, humor, and empathy made it feel more like a collaborative project and less like solitary confinement. I am very grateful to my editor at Reaktion, Vivian Constantinopoulos, for her warm support for this project during its entirety, and also for her insightful comments and suggestions.

Richard Shiff, my graduate adviser and now my good friend, made me want to be an art historian, taught me how to research, and perhaps most importantly, showed me that one could be serious without being pretentious. His work on modern and contemporary art is the thing I turn to again and again, astonished by its meaningfulness, its depth, his capacity for intellectual accounts of physicality and felt life. I am grateful for the time I have spent with him and with his writing, and would be a different person without him.

The person to whom I owe the most is Paul Mattick. He has read, argued, and informed every page of this book, and encouraged me in believing that it was worth writing. His capacity for historical and structural thinking, exercised on a daily basis, made me see, finally, how I might begin to think that way; his unstinting love makes it worth getting up in the morning. And last, in that vein, thanks to Felix, whom I just love.

Photo Acknowledgements

Index